THE
PICASSO
BOOK

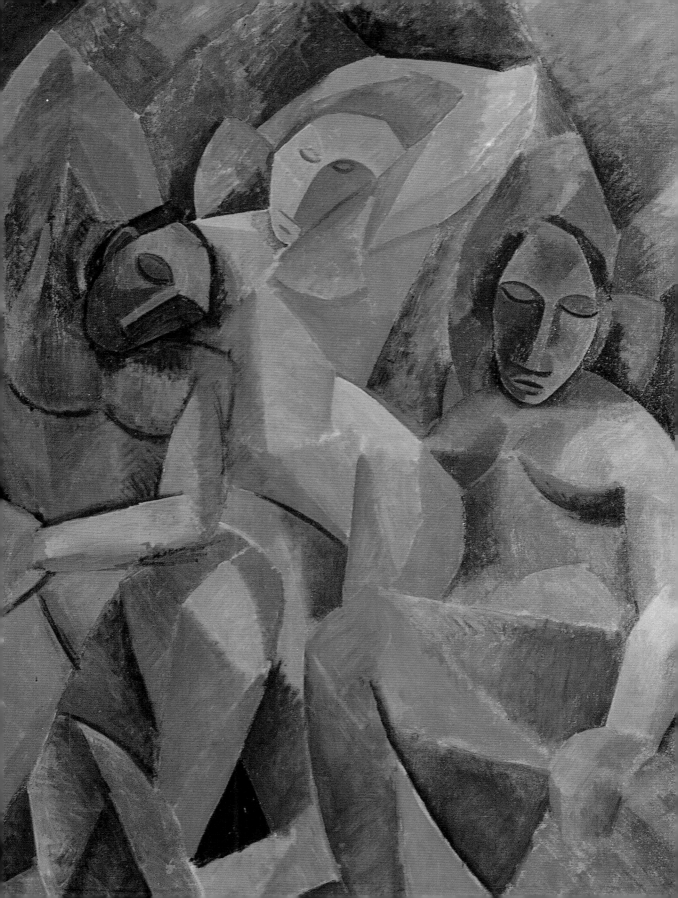

NEIL COX

THE PICASSO BOOK

TATE PUBLISHING

First published in 2010 by order of the Tate Trustees by
Tate Publishing, a division of Tate Enterprises Ltd, Millbank,
London SW1P 4RG

www.tate.org.uk/publishing

Original texts in 'Picasso's Writings' (see pp.178–185)
are taken from *Picasso: écrits*, Marie-Laure Bernadac
and Christine Piot eds., Paris, Réunion des mes musées
nationaux and Éditions Gallimard 1989, reproduced with
permission, © Éditions Gallimard, Paris

English translations of the texts in 'Picasso's Writings'
(see pp.178–185) are taken from *Pablo Picasso, The Burial of
Count Orgaz and Other Poems*, eds. Jerome Rothenberg and
Pierre Joris, Cambridge, MA 2004, courtesy of Exact Change.

A catalogue record for this book is available from the
British Library
ISBN: 978 1 85437 843 9

Distributed in the United States and Canada by
Harry N. Abrams, Inc., New York
Library of Congress Control Number 2009941719

Designed by Susan Wightman at Libanus Press
Template designed by Esterson Associates

Colour reproduction by Evergreen Colour Separation
CO. Ltd., Hong Kong
Printed and bound in China

Front cover: *Nude Woman in a Red Armchair* 1932
(detail fig.35)
Frontispiece: *Three Women* 1908 (detail fig.42)

Measurements are given in centimetres, height before width

Some of the ideas in this book are condensed from lectures presented elsewhere over recent years. For those opportunities I'd like to thank Dr Nazan Ölçer and Kerim Bayer of the Sakıp Sabancı Museum, Istanbul, and the curator of the extraordinary exhibition there, Marilyn McCully; Kathleen Bartels and Ian Thom at the Vancouver Art Gallery; Lynn Stevenson and pupils at Colchester VI Form College; Judy Purbeck and Hilary Laurie at the Highgate Literary & Scientific Institution; and the audience at an Association of Art Historians VI Form Study Day at Tate Britain. Research for some parts of the book was made possible thanks to Sylvie Fresnault and Jeanne-Yvette Sudour at the Musée Picasso, Paris, as well as the staff of the Albert Sloman Library, University of Essex. My colleagues at Essex allowed me time away from teaching to write it.

The book happened thanks to Michael White, University of York (who is also incidentally the author of the underground pop song 'Surfing Picasso'). At Tate Publishing I have had the pleasure of working with the excellent team of Roger Thorp and Alice Chasey, and highly efficient picture editor Vicky Fox. My editor, Johanna Stephenson, was a (ruthless) marvel.

My main debt is, however, to the three colleagues who agreed to act as brutally honest readers, Elizabeth Cowling, Christopher Green and Peter Vergo. Each brought great acuity and knowledge to the task, and was considerably more efficient than the author in meeting deadlines! The book is many times better for their work.

Dana and Emlyn looked after me, as ever.

Acknowledgements

For the last Picasso exhibition that the artist oversaw, held at the Palais des Papes, Avignon, in 1973, 201 paintings were selected from among those produced in the two preceding years. When the show opened on 23 May Picasso had been dead for less than a month, so the exhibition became a valedictory message to dealers, collectors, critics and the general public, a final statement of energetic creativity. In this posthumous show Picasso asserted his supposedly undiminished powers by insisting that the exhibition consist only of his latest output, much of which was on a large scale. The work horrified some of his erstwhile supporters, such as the collector Douglas Cooper, who saw in it only 'the incoherent scrawls done by a frantic old man in death's antechamber'.[1] Moreover, Picasso's final statement seemed to underline the irrelevance of his achievement for his younger peers in France, who were rather more indebted to his old rival Henri Matisse and to the idea of abstraction, and his legacy languished forgotten for most of the 1970s: 'I can't see him as the origin of anything', wrote the philosopher Roger Caillois.[2]

Subsequent decades might from one point of view seem only to strengthen Caillois's case; it is, after all, Marcel Duchamp, not Pablo Picasso, whose light seems to lead contemporary art.[3] Yet there is something deeply paradoxical about that definitive sense of an ending: for Picasso's death was also a beginning. When, after years of legal activity, the French State accepted a portion of the artist's own collection in lieu of inheritance tax, the floodgates were opened to a vast new resource to be explored in exhibitions and scholarship. This remarkable body of work toured Europe and North America in the late 1970s and early 1980s, before forming the astonishing collection of the new Musée National Picasso in Paris, an institution that dwarfed the existing Museu Picasso, Barcelona, and Musée Picasso, Antibes. The exhibition of these works of art, previously kept back by Picasso from the art market, many of which were barely known, was called *Picasso's Picassos*, and it marked a new phase in the understanding of the artist's oeuvre.

Beyond the works that entered the collection of the Musée Picasso, a still larger proportion of Picasso's collection was distributed among his heirs. Although these works were less accessible than those in the museum, they have nevertheless gradually entered the public domain through publications and temporary exhibitions. There have also been further donations to museums of elements of the inheritance by various family members (in one case leading to the creation of the elegant Museo Picasso in Malaga), in particular those given in lieu of tax after the tragic suicide of his last wife, Jacqueline Roque, in 1986.

His oeuvre – which includes but vastly exceeds the estate shared out after his death – makes Pablo Ruíz Picasso the most prolific artist in the history of Western art. Born on 25 October 1881 in the Andalusian city of Malaga, he spent almost all his productive

Preface: Origins?

life in France; he died in Mougins, near Cannes, and is buried in the grounds of the Château de Vauvenargues near Aix-en-Provence. In more than seven decades as an artist Picasso finished over two thousand oil paintings alone. To put this in some perspective, the seventeenth-century Dutch artist Vermeer, whom Picasso admired, is known to us through a mere thirty-six paintings. Even Velázquez only managed a few hundred finished paintings. If Picasso spent so much time painting in oil, we might imagine that he produced relatively little in other media. Not so: his estate alone included some 600 sculptures, 500 ceramics, many thousands of prints (of which some 2,000 are etchings), 158 sketchbooks and approaching 10,000 loose drawings.[4] In addition, he produced hundreds of photographs, numerous poems, two plays, the odd short film, jewellery and silverware designs, and is credited with the invention of a new medium in twentieth-century art: collage.

A book like this, with a mere eighty illustrations, can only offer glimpses of an extraordinarily diverse range of work. Each of the six chapters ranges across Picasso's oeuvre: this is not to say that there is no chronological thread, but the divisions of the chapters and their sequence are conceptual rather than (merely) chronological. Each relates paradigmatically to a particular period in the artist's career: the second relates to Cubism and Neoclassicism; the third to Picasso's early Cubism and the Surrealism of the 1920s and 1930s; the fourth to the later 1930s through the 1940s; the fifth to the late 1940s and 1950s; and the last to the 'late' prints, paintings and sculptures. The first chapter, in addition to describing Picasso's early development as an artist, examines the role of his biography as a key to interpreting his work through an exploration of the figure of the Minotaur so important to him in the 1930s.

Written as a series of stories rather than a single narrative, the book is designed to address the fundamental challenges posed not only by the scope of Picasso's work, but also by the present state of Picasso studies. The shock of his representations of fragmented human faces in 1937, or the role of politics in his art, deserves to be considered at arm's length from *local* historical as well as biographical contexts. My intention is broader still, addressing further questions: what does the figure of 'the artist' mean in the twentieth century; how does Picasso's lived life relate to the visions of horror or of joy so common in his work; how might his exploration of the human form relate to contemporary understandings of what it is to be human; and is Picasso, in the end, the origin of anything?

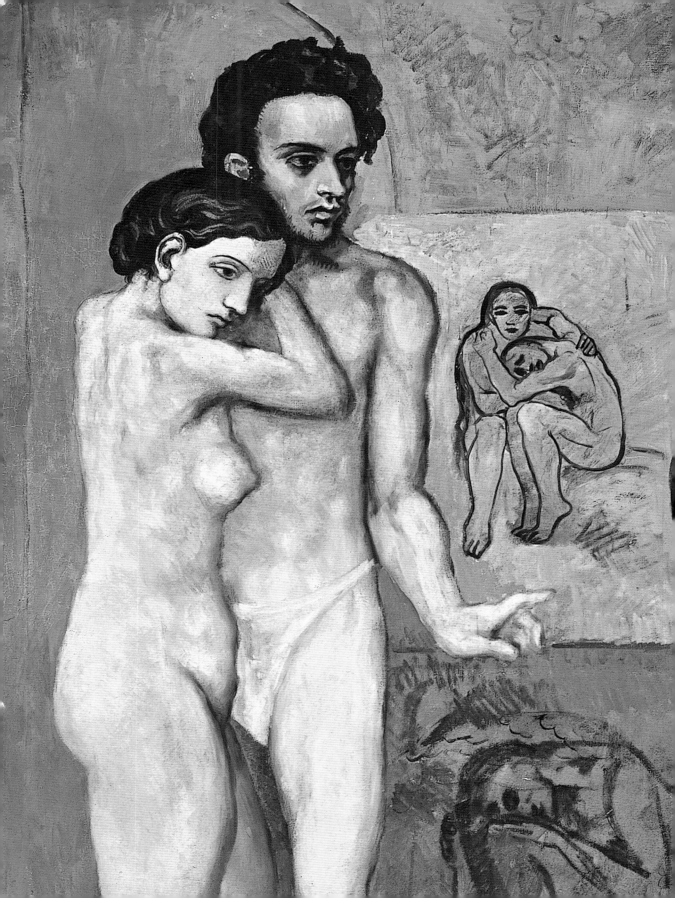

One of the many ways we can define modernity is in terms of the category of the individual, expressed in phenomena such as, for example, the rise of the novel and the musical form of the symphony in the eighteenth century, the advent of military-political demagogues such as Napoleon Bonaparte, or the development of parliamentary democracies based on the notion of the enfranchised citizen. Perhaps the most powerful representative of the idea of the autonomous individual is the figure of modern artist. In the most important foundational text for modern notions of art, Immanuel Kant's *Critique of Judgement* of 1790, the figure of the artist is understood in terms of 'genius', an apparently innate ability to create art anew with each work.[1] The idea of the artist as a natural genius empowered to reinvent art was central to the Romantic movement and to the rise of what we now call modern art.[2] Yet by the time Picasso set out to make a career as an artist, the notion of artistic genius, dependent as it was on the notion of the individual, was no simple thing. Picasso was the contemporary of Marcel Proust, whose exploration of selfhood in his series of books *In Search of Lost Time* demonstrated that the sense of self is caught up in a flux of memory images that is unstable. At the same time Sigmund Freud had, almost in passing, undermined the stable limits of individual consciousness while arguing that it is through a dynamic struggle between desire and socialisation that the human subject is effected; the 'individual' happens when desires are repressed, when a division occurs between conscious and unconscious thoughts, such that the subject is split from the outset.

Thinking about Picasso always means being caught in the trap that is the category of the individual, being seduced by the modern idea of the artist as genius. The main symptom of this is the predominance of biographically inspired writing about the artist, an approach that constantly emphasises the artist's self-determined nature, isolating him from his contemporaries and, crucially, seeking to tie 'the meaning' of every work to a life event. There is circular argument here: the act of biography reinforces the notion of the individual genius, which in turn feeds the biographical project. More importantly, however, seeing Picasso and Picasso's work in terms of biography is ideological: it conceals from view the fact that the categories of the individual, of genius, of lived life and of the work of art are all constructed in modernity, are all forms of contemporary representation that permit social relations to be how they are, and reinforce them.

None of this is to say that the fruits of the work of Picasso's many biographers can be ignored. Furthermore, we cannot easily overcome any of those ideological categories, since not only were they fundamental to Picasso's own understanding of his work, and shape it accordingly, but they are also implicated

1 Picasso's 'Picasso'

. . . every now and then the world looks for an individual on whom to rely blindly – such worship is comparable to a religious appeal and goes beyond reasoning. Thousands today in quest of supernatural aesthetic emotion turn to Picasso, who never lets them down. (Marcel Duchamp)[3]

in the very language we use when we speak of 'art' and of 'artists'.

Picasso had a complex and ambivalent attitude to the notion of genius, and indeed to the idea that his work was a direct expression or reflection of his lived life. On the one hand, he conspired in constructing a story of his life, representing key events in the narrative to many different biographers or admirers in order to produce a sense of who 'Picasso' was, and no doubt to deny other possibilities. For example, a supposed event of 1894 is often cited as a turning point in the young artist's development: Picasso described to his first biographer and personal secretary Jaime Sabartés, how his father, José Ruiz Blasco, was struggling to finish one of his own pigeon paintings. 'Don' José's failing eyesight meant that he had difficulty painting the intricate details of a pigeon's claws; so he chopped the claws off the dead bird that was his model, nailed them to a board and charged his son with painting them while he went for a walk. On his return the results were so stunning as to prompt him to surrender his palette and brushes to young Pablo, and vow never to paint again. The story is a fantasy on Picasso's part: his father continued to paint for many years. But whether it is true or false is beside the point: what matters is the way the story fills the space we call 'Picasso', makes sense of it with a tale of an origin, of youthful genius. The fact that it is repeated as a foundational myth by many biographers is a clue to the desire to share with Pablo Picasso in the legend of 'Picasso', to identify his artistic powers with the picaresque dramas of his life 'story'.

On the other hand, Picasso grasped problems that were endemic to the Romantic idea of the individual: authentic experience eludes us in everyday life; creative ideas come from unexpected and inexplicable directions, often outside the self; our individual prejudices can stand between us and the achievement or understanding of the highest kinds of art; the work of art is an entity separate from the individual, existing in dialogue with other works of art and with manifold possible futures. From this point of view things are reversed: the life of Pablo Picasso is fragmented and ineffable, while his work is coherent and meaningful. He went a step further, however, and made his work appear as if a symptom of a fragmented subject, and himself the author of a body of work whose stylistic diversity would challenge the very idea of the unity or coherence of the artist as paradigmatic individual. Bursting forth like fireworks, so many different 'Picassos' might well seem the perfect performance of genius, as Duchamp suggested – a Symbolist, Cubist, Neo-Classical, Surrealist, Expressionist Picasso, a serious and philosophical Picasso alongside a socialite and superficial Picasso – but in fact they defy the very notion of a unified subject underpinning Picasso's 'Picasso'. What we are faced with is an irresolvable tension between the idea of the individual genius and a range of work that cannot easily be seen in terms of a life

1
Self Portrait 1901
Oil on canvas
81 x 60
Musée Picasso, Paris

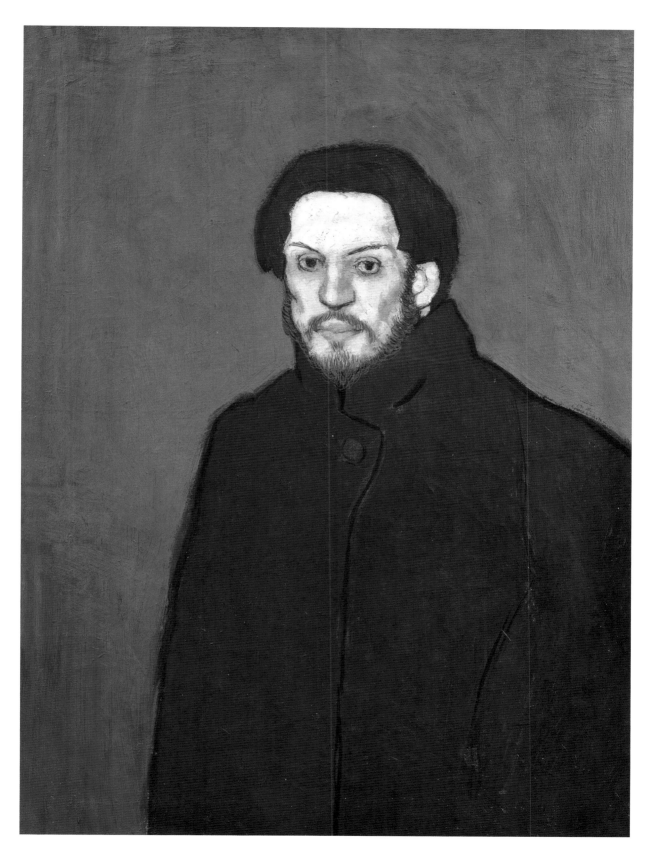

journey or as the expression of a unified set of feelings and experiences. Encouraged by some of Picasso's statements, biography attempts to resolve this tension through an anecdotal mapping of works to what now, from this perspective, seem arbitrary events, on the assumption that one is a reflection of the other.

In the following section, setting out on the road of Picasso's early 'life story', the period of his formation as an artist, the problem of the 'self' arises in a few early self portraits: there is a gap between the considerable amount that we 'know' of his life and how 'Picasso' appears in paintings. (It is in this spirit that biography is deployed throughout these pages, never merely as a means of explaining the artist's works, but rather as the necessary frame against which to examine the relationship between the notions of the individual, the genius, and the construction that is 'Picasso'.)

I, Picasso

One of the arresting presences in the collection of the Musée Picasso, Paris, is a self portrait of late 1901, painted in the style now known as the artist's Blue Period (fig.1). There is nothing here to tell us that the subject is an artist. The fixed stare, the gaunt features, reddish beard and mop of hair appear in a sombre field of blue, atop a tightly buttoned, heavy overcoat. Turning his head to face us, this off-centre 'Picasso' seems nevertheless withdrawn, introspective.

Surprisingly, Picasso made this painting in Paris having tasted success in his first serious attempt to establish himself as an up-and-coming artist in the world-leading city for artistic culture, with an exhibition at Ambroise Vollard's Paris gallery. Picasso painted furiously for the exhibition, in what he regarded as the styles with the most currency among progressive collectors. The critical reception of the Vollard exhibition was limited but positive. Aged only 19 when the show opened, Picasso already demonstrated his prodigious ability to produce large numbers of works quickly. Half of the work sold and some of the remaining paintings were retained by Vollard and another dealer, fellow Spaniard Pedro Mañach, who had brokered the exhibition in the first place. The positive response – and the income – led Picasso to believe that he was destined for great things, but the impact on his earnings of this brief moment of glory did not last. Gradually he found himself short of money yet was reluctant to deliver paintings in fulfilment of his contract with Mañach. The lack of further opportunities to exhibit and for sales was no doubt a serious blow to the ambitious young painter. After months of swagger, expressed in brightly coloured and dramatic compositions showing Parisian life and Spanish bullfights, his work became filled with melancholy, pity and pathos. In so doing, he found an artistic language and forms of subject matter that he pursued for several years, making works

that, much later, were highly prized by collectors.

Of course, this was far from being Picasso's first self portrait – as a schoolboy in Spain he had often examined his own reflection in the mirror, sometimes as an exercise in the academic realism of his day, or in one painting, closer in spirit to his 1901 self portrait, posing as an eighteenth-century gentleman as if a young Goya.[4] Drawing after drawing reveals earnest self-seeking alongside growing confidence with the language of Northern European Symbolist art until, by the time of the Vollard exhibition, he could make a dramatic, expressive and highly coloured self portrait (now in a private collection) inscribed boldly 'I Picasso' (*Yo Picasso*). Showing the artist staring out at his audience with self-consciously Spanish virility, wearing what appears to be a crowd-pleasing artist's garb of loose white smock and orange cravat, Picasso made sure that this painting was listed first in the catalogue of the Vollard show.

Yet nothing about *Yo Picasso*, not even its title, was natural or given. At birth (in the fashion of his native Malaga) Picasso was endowed with an absurdly long list of names: he was christened Pablo Diego José Francisco de Paula Juan Nepomuceno María de los Remedios Crispin Crispiniano de la Santísima Trinidad Ruiz y Picasso. During his teenage years he groped towards a definitive identity and became plain and simple 'Pablo Picasso', rejecting his father's family name (Ruiz) in favour of his

mother's (Picasso), and shedding all but one of his numerous forenames. This decision might in retrospect appear significant, as a statement of artistic direction, since his father was, as we have seen, an artist specialising in paintings of pigeons, still lifes and genre scenes of Spanish life. Don José supplemented his artistic income by teaching in art schools, at first in Malaga and then, from 1891, at La Corunna on the Atlantic coast in the far north-west of Spain, where Picasso was accepted into his father's drawing class. Picasso made much in later life of claims about his prodigious talent: 'at the age of 12 I drew like Raphael', he said; or, 'I have never done children's drawings. Never. Even when I was very small'.[5] The work that survives from Picasso's childhood, or indeed the work of his early teenage years, does not support these assertions: he was an able but not dazzlingly talented child artist.

After 1894 his work made major advances in quality, particularly after his father moved again to the art school in Barcelona. Before that, Picasso did his growing up: brothels, a first girlfriend, drinking in rough bars and bohemian cafés. He also redoubled his artistic efforts, with several ambitious realist paintings with religious or moral-allegorical themes, and a brief period of enrolment in the art school in Madrid, brought to an end by illness and followed by convalescence in the mountains in a town called Horta de Ebro.[6]

It was on his return to Barcelona in 1899 that Picasso really flourished for the first time as a self-consciously 'modern' artist, and

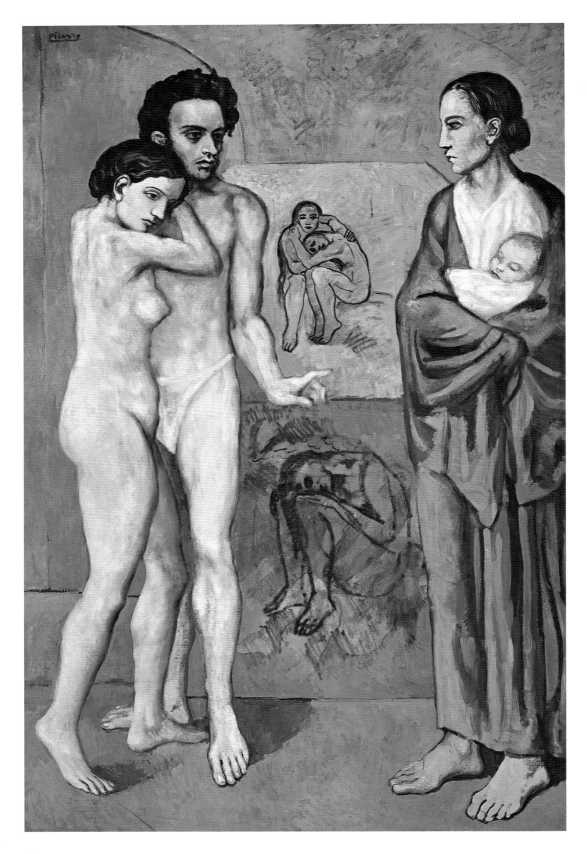

THE PICASSO BOOK

2
La Vie (*Life*) 1903
Oil on canvas
197 x 127.3
Cleveland Museum of Art

opted to use his mother's name, rejecting his father's uninspiring artistic legacy. He took up the visual style of Northern European Art Nouveau, encouraged by the circle around the café Els Quatre Gats (The Four Cats), advocates of the Catalan *Modernisme* movement.[7] Here Picasso heard about the counter-cultural positions of some recent Parisian art and literature, particularly ideas associated with what was at first a literary movement called Symbolism, a reflection of the pessimism of the *fin de siècle* and a gloomy legacy of a long economic recession. Symbolism implied the rejection of realism and Impressionism in favour of fantasy and 'abstraction' (at this time merely the simplification of forms and colours). This often resulted in deeply personal or obscure meanings in Symbolist works or, at other times, in obvious criticisms of contemporary European morality or politics through a celebration of non-Western cultures. It also permitted some of the wild inventions of Art Nouveau design and architecture.[8]

Life?

The lingering impact of Symbolist ideas is evident in Picasso's Blue Period, which is thought to have lasted roughly three years, from late 1901, the end of his second trip to Paris, to 1904, when he finally settled there. As he explored his own imagined identity, Picasso revisited allegory with much greater enthusiasm than had been evident in his teenage religious works. One of his most ambitious allegories – painted over an earlier deathbed scene – is *La Vie* (*Life*) (fig.2), a mysterious picture planned in Barcelona in spring 1903 and completed there in the early summer.

La Vie shows three adult figures in what might be an artist's studio. There is an arch on the left, before which stands a naked woman leaning on the shoulder of a semi-naked man who points, in a curiously tentative way, in the direction of a clothed, possibly older woman on the right, clutching a sleeping baby in her arms. Behind these figures, and in the centre of the composition, are two canvases stacked one above the other: in one, two naked women huddle in an inhospitable landscape, while in the other a naked woman crouches forlornly in a foetal position. These pictures within a picture are uncanny in their animation, hovering on the border of reality. The whole composition is above all a question, its size, morbid colour and melodrama underlining its significance.

Faced with this enigmatic scene, writers have nevertheless attempted to explain its meaning in terms of art historical precedents. The portentous title and the figure types have led commentators on the Blue Period to see a reference to the tradition of 'philosophical pictures', including the example of Gauguin's *Where Do We Come From, What Are We, Where Are We Going?* 1897–8 (Museum of Fine Arts, Boston), which Picasso had seen in Vollard's Gallery.[9] Some see the opposition between the clothed mother figure and the

naked woman as reflecting the subject of sacred and profane love; others interpret the figures of infant, young woman and older mother as suggesting the Three Ages of Man, a popular subject in the late nineteenth century.[10]

The composition went through an important revision during the painting process: four surviving drawings reveal that the male figure originally began as a self portrait. In 1971 art historian Theodore Reff argued that the key to the allegory of *La Vie* is biographical: he saw the male figure in the painting as a portrait of Picasso's friend Carles Casagemas, who committed suicide in Paris in early 1901. Casagemas left Paris with Picasso in late 1900 and travelled with him to Malaga. He was however pining for a woman called Germaine Gargallo (later the wife of another Catalan artist, Ramon Pichot), so returned to Paris alone. On being rejected by Germaine in favour of her then husband, he invited his friends to a farewell dinner in a café, attempted to shoot Germaine with a revolver and then turned the gun on himself. One friend later suggested that Casagemas had recently discovered that he was impotent, and that this had prompted his suicidal act, a claim that led Reff see the awkward loincloth worn by the figure in the painting as a sign of impotence. Reff argued that, given the circumstances of his suicide, the dead Casagemas could stand in for Picasso because the artist himself harboured similar deeply ambivalent feelings towards women. In this biographical interpretation the painting is made to reflect or embody Picasso's attitudes, where women are regarded as a source both of personal suffering and of sexual pleasure.[11]

Persuasive though this argument may at first appear, it does, however, rest on much speculation: Picasso's supposedly ambivalent attitude to women is unproven, while the idea that it could play a causal role in the making of a painting implies a whole theory of art that views artistic expression on a profoundly problematic model of causes and effects. Moreover, even if we accept all of this, the reason for the apparent substitution of Casagemas's face for Picasso's in the final version of the painting could have another explanation. If Picasso felt guilty for abandoning the depressive Casagemas, allowing him to return to Paris alone, then should the substitution, as a form of identification, be interpreted instead as reparation for guilt?

In a much later interview Picasso rejected the idea that *La Vie* was an allegory that could be completely decoded. 'It wasn't me who gave the painting that title', he said; 'I certainly did not intend to paint symbols; I simply painted images that arose in front of my eyes; it's for others to find a hidden meaning in them. A painting, for me, speaks for itself.'[12] The images that appeared to him did perhaps draw upon precedents from European art, and these may in turn provide clues to the types of meaning that Picasso sought to suggest. Yet among such images his

own face was interposed, here taking the form of a self portrait, a gesture in the developing and fluid nature of the artist's own sense of 'Picasso'. The substitution of another male face initiates the deferral of 'Picasso', or the posing of 'Picasso' as a question for the spectator. If *La Vie* speaks, it speaks in tongues.

It is possible to think of *La Vie* in terms of Tarot symbols where, in the part of the pack of cards called the Major Arcana, feelings, life events or human capacities and failings are represented in the guise of strange figures.[13] These cards are combined according to chance, and then interpreted by the cartomancer. They form an allegorical representation of the life situation of the person seeking to know their fortune. In the same way, perhaps the meanings of *La Vie* exist as the dynamic interpretation of the shape of a life in a collection of arcane gestures, figures and objects.

Stories and constellations

Cartomancy certainly resonates with some anecdotes that describe Picasso's fanciful 'readings' of his own works. These were not interpretations of pictures, disquisitions designed to solve their enigma for an eager public – rather, Picasso enjoyed *inventing* stories about the figures represented, as if they were characters in a legend, fairytale or novel – and, strikingly, he did this after they were finished, when whatever 'intentions' we project onto the white heat of their

making were, as expressive ideas, things of the past. This storytelling activity was also a form of courtship – Picasso engaged in it with friends, but also with women to whom he was attracted. In 1944, when he embarked in earnest on the courtship of a young painter called Françoise Gilot (fig.3), he decided to entertain her with stories about the hundred prints he had begun over a decade before, commissioned by Ambroise Vollard and eventually published after the end of the Second World War, long after the dealer's death, as the *Vollard Suite*. Turning to a series of prints from the suite representing minotaurs (fig.4), Picasso described their life in a mythological Crete:

That's where the minotaurs live, along the coast. They're the rich *seigneurs* of the island. They know they're monsters and they live, like dandies and dilettantes everywhere, the kind of existence that reeks of decadence in houses filled with works of art by the most fashionable painters and sculptors. They love being surrounded by pretty women. They get the local fishermen to go out and round up the girls from the neighbouring islands. After the heat of the day has passed, they bring in the sculptors and their models for parties, with music and dancing, and everybody gorges himself on mussels and champagne until melancholy fades away and euphoria takes over. From then on it's an orgy . . .[14]

If Gilot is to be believed, Picasso's chat-up line was more than a little poetic, even if its gender stereotyping might be a little distasteful to us now. For Picasso, the

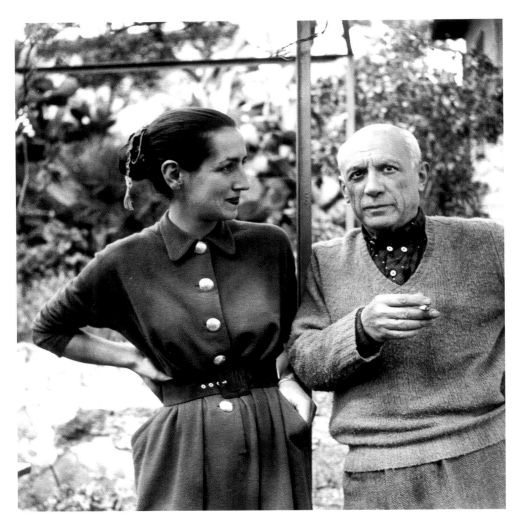

3
Pablo Picasso and
Françoise Gilot c.1952
Private Collection

THE PICASSO BOOK

romance of the minotaur stemmed from its hybrid human-animal existence, though whether he saw in this a fascinating melodrama of the real-life struggle between beastly urges and higher passions, or rather an expression of the human condition, is a key question.[15] He had been drawing and painting minotaurs since the early 1920s, perhaps inspired by contemporary excavations at Knossos, Crete, the mythological home of the Minotaur.[16] But the mythic background is equally important as a context for his representations and his stories invented for Gilot.[17]

In 1930 Picasso had illustrated Ovid's *Metamorphoses* (see fig.61), which tells part of the story, but there he had taken no interest in the minotaur episode.[18] Nor, indeed, do his minotaur representations attempt to explore the other characters in the narrative. Instead, as his playful account to Gilot makes clear, in some of his prints he ignored the detail of the myth in favour of a fantasy of luxury and lust, melancholy and, frequently and in keeping with the Greek myth, tragedy. The scene in the print reproduced here (fig.4) is no doubt one of those remembered by Gilot: the minotaur and his companion (who may be the character of the sculptor who features in other *Vollard Suite* prints, or indeed one of those swarthy fishermen) hold their champagne bowls aloft as the hot evening breeze blows the thin curtain on the right. The two female figures are those Picasso later saw as 'girls from neighbouring islands', reminiscent also of the figures

in Ingres's *The Turkish Bath* 1862 (Musée du Louvre) and a host of other supine nudes in nineteenth-century painting and sculpture, swooning under the firm grasp of dirty hands or lolling across the hairy *seigneur*-creature. This print is an early example of what could be thought of as a 'series' of around sixty works on the subject of the minotaur, including not only the *Vollard Suite* but also other prints, paintings and drawings. In Picasso's new mythic universe, minotaurs are blinded, wounded and sacrificed.

'If all the ways I have been along were marked upon a map and joined up with a line, it might represent a minotaur', he told one friend.[19] This remark has often been adduced to support the view that the minotaur wandering through the *Vollard Suite* and elsewhere is a stand-in for the artist, a creature whose odyssey of suffering is an allegory of Pablo Picasso's personal life at the time. On the face of it there is much to support this idea: commentators remark on the frequent resemblance of the 'girl' in some minotaur prints and drawings to Picasso's clandestine mistress of the period, Marie-Thérèse Walter.[20] Or there is the compelling identification of a nude female figure in an ink drawing of 5 September 1936 (now in the Musée Picasso, Paris) who is being molested by an anguished minotaur, as Picasso's new lover, the photographer Dora Maar.[21]

Yet there are other ways to read Picasso's gnomic statement.[22] For the minotaur that is to represent Picasso is something

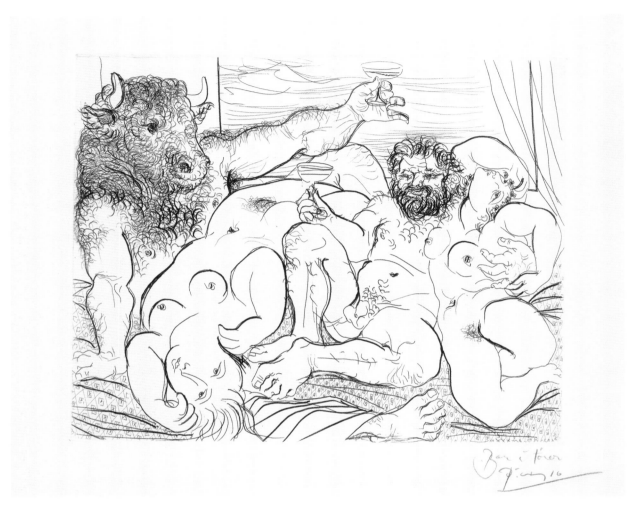

4
Bacchic Scene with the Minotaur
from *Suite Vollard* no.85
1933
Etching on Montval,
edition of 260
29.9 x 36.6
Musée Picasso, Paris

like a constellation – an arbitrary or accidental image formed by objects – or in this case events and emotions, that are in fact separated in time. The dots creating this minotaur image are bright nodal points, conspicuous events such as an affair, a marriage, childbirth or a divorce; in any case all are mere vestiges of the continuum of his life. Perhaps we could go further and suggest that, just as with a constellation where the bright points are in fact on different planes in space, so this accidental image of the minotaur that represents Picasso is also made up of the imaginative events we call works of art, events that are themselves made out of layers of ideas, visual fantasies, inherited or purloined images. Picasso's 'Picasso' is, in the same way, both the sign of an heroic individual, a powerful centre for our culture, around which a vast array of works and life events gather, and a conundrum, an agglomeration of decentred meanings and hybridised languages of art.

Minotauro-machia

The basic composition of this very large etching was the result of a single day's work on Saturday 23 March 1935, in the workshop of Picasso's printer, Roger Lacourière. The copper plate went through seven states, the initial forms of the figures and their setting being progressively modelled with a variety of hatchings and scrapings. Each of the states was printed in a few proofs to check progress. Picasso made only one other print of this size, the so-called *Large Corrida*, which was not released in his lifetime.[23] *Minotauromachia*, by contrast, was very much a public *tour de force* and a number of the edition of fifty prints pulled from the seventh and final state were purchased immediately; nearly all of the known prints are now in public or permanent collections.

The scene is an unidentified shore – a yacht is visible on the horizon – with the simple, dark mass of a building on the left. The composition is arguably dominated by the head of the minotaur; beyond this the print presents a range of characters, four of whom seem to be of equal significance: there is a man ascending a ladder on the far left; next to him, a girl in a dress holding a bouquet in her right hand and in her left, held aloft, a burning candle. In the centre is a horse, leaping but at the same time spewing its entrails from a wound in its stomach, and carrying across its back a sprawling, dishevelled and apparently unconscious female matador whose breasts are exposed. Over her and over the horse's head the minotaur's powerful arm extends in a gesture that appears designed to block the light from the candle, or to ward it off. On his back the minotaur carries a large sack. Rain falls from a cloud behind him. Witnessing the whole spectacle are two women gazing down from the building, accompanied by two doves.

Not long after Picasso completed his enigmatic print, a friend described it in a postcard as 'the large plate with the minotaur, female bullfighter, child with a candle, two women at a window and the man on a ladder'.[24] There was, in other words, no ready name with which to refer to it. Given Picasso's normal tendency to leave his works untitled (*La Vie* is probably a rare exception to this rule), it would seem that the clever moniker of this work was the invention of someone in Zwemmer Gallery in 1935 on the occasion of the print's first London showing.[25] Whoever invented it, what *Minotauromachia* ('minotaur/bullfight', or 'minotaur fight') does is to forge an equation between Picasso's theme and, first, the twofold significance of Crete as the home of the Minotaur and of bullfighting, or bull leaping, in a ring; second, to merge these two elements of Picasso's own visual imagination; and third, to link the ambitious print with the famous series of etchings, the *Tauromachia* of around 1815, by Goya, whom Picasso greatly admired.[26]

Minotauromachia poses once again for us the puzzle of Picasso's 'Picasso'. The print was made, as Picasso later put it, during 'the worst time of [his] life'.[27] The central problem was his attempt to divorce Olga Khokhlova while Marie-Thérèse Walter, still a closely guarded secret in his life, became pregnant with their daughter, María Concepción, whom Picasso called Maya. Khokhlova finally left him in July 1935; Maya was born on 5 September. Setting it against these painful events, of which a great deal is now known, *Minotauromachia* seems to be what Alfred Barr called 'a moral melodramatic charade of the soul'.[28] Some see it as a blatant personal allegory: for Pierre Daix, in a brief and literal biographical interpretation, the minotaur, embodying 'dark impulses' of 'guilt and desire', *is* Picasso, the matador the pregnant Marie-Thérèse Walter.[29] Much more subtle readings attend to the matrix of symbols in play. Many locate the central meaning of the print in terms of a confrontation between sinister darkness (the minotaur) and enlightened truth (the candle-bearer), while Jungians elaborate this approach through a series of archetypal meanings.[30] A recent publication by Lisa Florman notes the strong association between the minotaur and the Christ-like figure ascending or descending the ladder on the left, opening a connection to discourses of sacrifice and self-sacrifice (of a terrifyingly divine nature), linked perhaps to Picasso's

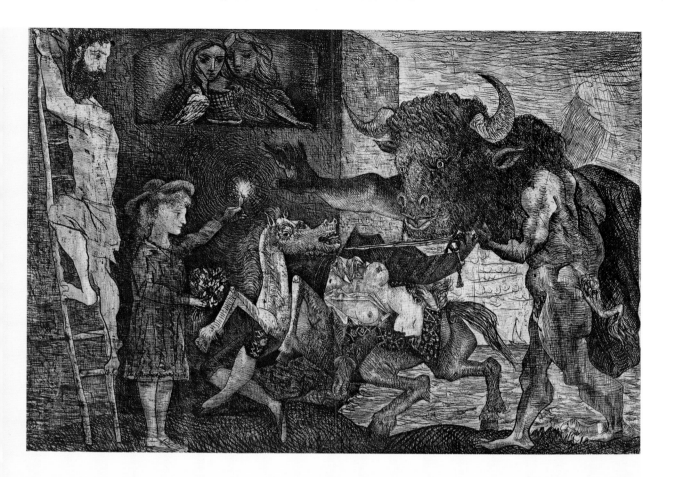

5
Minotauromachia 1935
Etching and grattoir on
paper, edition of 50
49.4 x 68.9
Musée Picasso, Paris

earlier, strange *Crucifixion* of 1930 (see fig.36).[31]

But whatever weight we give to the extreme emotional situation that Picasso had brought upon himself in 1935, it also seems likely to those who follow Picasso's work through the late 1930s that *Minotauromachia* is a response to contemporary events. This notion is largely based on two things: the overall baleful tone of the scene, with its undercurrents of violence and sacrificial rites, and the fact that *Minotauromachia* is in effect the visual resource out of which Picasso made his greatest political statement, *Guernica*, in 1937 (see fig.46). Certainly there had been violent clashes between leftists and fascists in France in 1934, together with ominous indications of looming conflagration in Europe, when Picasso made the etching – but it is problematic to read too much

political meaning into *Minotauromachia* retrospectively.

Having finished *Minotauromachia*, Picasso embarked on an extended period of writing producing vivid, sometimes crazed and multilingual stream-of-consciousness poetry (see pp.179–82). This acted to a large extent as a substitute for painting: he produced no works of visual art (apart from a few tender pencil drawings of Marie-Thérèse Walter and his newborn daughter, Maya) between the May 1935 and around the beginning of April 1936. This was an extraordinary situation for an artist who had painted, drawn or sculpted virtually every day since the beginning of the century. But then poetry had always been at the centre of his creative activity, and it is to the relationship between this and his art that we now turn.

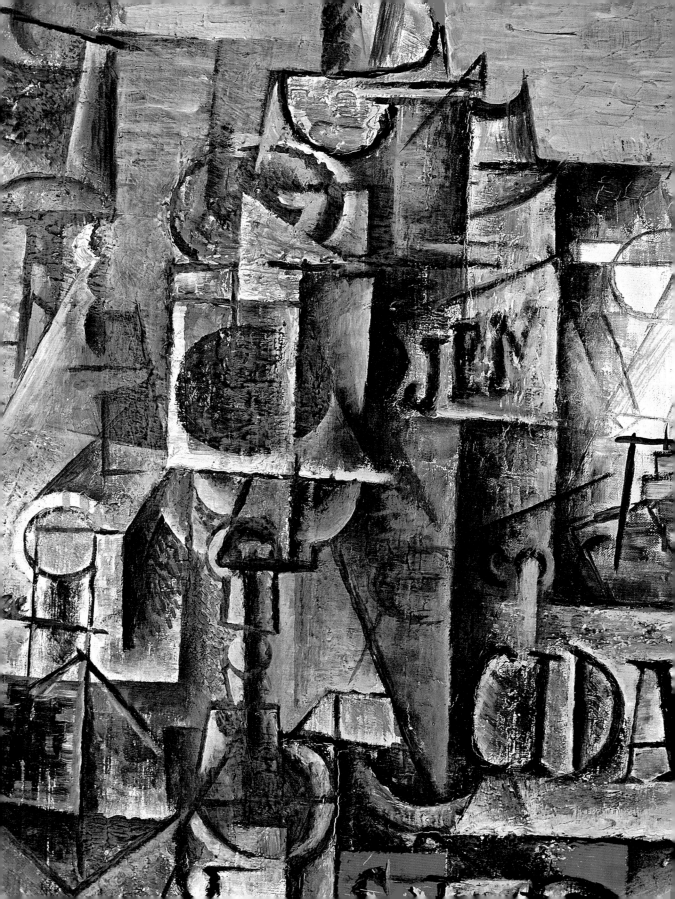

In 1900 Picasso made a quasi-caricatural portrait in charcoal and watercolour of his friend Jaime Sabartés, inscribing it 'Poeta Decadente' ('Decadent Poet'). The picture, now in the Museu Picasso, Barcelona, shows Sabartés holding a flower and surrounded by white crosses in a graveyard. Never a successful poet, Sabartés left Spain for Latin America in 1904; when he returned in 1935, Picasso asked him to become his secretary and later his official biographer. By then Picasso was in the midst of a personal crisis (see p.24 above), which precipitated his own turn to poetry. Sabartés was hardly a foil for his friend's poetic activity – but there were several serious writers in Picasso's circle, including the leading Surrealist poets André Breton and Paul Eluard, who took an interest in what he was doing. Picasso's relationship with poets and love of poetry dated back to his earliest days in Paris, and to some degree reflected his suspicion of art critics, museum curators and other art world professionals: 'Poetry's alright', he told one journalist in 1957. 'Perhaps it would be better if all critics were poets and wrote poetry instead of pedantry'.[1] Poets offered what Picasso regarded as a much deeper appreciation of his work as a visual artist and, perhaps more importantly, he believed in their understanding of the nature of art.

This chapter examines the beginnings of Picasso's poetic attitude to art around 1902–5, and then jumps into the midst of his most imaginative of visual worlds, his Cubism from around 1910 to 1914. His interest in poetry continued throughout the First World War and after, but the different poetic values expressed first by Jean Cocteau and then the Surrealist poets are important contexts for Picasso's strange journey from pre-war Cubism to his simultaneous embrace during the war of Neo-Classicism and a reinvented and theatrical Cubism, leading finally to a new, Surrealist art.

The idea of poets as art critics belonged to Picasso's first experiences in Paris, and the formation of what became known as 'La Bande à Picasso' or 'Picasso's Gang' around his studio in the ramshackle building and former piano factory in Montmartre dubbed 'Le Bateau-Lavoir' or 'The Floating Laundry'. On only his second trip to Paris he fell in with the poet Max Jacob (see fig.17), a dazzling intellect who, until his death in a deportation camp in 1944, would remain important to, if increasingly alienated from, Picasso. In 1901 Jacob, then living in near-poverty in an attic overlooking the river Seine, had written an admiring note to the artist on the occasion of his Vollard exhibition. On their first meeting the two men communicated enthusiastically in sign language, since neither spoke the other's tongue.[2] Jacob was to become Picasso's first and most important teacher in French language and literature. In 1902 he took pity on the young artist, who was by then himself living in penury in a dire hotel in the Latin Quarter, and suggested that he move into his own apartment on the Boulevard Voltaire; the two shared a room, later claiming, probably as a means for Picasso to defend his masculinity, that they occupied the

2 Picasso Poetic

single bed on a shift basis (Jacob by night, Picasso by day). Jacob's love of Symbolist poetry, in particular that of Paul Verlaine and Alfred de Vigny, formed part of the creative imagination of the figures Picasso depicted in melancholy blue (see fig.25). He gradually left this mood behind during 1904–5, partly as a result of his permanent move to Paris and his occupation of a studio in Le Bateau-Lavoir.

Le Bateau-Lavoir was the scene of Picasso's invention of a whole new form of pictorial representation and his transformation from interesting young Spanish painter to one of the most talked about modern artists in Paris. Central to these two momentous developments were his associations not only with Jacob, but also with two other poets, André Salmon and Guillaume Apollinaire. Salmon was introduced to Picasso in early October 1904 and was overwhelmed at the array of Blue Period paintings on view in the artist's studio; soon afterwards he moved into Le Bateau-Lavoir where he became Picasso's close friend.[3] Apollinaire may have met Picasso only a few weeks after Salmon, on 25 October 1904 (although Apollinaire specialist Peter Read argues that the more likely date is February 1905).[4] The most imaginative and inventive poet in a talented group, Apollinaire was to be the most important of the three in terms of Picasso's career, thanks to his energetic efforts as an art critic and champion of new creative ideas. The three writers formed the core of Picasso's Gang, and he honoured them by writing 'au rendez-vous des poètes' ('the poets' meeting place') above his studio door in blue chalk.[5] The fourth member of the Gang was Picasso's first serious love, the artist's model and Bateau-Lavoir resident Fernande Olivier, with whom he began a relationship in the summer of 1904.

Socialising for the Picasso Gang revolved around word-play, private jokes and play-acting; when Picasso ventured out in the evening, he took most pleasure in popular culture, especially the circus, boxing matches, cabarets, the music hall and the cinematograph.[6] The Gang often ended their evenings out at Le Lapin Agile ('The Nifty Rabbit'), a café owned by the redoubtable Frédé, a former fishmonger and would-be musician painted by Picasso in *Au Lapin Agile* (fig.6). Frédé commissioned this decorative painting for the café's main room in exchange for credit, enabling Picasso to frequent the café even though he was more or less penniless.[7] Another of Picasso's self-portrait masquerades, here he is dressed incongruously as the *commedia dell'arte* character Harlequin, clutching a glass of absinthe and standing at the bar with a woman in a feather boa usually identified as one of his passing lovers at the time (none other than Germaine Gargallo, the fatal obsession of Carles Casagemas a few years earlier).[8] Behind them sits Frédé, serenading on his guitar. The woman and the artist stare listlessly into space, settling for the crude music as they become slowly drunk. The scene is ludicrous in its contrasts, but the free painting style and rich colour, combined with Picasso's preoccupation with theatrical

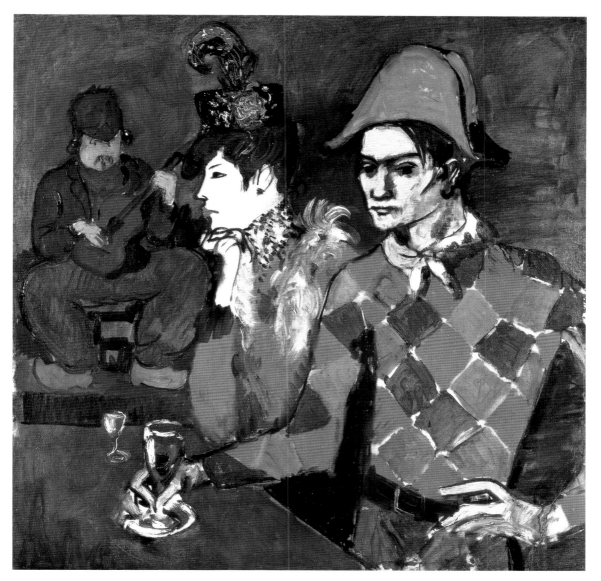

6
Au Lapin Agile (*At the Lapin Agile*) 1905
Oil on canvas
99.1 x 100.3
The Metropolitan Museum of Art,
New York

fantasy, signal in their playfulness the move away from Blue Period realism prompted by his new intellectual milieu. Frédé was later blamed by Picasso for encouraging a tourist attitude to Montmartre's artistic community; in the process he made a gross financial mistake, selling Picasso's painting to a German dealer and replacing it with populist local views.[9]

By the time of Picasso's show at the Serrurier Gallery in spring 1905 he was using colour much more freely, and his subject matter had changed resolutely in favour of circus and *commedia dell'arte* subjects, later prompting Gustave Coquiot to call the years 1904 to 1906 Picasso's Rose Period.[10] His most ambitious painting of this period is undoubtedly *The Family of Saltimbanques* (fig.7), completed in the autumn of 1905. Saltimbanques were circus acrobats, with whom Picasso and his poet friends frequently identified, both for their skills and their insecure existence. Standing or sitting in a nondescript arid landscape, the six figures seem to be waiting to set out for the next village fair. Harlequin appears again, standing with his back to the viewer on the far left, holding hands with a young girl in a dance costume and carrying a basket of flowers. Next to him a fat clown in red carries his gear in a sack slung over his shoulder, while in the centre stand two boys, the taller one carrying a drum behind his head. To the far right is a seated woman, perhaps in Majorcan costume, her hat floating mysteriously above her head. Between the boy and the woman is an earthenware jar.

This was the largest painting Picasso had attempted to date (it is considerably bigger than *La Vie*, fig.2), in a concerted effort to achieve a new form of synthesis with the traditions of French genre painting. The figure of Harlequin had been made central to French art by Antoine Watteau at the beginning of the eighteenth century, becoming a metaphor for the figure of the artist, poet and writer as outsiders in depictions by Daumier and Toulouse-Lautrec. There is also in Harlequin a diabolical aspect (Harlequin derived from 'Hellequin', an emissary of the Devil in medieval Passion plays, whose blackened face and red costume are the source of Harlequin's motley garb and whose malevolence becomes Harlequin's trickster behaviour).[11] Picasso's style here resonates with the work of Pierre Puvis de Chavannes, who specialised in timeless Arcadias where classically dressed and naked figures rendered in pastel tones are arranged in gentle landscapes.[12] A surviving sketch (now in the Pushkin Museum, Moscow) shows that Picasso originally conceived of the figures in a racecourse setting, perhaps with Degas's racecourse paintings in mind, and an X-ray of the finished work shows that an earlier version of the composition had the tumblers sitting near their caravan and cooking up a meal. Just as in *Au Lapin Agile*, in the racecourse sketch the figure of Harlequin is given the features of Picasso. The developmental process for the

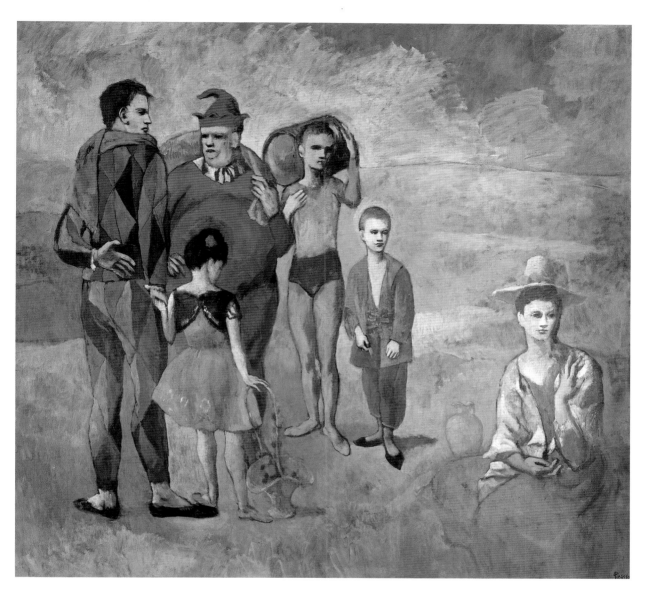

7
The Family of
Saltimbanques 1905
Oil on canvas
212.8 x 229.6
National Gallery of Art,
Washington, DC

Saltimbanques is, however, exactly like that for *La Vie*: what begins with an element of self portraiture is steered in the direction of poetic ambiguity.

Inevitably, the potent image of Picasso surrounded by his three poets, the modern incarnation, so Jacob thought, of the great figures of seventeenth-century French literature (La Fontaine, Molière and Racine), has inspired some art historians, encouraged by the Pushkin sketch, to see *The Family of Saltimbanques* as a fantastical portrait of the artist (Harlequin) accompanied by Apollinaire (the fat clown in red), Salmon (the acrobat carrying the drum), Jacob (the smaller acrobat), and Fernande (the seated woman on the right).[13] Picasso's depictions of his friends were usually more direct, however, with a hint of caricature, like his comic drawing of Apollinaire as a member of the French Academy (fig.8), perhaps mocking the poet's desire for official recognition.[14]

The link between *The Family of Saltimbanques* and Picasso's new poet friends was nevertheless strong, although different in kind from portraiture. It was Apollinaire who first gave poetic voice to Picasso's circus scenes, and to his large painting in particular. On 2 October 1905 he sent the artist a blue postcard inscribed with nothing else but two poems, one on each side.[15] Entitled 'Performance' and 'The Saltimbanques', both appeared (with a few changes and 'Performance' retitled 'Twilight') in his most important anthology, *Alcools*, in 1913. Although neither poem is a literal description of the figures in *The Family of Saltimbanques*, both express the condensed experience of a host of Picasso's circus scenes of the period. Many of the images in *The Family of Saltimbanques* and the second poem clearly resonate:

In the plain with its quiet gardens,
Where travelling players move along,
Past the doors of grey inns
And through the villages without
 churches,
The youngest children lead the way,
And the others dreaming, follow on.
Every fruit tree accepts its fate
When they wave to it from afar.
They have heavy weights, round or
 square,
Drums and gilded hoops.
The bear and the monkey, well-trained
 animals
Beg for coins, as they pass by.
Next to one of them who is dying on the
 road
And who by tomorrow will be forgotten,
A little saltimbanque uses his hand
In place of the handkerchief he doesn't
 own.
And the woman breast-feeds
With her River Lethe milk of forgetting
A newborn baby, beside the sad dwarf
And Harlequin Trismegistus.[16]

Magical or mythical figures succeed an ordinary vision of the travelling players wandering from village to village, bearing their props and struggling to survive

8
Caricature of Guillaume Apollinaire in the costume of an academician 1905
Pen, ink and wash
22 x 12
Musée Picasso, Paris

with few possessions. The modernity of Apollinaire's tumblers is also their rootlessness, their alienation from any particular place or time, arguably expressed in Picasso's painting through the dissociated glances of the figures, their listlessness (a striking contrast to their acrobatics), and their ethereal presence against the landscape – most obvious in the case of the seated woman, a late addition to the composition, who seems to evaporate at her lower edges and shimmer (as a result of Picasso's adjustments in her outline) around head, shoulders and hat. This dislocation from the affairs of modern life, from the hurly-burly of the city or the routines of agricultural production, means that unless performing, these saltimbanques lack identity and purpose. If *La Vie* posed a series of questions to the viewer through its puzzling gestures and *mise-en-abîme* background pictures, *The Family of Saltimbanques* is itself an open question.

This question inspired a different kind of poetic voice in the German poet Rainer Maria Rilke, who had met Picasso and who himself frequented the performances of tumblers in Paris squares, in the fifth of his ten *Duino Elegies*.[17] The 'Fifth Elegy', completed in 1922, was perhaps first conceived in 1915 when Rilke stayed in the Munich residence of the then owner of *The Family of Saltimbanques*, Herta von Koenig, where he had the opportunity to contemplate the painting at length; it is to von Koenig that the 'Elegy' is dedicated.

Like Apollinaire, Rilke responds to the magical aspect of the saltimbanque, the notion of the acrobat as an other-wordly spirit. But Rilke imbues Picasso's scene, which he explores at much greater length, with an anguished drama of the soul expressed through a series of unanswered questions, commencing with that famous beginning: 'Tell me who, who are these travellers, more fugitive, even,/Than we?'[18]

It was this counter-working of Picasso's pictorial imagination, producing a poetic re-reading, that mattered so much to the artist: Picasso's poets were indeed, for him, his best interpreters. We should not underestimate the degree to which he aspired to achieve in painting what he found in poetry, and hence the galvanising effect that Apollinaire, Jacob and (to a lesser extent) Salmon had upon the nature of his art.

Apollinaire had another hugely important role in Picasso's development and his success: he acted as a key promoter of his art by writing art criticism and, later, publishing photographs of his most radical work. His first critical text on the artist was published in 1905, on the occasion of the Serrurier show, but his best criticism was inspired by the artistic coup by which Picasso would make his name: the invention of Cubism.[19]

What kind of visual art could match the compression, the polyvalence, the rhythmic energy, and the heady swirl of imagery of Apollinaire's poems, or the sheer invention of Jacob's fantastic stories? In 1910 Picasso

had the opportunity to illustrate a book by Jacob called *Saint Matorel*. What he did tells us a great deal about how his art changed under the impact of those first encounters with poets and how wildly it had exceeded the challenges of modern poetics. The book was commissioned by Picasso's dealer, Daniel-Henry Kahnweiler, but with the original intention of having it illustrated by Picasso's friend the well-known avant-garde painter André Derain. Jacob wrote the first part of his hallucinatory story in a few days in late 1909, but when he read it Derain pulled out. Picasso, still what might now be called an 'emerging' artist, stepped in enthusiastically, and made a series of etchings that summer in Cadaqués, four of which were used in the publication of 1911.

Saint Matorel is itself radically experimental, by turns comic and serious. It is the fragmentary telling of the life of Victor Matorel, an intellectual and debaucher who converts to Catholicism, to become Brother Massané in the Lazarist Monastery of St Theresa in Barcelona. He has a series of menial jobs, including working as a guard on the Paris Metro, after which he travels through France in a gypsy caravan with his friend Emile Cordier (a kind of alter-ego), stopping along the way at inns for supper, and ending up in Barcelona. Matorel's crazed writings make him a kind of anti-literary anti-hero. Part I concludes with Jacob's first published prose-poem in the form of the hallucinatory notes supposedly emanating 'from the imaginative, auto-synthetic brain' of the

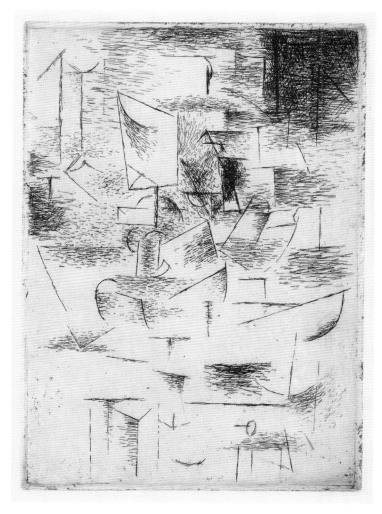

9
The Table, illustration for
Max Jacob's *Saint Matorel*
1910
Etching
20 x 14.2
Musée Picasso, Paris

'unfortunate' Matorel, who in his religious fervour is subject to a 'Mystical Psychosis'.[20] Here we learn more of Matorel's former mistress, Mlle Léonie, a woman with many lovers who left him to marry another man. Léonie is never described; we simply hear in passing of her marriage, divorce, and remarriage, and her future career posing as a Greek dancer at the Eldorado theatre.[21]

Faced with the task of 'illustrating' *Saint Matorel*, Picasso chose to focus on three concrete elements: Mlle Léonie, a still life (perhaps recalling Matorel's dinners in French inns) (fig.9), and the monastery.[22] As published, the book featured two representations of Mlle Léonie, one standing and one seated on a chaise longue (fig.10).[23] The visual idiom of *Mlle Léonie on a Chaise Longue* is astonishing, and quite unlike *The Family of Saltimbanques* of only five years earlier. At first all that can be grasped is a dense network of straight and curved lines, with shading suggesting a jumble of planes or rigid forms piled one on top of another; but it is possible to make out two crudely shaped feet, perhaps striated by the laces of a shoe. To their left is the form of the chaise longue with its wooden feet and curved seat; its straight back appears in the top right. Mlle Léonie herself sits in three-quarter view, her head and neck creating a precise angle, her shoulders formed by three shallow curves gently sloping from right to left. Below these are her breasts, one exposed, the other a soft oval. She leans back with her right elbow against one of the arms of the chaise longue (the two planes just

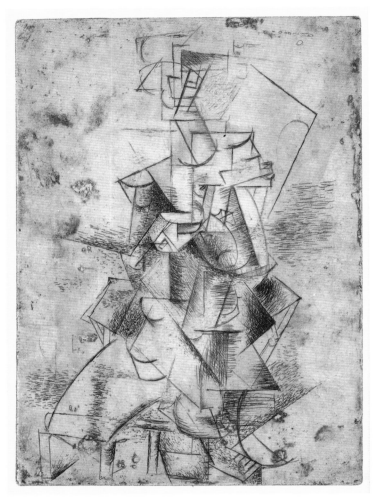

10
Mlle Léonie on a Chaise Longue, illustration for Max Jacob's *Saint Matorel*
1910
Etching on Japanese paper
20 x 14.2
Musée Picasso, Paris

below centre to her right and left, with their wooden struts underneath), the unshaded double curve of her buttocks turned outward.

What kind of art is this, so far removed from any standard of realism found in Western art of the preceding four hundred years? Picasso invented it in collaboration with French artist Georges Braque during the years 1908 to 1910, and not long after their first assaults on conventional pictorial representation their work acquired the mocking name 'Cubism'. Mlle Léonie is a Cubist creature, the perfect complement, perhaps, for Jacob's fragmented, dreamlike, comic and deliberately obscure novella.

Cubism was, of course, the product of many forces other than the poetics of Apollinaire and Jacob, not least the intense dialogue between Braque and Picasso. Among other sources were the work of Cézanne, who had died in 1906, and what were perceived as the extraordinary revelations of non-Western, and especially Oceanic and sub-Saharan African art (see Chapter 5).[24] Yet the very notion of poetics, a 'new language' of representation, had its own momentum, as the only fitting response to the giddying world of electricity, aeronautics, telephones, cinema and, of course, the spectres of capitalist militarism and revolutionary politics, as Salmon suggests in his text on 'Young French Painting' of 1912:

... the concern to make us experience an object in its total existence is not absurd in itself. The world

changes its appearance, we no longer have our fathers' masks, and our sons will not resemble us. Nietzsche wrote: 'We have made the earth very small, say the last men, and they flicker.' A terrible prophecy! Does not the salvation of the soul on earth reside entirely in a new art?[25]

Salmon suggests that Cubism was the rendering of things 'in their total existence'. At its very centre stand paintings such as Picasso's *The Poet* (fig.11), thought by some to be a composite portrait of Jacob and Ramon Pichot, another of Picasso's friends; but the word 'portrait' here is meaningless.[26] A journalist in 1912, when shown this painting by Picasso's dealer Kahnweiler and told that it represented a poet, exclaimed 'Ah!', but thought to himself '(Good manners demand that I limit the expression of my total astonishment to this exclamation. I thought I was looking at a landscape, and it turned out to be a poet)'.[27]

Picasso painted *The Poet* in Céret in the French Pyrenees in the summer of 1911, but no rainbow of Mediterranean colour permeates its dense network of linear elements and daubs of shadow and light. Among the shimmering planes there are some more identifiable elements, such as the poet's moustache and the pipe he is smoking, and a pipe rack behind him to his right. On his left, and less easy to identify, is a wine glass, typical of the idiom of this period in Picasso's Cubism. Beyond these easy entrées, the poet appears – or rather fails to appear – in a pyramidal matrix of what seem at one moment solid and at another transparent surfaces. Does the poet sit in an armchair? Does he read a book? Close viewing reveals his left hand clutching what could be an open book – there is a blank space that might suggest the page he is reading, and two half-pipe forms like the spines of leather-bound volumes on either side of the hand. But that the poet is reading a book is a kind of metaphorical deduction from these fragmentary elements. The late nineteenth-century poet Stéphane Mallarmé considered his own works, beloved of Apollinaire, as 'prismatic subdivisions of the idea', and such a notion of depiction, as a shattering and disarticulating of forms, seems to underlie *The Poet*.[28] So if this painting gives us the 'total existence' of the poet, it can only be as a dazzling mental image.

Picasso signed *The Poet* and dated it (incorrectly) 1910, long after he painted it, probably at the request of its owner. When Braque and Picasso made such paintings in the summer of 1911 they did not sign them. The two artists relished the closeness of their work, but they were also locked into a competitive struggle of invention. *The Poet* is one of a series of highly impressive pictures Picasso made rapidly at the start of the Céret sojourn, forging ahead before Braque arrived after him. Later, having absorbed Picasso's latest work, Braque began one of his most famous Cubist works, *Le Portugais* (*The Portuguese Man*) 1911–12 (Kunstmuseum, Basle), in which

THE PICASSO BOOK

11
The Poet 1911
Oil on canvas
131.7 x 89.5
Peggy Guggenheim
Collection, Venice

he included fragments of painted lettering in imitation of the stencilled signs on café windows.

This extraordinary gesture brought the word, elements of language, into the space of Cubism in a truly literal fashion. Braque later explained that stencilled letters were 'forms outside space and therefore immune to deformation'.[29] This tells us a great deal about what the practices of Cubism meant for Braque and Picasso: central to their new visual language was a 'deformation' of the pictorial space which had prevailed in Western art since single-point perspective construction had come to dominate it in the mid-fifteenth century. There is also in Braque's statement the notion of forms inside the space that is being deformed: the fate of these forms once space is 'deformed' is again a central idea for Cubism. All of this makes the process sound calculated and planned, whereas every 'move' in the development of Cubism was of course improvised.[30] At the same time, both Picasso and Braque had an overarching idea that framed each innovation in their Cubism, that a new form of pictorial representation could be forged from the crudest materials and most basic means of art.

The subjects of Picasso's Cubism were fairly consistent: still life or the single figure, usually half-length. Among his still-life pictures, musical instruments and café tabletops were particular favourites. But the visual lexicon of Cubism permitted metamorphoses from one subject to another. So a still life with a guitar could become a figure or a head.[31] Following Braque's introduction of lettering in *Le Portugais*, Picasso took the device further with a remarkable oval work called *Still Life with Chair Caning* (fig.12). Here he used painted lettering – the fragmentary word 'JOU' painted with an insouciant crudeness compared with Braque's meticulous imitation of stencilling – and also pasted a piece of printed oilcloth, imitating the caning of chair seats and cheap tables, into the bottom left segment of the canvas. This gesture was a whimsical riposte to the technique of imitating wood graining, which Braque had learned from his painter-decorator father and applied to the surface of another painting of late 1911, *Homage to J.S. Bach* (Caroll Janis Collection, New York). In *Still Life with Chair Caning*, coarsely painted café objects cast their shadows across the foreign (unpainted) element, while a striped painted band suggests the table edge. On the far right a knife bisects a lemon, and in the centre sits a wine glass. A rope frame, a literal version of the rope-like decorations on wooden frames, surrounds the painting. The oval form suggests the decorative panels of eighteenth-century rococo boudoirs, but it also creates an ambiguity between literal and figural: its shape echoes that of the tabletop, or perhaps represents a mirror in which a chair back is visible.[32]

Still Life with Chair Caning was made in Paris in May 1912, just before Picasso set off for Céret once more. There he made another oval work, the *Spanish Still Life* (fig.13), which

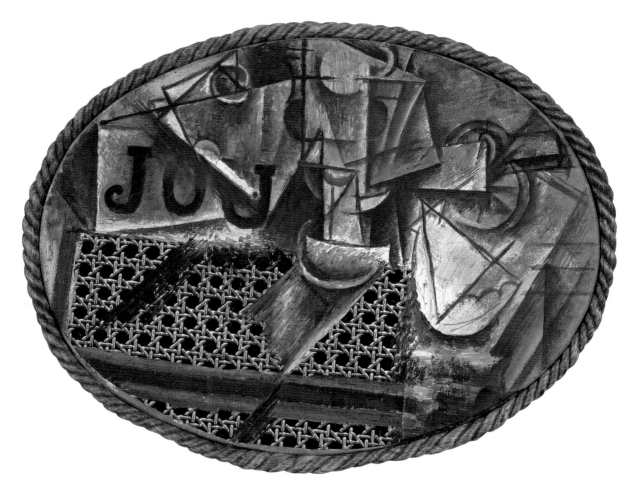

12
Still Life with Chair Caning
1912
Oil, oilcloth and pasted
paper on oval canvas
framed with cord
29 x 37
Musée Picasso, Paris

13
Spanish Still Life 1912
Oil on canvas
46 x 33
Musée d'art moderne
de Lille Métropole,
Villeneuve d'Ascq

imitates the appearance of collage in paint, as for example in the bullfight ticket, in Spanish colours, at bottom right. The paint used included the industrial enamel Ripolin, an innovation disapproved of by the collector and dealer Wilhelm Uhde: Picasso wrote to his dealer, Kahnweiler, to this effect, adding that 'perhaps we'll succeed in disgusting everyone and we haven't said everything yet'.[33] The Spanish theme continues in the fragmentary lettering revealing the brand of the bottle of anisette and the name of the newspaper, *La Publicidad*. The bottle itself is a perfect example of the deformation of space that Braque understood as a key achievement of Cubism: the circular opening of the bottle neck is depicted as a neat circle, whereas in conventional pictorial space, given the fact that the rest of the bottle is seen in profile, it should be a shallow ellipse. For many critics it was this key device in Cubism, the rendering of forms as if seen from different viewpoints, which made it reveal things in their 'total existence'. In 1910 Jean Metzinger, one of the first artists to follow Picasso in this direction, described early Cubist paintings in terms of a 'free, mobile perspective'.[34]

It was not Picasso but Braque who, in September 1912, exposed the real possibilities of collage by inventing a specialist branch of the craft: *papiers collés*, or pasted papers. Picasso was stunned by Braque's application of pieces of newspaper and printed imitation wood graining to paper, drawn together with a few charcoal lines. Picasso then embarked on an extraordinary burst of activity in which he pasted newsprint, painted paper, musical manuscript, coloured card – just about anything – to paper or cardboard, and reinvented the language of representation. During the autumn of 1912 he filled his studio walls with *papiers collés* of violins and guitars, and even made a sculpture of a guitar out of cardboard (see fig.64). In *Musical Score and Guitar* (fig.14) we get an immediate sense of improvisatory excitement from the dressmaking pin holding a striped rectangle of paper in place at the centre of the image: Picasso is now treating depiction in a way completely different from that elaborated in *The Poet* and the *Spanish Still Life*. There is only a token presence of the artist's paintbrush or pencil (in the handmade black stripes in the centre): the entire picture is made of paper shapes applied to a blue ground. The shape of the guitar is produced by the interaction of the shapes: the brown fragment on the left provides one silhouette of the body, while the grey piece at the bottom makes a similar silhouette, but in a 90-degree orientation, against the pale straw sheet. Another cut out of grey suggests a further curve at top right, while a third piece at centre right with a shallow scalloped end suggests something of the headstock, the sound hole, and perhaps the arched section of the neck. A white rhombus is the fingerboard terminating in a single tuning head, making the pin appear like a filament of guitar string. The body of this guitar is clearly meant to be in front of

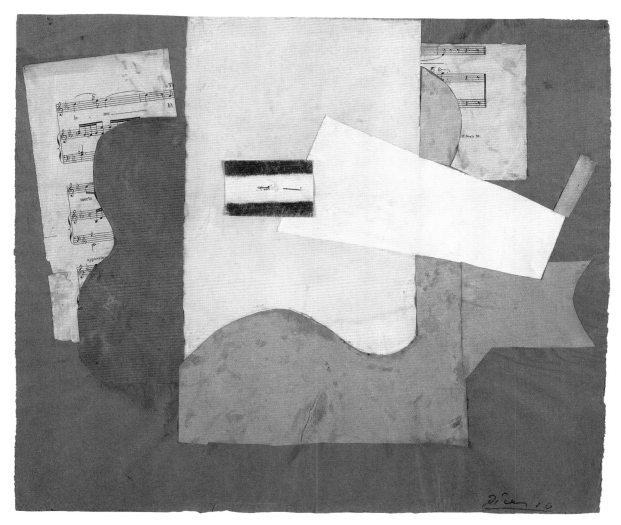

14
Musical Score and Guitar
autumn 1912
Pasted and pinned paper
on cardboard
42.5 x 48
Musée national d'art
moderne, Centre Georges
Pompidou

the music – though it is obvious that the sheet of music on the left is carefully cut out to reinforce the curves of the brown sheet.

Works such as this have led to a powerful but controversial reading of Picasso's strategy, derived in part from the structuralism of Swiss linguist Ferdinand de Saussure, and partly from Russian Formalism.[35] For Saussure, the system, the grammar of any language depends on a fundamental arbitrariness, where every word is both a sound-image and a meaning that are merely conventional in their association ('tree' in English means the same thing as *arbre* in French, but the sound-image is entirely different in each language system). Similarly, the argument runs, when Picasso makes the guitar appear before our eyes in this *papier collé*, he does so by demonstrating that just about any minimal combination of curving and rectilinear shapes can stand for a guitar *as long as they are placed in the right relationships*: reshuffle the shapes and you get a face instead of a guitar. The work of art now rejoices in the creative play of signs, showing that the meaning of any sign is arbitrary, and the poetry of formal composition continually makes pictures out of that arbitrariness.[36] What the sound-image conjures for us is not reality, not a 'real' tree, but simply, through its arbitrary link in a given language, a concept, the meaning 'tree' (the two things, sound-image and meaning, do of course always seem inseparable to the speakers of any given language; they 'happen'

simultaneously, like the two sides of a coin). By the same token, Picasso's pictures do not give us a real guitar, face, wine glass or whatever; they simply produce a representation of such things and draw attention to the means of representation.

The notion of Cubism as an autonomous world of representations was one that Apollinaire would have understood. The rise of Picasso's Cubism coincided with Apollinaire's entrée as a professional art critic: he wrote a regular column for the newspaper *L'Intransigeant* from 1910 until 1914, and in 1912 he published an article on 'The Beginnings of Cubism', arguing that Cubism produced 'new compositions with elements taken not from visual reality but from conceptual reality'.[37] Apparently Picasso and Apollinaire even used the term 'conceptual art' to refer to the artist's Cubism.[38] At the same time Apollinaire was immensely sensitive to the material aspects of the artist's Cubism. In 1913 he published *The Cubist Painters: Aesthetic Meditations*, and in the chapter on Picasso he insists that he has 'no preconceptions concerning artists' materials'. This statement is followed by an astonishing list of what might now constitute the work of art: 'You can paint with whatever you like, with pipes, postage stamps, postcards, playing-cards, candelabras, pieces of oilcloth, shirt collars, wallpaper or newspapers.'[39] It is easy to see that this list is not arbitrary: Picasso had indeed used some of these objects in recent collages and *papiers collés*.

In November that year, in the journal

Les Soirées de Paris, Apollinaire reproduced a series of photographs of Picasso's latest innovation, Cubist constructions, a sort of hybrid between sculpture and collage. When subscribers saw these photographs many of them cancelled their subscriptions, appalled at being asked to take these objects seriously as art. One was a relief sculpture in polychromed wood showing a guitar and a bottle of Bass ale, a work that Picasso seems to have partially dismantled or rethought after it was photographed (figs.15, 16). It was works like these constructions, poetic objects that seemed to have their own parallel existence when compared to reality, and also the rise of apparently entirely non-representational paintings by artists such as Robert Delaunay, that encouraged Apollinaire to speculate on the birth of a new reality of 'pure painting', and a few years later to coin the idea of an art that produced a superior reality, which he named 'sur-realism'.[40]

Picasso's constructions were, like his Cubism more generally, hugely influential for a generation of artists working in Paris and beyond, including figures of such importance as Piet Mondrian, Vladimir Tatlin and Marcel Duchamp. Yet he himself initiated a stylistic change in his art around 1914–15 that appeared to many as a volte-face from the radicalism of the preceding years. This was announced privately in a painting of two figures in an artist's studio (see fig.75) and publicly by portrait drawings such as that of Max Jacob in the style of Ingres (fig.17).[41] The drawing commemorates Jacob's formal induction into the Catholic Church, but it became notorious first by rumour and then when it was reproduced on the front page of the new art magazine *L'Elan* in December 1916. Why was the drawing so controversial? Because Picasso, widely treasured by avant-garde artists, collectors and devotees of modern art as the most 'advanced' artist of his time, appeared to be making a shocking u-turn in the direction of conservative artistic tradition. In 1917 he was mocked for appearing to return to the (conservative) Ecole des Beaux-Arts by the nihilistic former Cubist Francis Picabia, now a leading figure in the Dada movement, in the pages of his magazine *391*; Picabia added a spoof portrait with a photograph of writer Max Goth collaged onto a line drawing of his body.[42] The shift in Picasso's art that the Jacob drawing appeared to herald was identified with wider cultural and political debates concerning the need for a 'call to order' in French art, a return to the sober, balanced and supposedly 'Latin' values of tradition. The contrast was with a gothic German or 'Boche' culture, something that had often been associated with Cubism by its hostile critics, and Picasso's status as a non-combatant Spaniard made him appear politically suspicious in such an environment.[43]

Some biographers regard this reversion to Classicism as a reflection of the instability in Picasso's personal circumstances, perhaps causing a loss of creative direction. According to this view the Cubist years

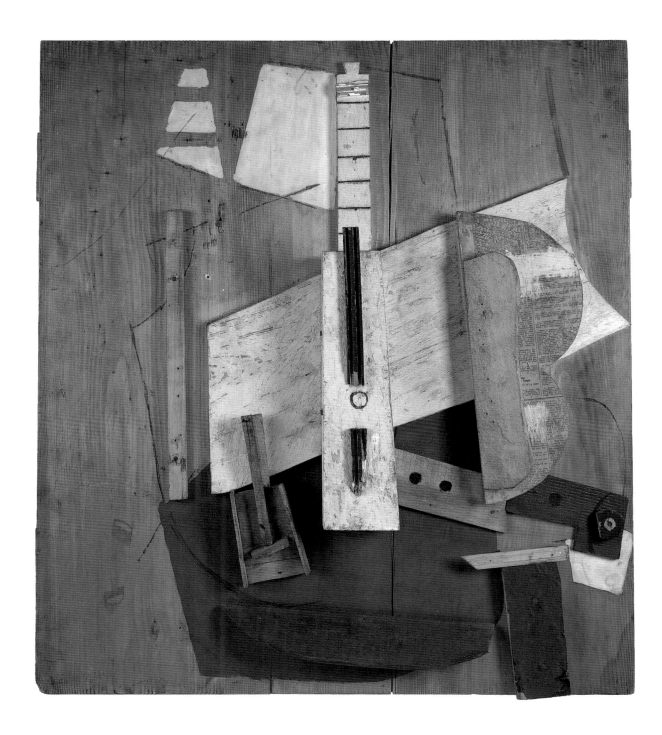

THE PICASSO BOOK

16
Guitar and Bottle of Bass
1913–14
(present state)
Assemblage, charcoal
and wood
89.5 x 80 x 14
Museé Picasso, Paris

had begun in obscurity and penury in the bohemianism of Le Bateau-Lavoir; his rapid success, thanks largely to the efforts of his shrewd dealer Kahnweiler, meant that by 1910 he had moved to a new and much more salubrious apartment on the boulevard de Clichy, although he rented a studio in Le Bateau-Lavoir again in 1911. He moved to boulevard Raspail in upmarket Montparnasse in the autumn of 1912. At the end of that year his relationship with Fernande was on the rocks, thanks in part to his affair with a woman known as Eva Gouel. (Eva was the woman to whom Picasso alluded in several Cubist paintings as 'Ma Jolie' or 'Jolie Eva'.) He moved again in August 1913, to rue Schoelcher, where he appears to have been very happy with Eva, but alas she died of cancer in December 1915, her illness coinciding with the advent of the First World War and the departure of Apollinaire, Braque and other close friends for the Front.[44] Eva's condition meant that Picasso felt free to form a new liaison, and he had a secretive love affair with Gaby Depeyre, to whom he proposed marriage in 1915. After Eva's death and the failure of the Depeyre relationship he courted another potential bride, Irène Lagut, mistress of Russian painter Serge Férat.[45] It was as a result of this period of casting about for a wife and a new kind of middle-class life that, it has been argued, Classicism re-emerged in Picasso's art.

Such an explanation is too one-dimensional, however, not only because it assumes too literal a connection between Picasso's emotional state and his work, but also because he continued to work in a Cubist idiom throughout the war – indeed, most of his publicly known work of the period remained Cubist. Furthermore, he had turned to a mock Classicism redolent of Ingres even before the onset of war, during the summer of 1914 in Avignon. His Neo-Classical Avignon works were an effort to prove to himself, as he told Kahnweiler, that he could 'do' Classicism 'better than before [Cubism]'.[46] Recent studies of his engagement with Classicism have underlined its complexity, strangeness and radicalism when compared to the conservative Neo-Classicism of reformed modernist painter André Derain or sculptors Charles Despiau and Aristide Maillol.[47]

Whatever the case, there is certainly a circumstantial relationship between the further development of Picasso's 'classical' style, the arrival of a new poet in his life, and the world that developed around his third and successful attempt to marry, towards the end of the war. At this time Picasso fell in with the circle around Sergei Diaghilev's Ballets Russes, where he met the dancer Olga Khokhlova (fig.18) whom he married in July 1918. His impressive and elegant portrait of Olga signals both a debt to the photograph on which it is based and a deliberate evocation of David and Ingres.

Picasso's encounter with Olga was facilitated by the dandyish poet Jean Cocteau, who had sought Picasso out in late 1915 on the pretext of having a portrait made. He had published writings and verses

17
Portrait of Max Jacob 1915
Pencil on paper
32.5 x 24.5
Musée Picasso, Paris

18
Portrait of Olga in an Armchair 1918
Oil on canvas
130 x 88.8
Musée Picasso, Paris

in various magazines, slated by Jacob and others as derivative and frivolous. He had co-founded a magazine called *Le Mot* ('The Word') in 1915, which promoted 'Latin' values and the idea of the 'return to order' in slick satirical fashion. Cocteau was working in military ambulances at the Front, and was able to come back to Paris fairly frequently to lobby various composers and impresarios regarding his various theatrical projects. This led, eventually, to the 'ballet' *Parade*, staged by the Ballet Russes in 18 May 1917, with music by Erik Satie, choreography by Leonid Massine and sets and costumes by Picasso, most of which were developed during a two-month sojourn in Rome and Naples in the early spring of that year. *Parade* was a short piece with a rather slight libretto by Cocteau; it supposedly represented the street performance by a circus troupe seeking to entice a paying audience for the main event. In his designs Picasso combined his recent Cubist style with a more naturalistic language indebted both to his own Rose Period and to theatrical convention.

The years of Picasso's involvement with the ballet, which extended until 1924, were a period of extensive travel as well as a transition to a high-society lifestyle and rather awkward domesticity. Picasso and Olga lived in the luxury Hotel Lutétia in 1918 prior to their honeymoon in Biarritz, before moving to a new apartment on the fashionable rue La Boétie. In the summer of 1921, following the birth of their son, Paulo, they rented a villa in Fontainebleau and

19
Three Musicians 1921
Oil on canvas
200.7 x 222.9
Museum of Modern Art,
New York

THE PICASSO BOOK

20
Three Women at a Spring
1921
Oil on canvas
203.9 x 174
Museum of Modern Art,
New York

Picasso turned the garage into a temporary studio. There he painted a number of major works that show him moving readily and with intent between a visual idiom indebted to Cubism and a Neo-Classical style. Two versions of a monumental composition called *Three Musicians* were painted here (fig.19), as well as a series that culminated in the equally grand *Three Women at a Spring* (fig.20).

Three Musicians is an example of Picasso's late Cubism, often called 'synthetic' since it seems to derive its forms from the elemental shapes of *papiers collés*, where guitars and violins could be invented as new realities (see fig.14). Yet, at 2 metres tall, the painting's ambitions are closer to those of grand European paintings than the cabinet pictures of pre-war Cubism. The picture shows, from left to right, a Pierrot-like figure playing a clarinet, Harlequin playing a guitar, and a monk holding a sheet of music, from which perhaps he is singing. Visible between their legs and the legs of a table is the shadowy form of a brown dog. The painting was famously interpreted by Theodore Reff as a mourning picture for the break up of Picasso's Gang: Apollinaire, who died in 1918 (Pierrot), Jacob who was now estranged from Picasso and was living in a monastery (the monk), with Picasso, as usual, in the guise of Harlequin.[48] John Richardson elaborates this reading by suggesting that *Three Musicians* was triggered by a poem of farewell written by Jacob recalling an evening spent with Picasso and Eva Gouel

in Figueres, Catalonia (hence the Catalan colours of Harlequin's motley).[49] Whether or not the picture is such a precise allegory (and others argue that it is more indebted to Picasso's recent ballet designs), it is remarkable in its contrast with *Three Women at a Spring*, although of almost identical size.[50] These monumental women appear to answer Apollinaire's encouragement in the summer of 1918 'to paint big pictures like Poussin', though their gestures and profiles also clearly relate to relief sculpture on Greek and Roman stele of a type that Picasso would have known.[51] The awkward heaviness of the bodies in *Three Women at a Spring* shows that if Picasso was paying homage to Poussin, it was a perverse one; his attempt was meant to thwart the conservatism of rival classicisms.

Both *Three Musicians* and *Three Women at a Spring* are surprisingly sombre works, each with three figures tightly compressed into a shallow space. The forlorn mood of these Neo-Classical women, with their massive bodies, feet and hands and their sculptural profiles, may echo the monumental language of the hundreds of war memorials being erected across France in the early 1920s.[52] They are uncanny versions of those water-bearers or nymphs that populate not only Poussin's paintings but also relief sculptures by the great Renaissance figure Jean Goujon, whose mannerist distortions are remarkably close in type to Picasso's.[53] The poet Pierre Reverdy, a friend of Apollinaire and Braque, wrote a text on Picasso in 1921 inspired by a retrospective exhibition at the dealer Paul

Rosenberg's gallery, in which he argued that 'poetry is to literature what Cubism is to painting'. Reverdy nevertheless understood that Picasso's Neo-Classicism was no simple retreat into 'literature', but the unidealised and disconcerting complement of the poetics of his Cubism.[54]

Reverdy's insistence on the poetic nature of Cubism became a dominant view among the most determinedly radical writers of the mid-1920s, the Surrealists, and the link between Surrealism and Picasso goes back again to his relationship with Apollinaire. On 17 March 1916 Apollinaire sustained serious head injuries, leading to a long period of convalescence back in Paris. Picasso helped to organise a dinner in his honour and to celebrate the publication of his book, *The Poet Assassinated*, on 31 December 1916. He introduced Apollinaire to Diaghilev, who commissioned the poet to write a note for the *Parade* programme, historic for including the first published use of the term 'sur-realism'. Unfortunately Apollinaire's own 'sur-realist drama', *Les Mamelles de Tirésias* ('The Breasts of Tiresias'), was performed after *Parade* and only once, on 24 June 1917, when Picasso was away in Madrid. He also missed Apollinaire's important manifesto lecture, 'L'Esprit nouveau et les poètes' ('The New Spirit and the Poets'), on 26 November 1917. This was closely studied by poets, including André Breton and Paul Eluard, who would soon forge a Surrealist movement out of their own Parisian version of Dada, and who would soon become key figures for Picasso, and Picasso for them.

Breton, later the leader of the Surrealist movement, first saw Picasso's Cubist constructions in the pages of Apollinaire's *Les Soirées de Paris*; they met in November 1917, and Breton subsequently bought several of Picasso's works. Whereas the Surrealism constructed by Breton, Eluard and others bore only a partial resemblance to Apollinaire's 'superior reality', of key importance was their reinterpretation of Picasso's Cubism as a resource for thinking about a parallel reality in which metamorphosis is linked to the metaphorical transformation of one sign into another (see Chapter 5). Surrealism, as defined in Breton's famous first 'Manifesto of Surrealism' of 1924, was 'pure psychic automatism' exposing the nature of mental life.[55] Through its courting of 'marvellous' and extreme juxtapositions of poetic images, Surrealism was to bring about the resolution of the states of dreaming and wakefulness, but this resolution was also to be revolutionary in the widest possible sense. Breton and Eluard celebrated such extraordinary works as Picasso's *Woman in a Chemise* of 1913 (fig.21), finding in it a destabilising and visceral eroticism (underarm hair, breasts hanging on wooden pegs, 'vaginal' folds in the chemise) that co-existed with ordinary daily existence (a newspaper, a fringed armchair). They reinterpreted Picasso's Cubism as Surrealism by including such works in major exhibitions of work by Surrealist artists including Salvador Dalí, Max Ernst, André Masson, and Joan Miró (fig.22).[56]

Breton reproduced Picasso's *Woman in a Chemise* in his important book *Surrealism and Painting* of 1928, but since 1924 had published numerous photographs of Picasso's work in the pages of the first Surrealist journal, *La Révolution surréaliste*. These included Picasso's great work of 1907, *Les Demoiselles d'Avignon* (see fig.28) and a major painting of 1925 now known as *The Three Dancers* (fig.23). X-rays of the latter show that at first, in early 1925, it depicted three ballet dancers, a kind of modern 'Three Graces', but was later radically altered. It now depicts three figures in an interior in front of a typical French balcony, with iron balustrade and double doors. The strongly patterned wallpaper of the interior contrasts with the intense blue sky outside. The dancers hold hands, each balanced on one foot. The figures are each painted differently: that on the right in a series of simple black, white and brown planes like paper cut-outs, the central one predominantly in a single pink with black-and-white highlights, and the more complex figure on the left, apparently wearing a skirt, in pinks, browns, reds, whites, blacks, and greens.

The Three Dancers is often interpreted as a turning point in Picasso's art. Alfred H. Barr thought the picture 'striking for its physical and emotional violence . . . The convulsive left hand dancer foreshadows the new periods of [Picasso's] art in which psychologically disturbing energies reinforce or, depending on one's point of view, adulterate his ever changing achievements in the realm of form.'[57] The word 'convulsive', used by Breton in his Surrealist writings, has often been said to capture the spirit of Picasso's painting, and the left-hand dancer credited with introducing a new 'Surrealist style', violent and expressive, to his art.[58] The convulsive image of human life presented in this painting marks Picasso's response, not so much to any visual style within Surrealism, however, as to the radical Surrealist unravelling of the boundary between reason and the unconscious.[59]

Picasso never committed to the Surrealist movement; instead he became a kind of artistic figurehead, his work frequently appearing in Surrealist exhibitions. He was fundamentally in sympathy with Surrealism's insistence on the primacy of the imagination, on metaphorical transformation, and on the juxtaposition of things normally unrelated. Above all he valued the opportunity to interact with a number of avant-garde poets, including not only Breton and Eluard, but also Louis Aragon, Robert Desnos, Michel Leiris and Benjamin Peret, several of whom were to be his lifelong collaborators.[60] Occasionally his paintings and drawings inspired Surrealist poetry. For example, the drawing now known as *End of a Monster* (fig.24), after the eponymous poem by its first owner, Paul Eluard, shows a garlanded woman rising from the sea like a nymph, holding up a mirror to the face of a minotaur struck through with an arrow. His horrified expression is no doubt the touchstone for the poem:

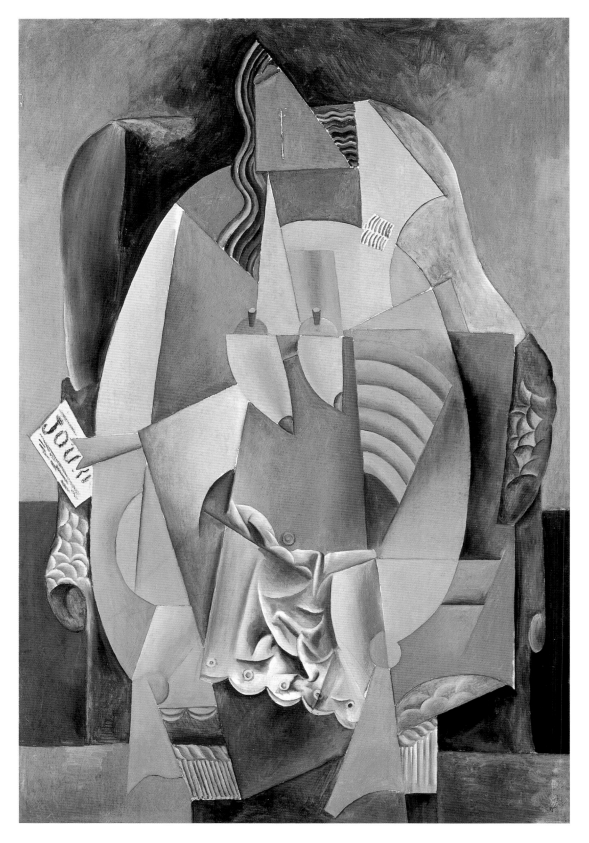

THE PICASSO BOOK

21
Woman in a Chemise 1913
Oil on canvas
150 x 99
Private Collection,
New York

22
Installation photograph
showing *Woman in a
Chemise* at the *London
International Surrealist
Exhibition*, 1936
Scottish National Gallery
of Modern Art, Edinburgh

You have to see yourself die
To know that you still live
The tide is high and your heart is very low
Son of the earth flower-eater fruit of ashes
In your bosom the darkness forever covers
 the sky.[61]

Picasso's painting has continued to inspire poetry beyond his immediate circle. For example, American poet Wallace Stevens made his name in 1937 with a volume of poems entitled *The Man with the Blue Guitar*, in which the title poem is inspired by Picasso's *Old Blind Guitarist* of 1903–4 (fig.25), which Stevens had seen in Chicago.[62] In the opening of the poem, the blue guitar becomes the power of the imagination itself: 'Things as they are/Are changed upon the blue guitar.' Taking a philosophical journey through meditating on the playing of the guitar, Stevens defends poetry as the true source of reality, using language that makes a powerful metaphor of the blindness of the old man, and at the same time resonates with the poetic making of Cubism:

Throw away the lights, the definitions,
And say of what you see in the dark

That it is this or that it is that,
But do not use the rotted names.

How should you walk in that space and
 know
Nothing of the madness of space,

Nothing of its jocular procreations?
Throw the lights away. Nothing must
 stand

Between you and the shapes you take
When the crust of shape has been
 destroyed.

You as you are? You are yourself.
The blue guitar surprises you.

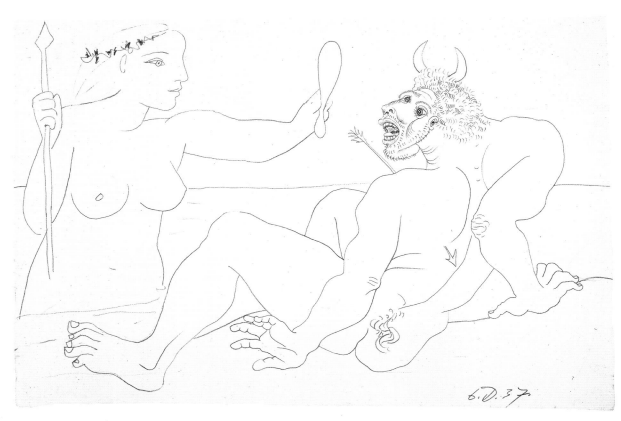

24
End of a Monster 1937
Pencil on paper
38.6 x 56.3
Scottish National Gallery
of Modern Art, Edinburgh

25
Old Blind Guitarist 1903–4
Oil on panel
121.3 x 82.5
Art Institute of Chicago

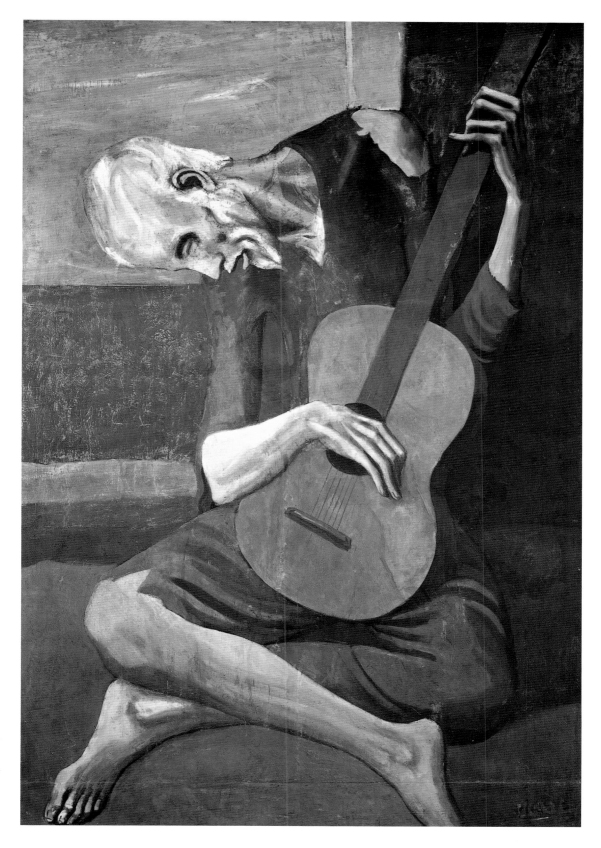

Bottle, Glass and Violin

This large *papier collé* includes four separate fragments of a newspaper, *Le Journal*, of 2 December 1912.[63] Yet although the language is everyday rather than poetic, its use in Picasso's representational game is nevertheless powerfully metaphorical and lyrical. The work was first exhibited in Paris and Zurich in 1932, having been cheaply purchased at a Kahnweiler sale by one of the most important figures in the Dada movement, Tristan Tzara.

The picture shows a bottle, newspaper, wine glass and violin. Although barely anchored in the open space, the suggestion of a table can be discerned in the line that runs up the right side of the violin and then at a sharp angle down towards the word 'JOURNAL'. Despite its modest means, this is a tour de force of representational invention: every fragment of paper engages with the viewer in a different way.

At the centre of this visual compendium is the literal: the word 'JOURNAL' cut from the masthead of the newspaper is both a picture of the newspaper and the actual newspaper; it is at once the word as pattern (black lettering on newsprint ground), a linguistic sign meaning a diary (the same in English as in French), and the brand name of the newspaper. The trenchantly angled word 'JOURNAL', roughly set off by the rectilinear charcoal frame suggesting simultaneously the edges of a table and a folded newspaper, sits above another kind of literal element: a rectangle of paper that appears to be a blank version of the same newsprint that makes up the remaining elements, as if standing for the substance out of which everything appears, for 'materiality'.

The sheet to the right of 'JOURNAL' is almost a quotation from Picasso's Cubist drawings: the body of the glass comprises a half-moon shape surmounted by a rhombus, with a circle, no doubt the lip of the glass seen in plan, cutting through its upper edge. The glass casts a refracted shadow across the paper. The illustration at the top of this piece of newspaper is comically appropriate, showing a ship at sea, with the caption: 'How to lay a line at a depth of 1,000 meters'. The water here suggests the liquid in the glass, while ironically the line tries to 'anchor' the floating Cubist drawing.[64]

The theme of depth carries other possible resonances here. One of the economies of Cubism was its apparent rejection of traditional perspective: in Picasso's *The Poet* the space in which the figure exists seems shallow; this begins to look like a tendency if one moves from *Spanish Still Life* to *Musical Score and Guitar*, where the illusion of space is represented by layering elements in the depth of a sheet of paper. It was in the insistent flatness of Cubism that American critic Clement Greenberg saw the highest achievement of modern art before post-war American art, which he believed was able to assert the fundamental condition of painting in a way that no other art form could. Flatness, in other words, had a critical resistance in it that distinguished painting from mass culture and protected it from absorption into mere kitsch.[65] Critic Rosalind Krauss has recently argued, however, that the flatness of Picasso's *papiers collés*, with their relentless 'frontality', is played off against what is absent: depth, light, transparency and other effects that so bewitched the viewers of painting from the Renaissance to the late nineteenth century. According to Krauss, *Bottle, Glass and Violin* finds a way to bring 'depth' back into Cubism – not illusionistically but as an idea. She points in particular to the violin.[66]

The violin is the most complex object in the picture, made of two paper fragments: a hand-painted piece of faux wood-grain with the silhouette of the letter B, a quadrilateral piece of newspaper upon which is drawn the scroll of the instrument. At this point the newspaper functions merely as neutral ground on which to draw. But the piece of paper is shaped to suggest foreshortening, as its plane apparently recedes into depth. The area of dark shading beneath suggests the space behind the strings, which are then drawn with converging lines familiar from the perspective constructions in Renaissance art. The volume of the violin and the way it angles into deep space in the picture are further signalled by the asymmetry of its 'f'-holes, that on the right notionally 'closer'

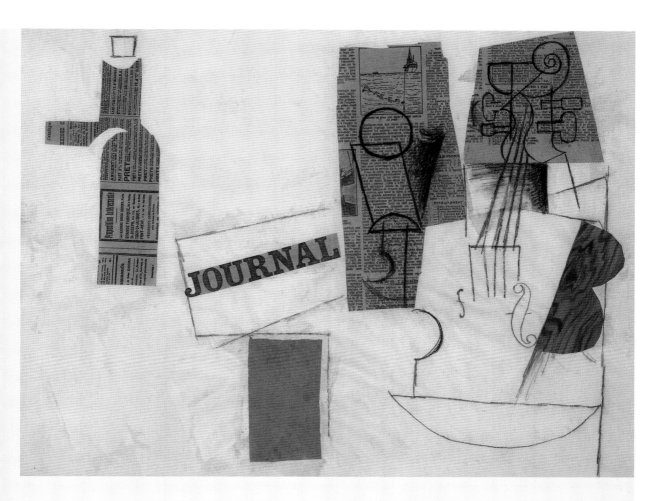

26
Bottle, Glass and Violin
1912–13
Charcoal and papiers
collés on paper
47 × 62.5
Modena Museet
Stockholm

to us than that on the left. In fact, Tristan Tzara, the work's first owner, noticed this kind of achievement in 1931 in an essay called '*Papiers collés*, or Proverbs in Painting':

> A shape cut out from newspaper and incorporated into a drawing or painting embodies the commonplace, a piece of everyday reality, the ordinary – compared to another reality constructed by the mind. The difference in materials, which the eye is able to transpose into tactile sensation, lends a new depth to a painting, where weight is inscribed with mathematical accuracy into the symbol of volume . . .[67]

Quite the opposite happens with the bottle: here the newspaper describes only the graphic outline of the bottle, a protruding handle on the left suggesting a soda siphon.

The newspaper tricks the eye: the crooked cut-out shape forms a highlight; if the 'handle' is obscured, the blank sheet to the immediate left of the newspaper bottle leaps into life as the left-hand edge, forced to do so by the imaginary line that runs down from the crooked shape. The body of the bottle, inexplicably asymmetrical in relation to its neck, is thus re-balanced.

Picasso plays one more game here: the newsprint that forms the body of the bottle has a label, courtesy of a perfectly placed section of boxed newspaper text, headed 'Interesting Proposition'. As Leo Steinberg has pointed out, this 'label' fictionally pasted onto the bottle could not be a more appropriate parody (or a more interesting proposition) for this work of art, a visual fiction, entirely based on pasted paper.[68]

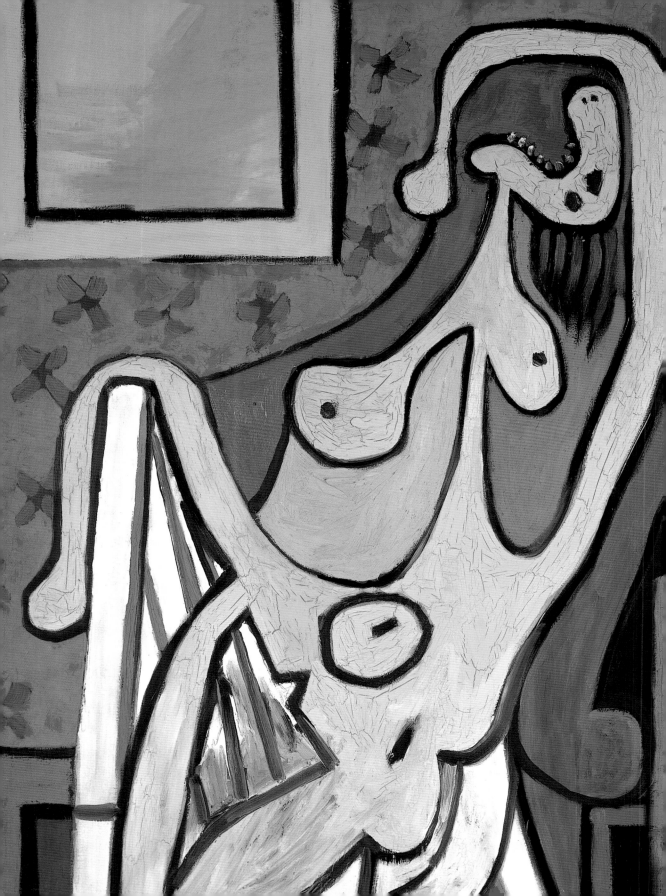

On 1 April 1939 Picasso painted several canvases shocking for their grotesque reformations of the human head (fig.27). In a dingy room a woman in a green dress looks out through one eye in a dark hollow, the other eye hanging on an elephantine nose. Twisting in the opposite direction, her grey mouth is framed by lank tresses of dark hair. That same day the Spanish Republicans had surrendered to General Franco: Spain had fallen under Fascist dictatorship. Hitler had invaded Czechoslovakia in March, and a few days before Picasso made this picture the British government had issued a statement offering support for Poland in the event of a German invasion. In this context Picasso's head can be seen as expressing the anguish of a European civilisation on the brink, a human crisis. The sources and the means of Picasso's transformations of the human form are the subject of this chapter.

1939 was an auspicious year for Picasso. The work that was the foundation of his disfiguring visions, *Les Demoiselles d'Avignon* (fig.28), featured in the inaugural exhibition of the new building of the Museum of Modern Art, New York, and was subsequently purchased by the Museum.[1] Until now the painting had languished largely unseen, first in Picasso's studio from 1907 until 1916, when it was briefly exhibited in Paris (when Salmon gave it its present title). In 1924 couturier and collector Jacques Doucet was persuaded by André Breton, his artistic advisor and librarian, to buy *Les Demoiselles d'Avignon*.[2] Later Doucet wished desperately to buy *The Three Dancers* (see fig.23). He tried to persuade Picasso by saying that he intended to donate all his collection to the Louvre (in the event his widow sold *Les Demoiselles d'Avignon* to a New York dealer[3]). The very first, poor reproduction of the painting, which accompanied an article of 1910 by American journalist Gelett Burgess in the US publication *The Architectural Record*, appears to have gone unnoticed. But it was a time bomb of a picture: although completed in the summer of 1907, its impact on many artists and on art history was delayed by its low profile.

Breton's assertion that *Les Demoiselles d'Avignon* 'marks the birth of Cubism' probably derived originally from Kahnweiler's book, *The Rise of Cubism* (1920).[4] But the painting is no witty still life or lyrically abstracted portrait: it is a painting of a brothel scene, 'monstrous women . . . hacked out of solid, brutal colours'.[5] The process whereby Picasso arrived at this work is now well known.[6] In 1905 he found new creative energy from his gang of poets. It was in this context that, after the achievement of the *Family of Saltimbanques*, he sought to realise a new large-scale work, at first thinking of an update of the popular and erotic Orientalist theme of the Harem. He developed this idea during the summer of 1906 in the Spanish village of Gósol, taking inspiration from such 'seminal' works as Manet's *Olympia* 1863 (Musée d'Orsay, Paris), depicting a naked prostitute brazenly staring back at the spectator, and Ingres's *The Turkish Bath* 1862 (Musée du Louvre), where a host of writhing female nudes

3 Disfigurations

27
Head of a Woman 1939
Oil on canvas
92 x 73
Private Collection

28
*Les Demoiselles
d' Avignon* 1907
Oil on canvas
243.9 x 233.7
Museum of Modern Art,
New York

present themselves for the delectation of the connoisseur. Both paintings were shown in the autumn Salon in 1905. But perhaps Picasso's most important challenge was Henri Matisse's *Le Bonheur de vivre* (*The Joy of Life*), shown in the spring Salon des Indépendants just before Picasso's departure for Spain (fig.29).

Matisse was older than Picasso, and had already achieved notoriety as the leader of the 'Fauves', the group of artists who had exhibited intensely coloured and expressive paintings in the salons of 1905. Matisse's major work of 1906 showed a group of naked male and female figures disporting in a fantasy landscape, a sensual idyll in acid tones where the human body was freely distended and, in the opinion of some critics, 'deformed' according to the artist's whim.[7] Matisse competed with Picasso for buyers, and was prepared to innovate in ways that constantly surprised the younger artist. If Matisse's work depicted sexual abandon through the myth of a Golden Age, Picasso's shift from a harem to a contemporary brothel scene in the spring of 1907 was clearly designed to offer a more brutish and discomfiting vision of sexual behaviour. The great poet and prophet of modernity Charles Baudelaire saw 'women and prostitutes' as quintessentially modern subjects for art. In his remarkable essay 'The Painter of Modern Life' (dated 1863 and often read as a veiled tribute to Manet) Baudelaire celebrated the work of Constantin Guys, a minor graphic artist whose drawings included brothel scenes and which Picasso certainly knew.

It is tempting to think that Baudelaire's text, taken together with the renown of Manet's prostitute *Olympia*, incited Picasso to confront public morals in the name of a 'Modern' art.[8] Yet Picasso's brothel would be so frighteningly deformed that not even the poetic cult of the 'modernity' of the prostitute would be able to celebrate it.

The earliest compositional studies for *Les Demoiselles* are found in sketchbooks. One drawing (fig.30) shows seven figures in the curtained boudoir of the brothel, two clothed men and five naked or semi-naked women. In the centre is a seated male, identified in other studies as a sailor; on the left, raising a curtain and holding a book in his hand, is a second male figure, whom Picasso later described as a medical student. In the process of developing the painting he expunged the two male figures and compressed the composition laterally, abandoning any allegory of the 'wages of sin' and instead turning the prostitutes around to face the spectator. Among the numerous individual paintings for the assembled cast of prostitutes is one showing a woman with an improbable ear, seen frontally rather than in profile (fig.31). Only recently has it been noticed that beneath this square painting is a study for the final composition (if the painting is turned 90 degrees to the left, the striations that indicate the left-hand curtain in the final painting are visible on the left, as are the faces and bodies of some of the female figures).

The creature that appears on top of this now concealed compositional study is an

29
Henri Matisse
Le Bonheur de vivre
(*The Joy of Life*) 1905–6
Oil on canvas
175 x 241
Barnes Foundation,
Merion, Pennsylvania

example of Picasso's early attempts to invent a new figurative language for his brothel scene. Gender signals are ambiguous (the figure is arguably male, not female), while the face becomes a semi-sculptural, almost concave mask. In experimenting with facial representations Picasso drew upon the Roman sculptures from the Iberian Peninsula that he saw in the Louvre (he briefly acquired one that had been stolen from the Museum!) and at the same time allowed the momentum of his drawn line to generate ideas.[9] This is evident in the line (in fact it is not continuous in the painting) running down the right side of the face, round the chin and up and into the nose to give a strong sense of the mass of the whole lower jaw and cheek. The blankness of the eyes, the left giving rise to the line of the profiled nose, flattens the upper part of the head. This flattening, conforming to the picture surface, is reinforced by pulling the ear round to face front. Such gestures are the first signs of Picasso's persistent desire to bring front and back of a figure into view simultaneously on a two-dimensional surface: 'drawing as if to possess'.[10]

Having filled several sketchbooks and painted dozens of studies of compositions and individual figures, Picasso made the painting of *Les Demoiselles* itself over a period of two months. Three of the five life-size figures leer outwards, while the two entering through curtains to left and right suggest that something is about to happen. There are no chairs or sofas, only the jagged tip of a table in the foreground, upon which sits

30
Study with seven figures: five demoiselles, medical student and sailor 1907
from sketchbook 9,
folio 29r
Black crayon on paper
19.5 x 24.3
Musée Picasso, Paris

31
Bust (Study for 'Les Demoiselles d' Avignon')
1907
Oil on canvas
60.5 x 59.2
Musée Picasso, Paris

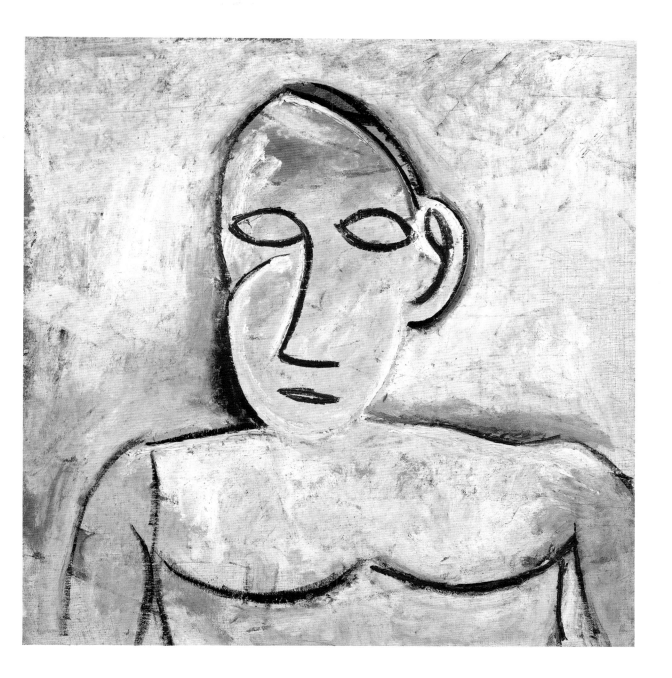

a tablecloth in disarray, a slice of melon, an apple, a pear and some grapes. The figures themselves are embedded in – or compressed by – the folding forms of curtains that become, ambiguously, crumpled pictorial space. The idea that space could be crushed and bent in this way is a shocking intervention in the history of European art. The same logic of deformation is applied to the spatial relationships between the bodies of the prostitutes: the nose of the left-hand figure seems to press against the upper arm of the next prostitute and their feet tuck together. The pose of the second figure is a vertical version of a reclining odalisque, and the pointed form of her elbow echoes those of the nude standing next to her, with a phallic knee projecting from her drapery. The two figures on the right possibly inspired Gelett Burgess to write in 1910 of 'figures like Alaskan totem poles', for they appear to merge into one frightening monolith.[11] The upper figure's head is a striated mask with hollows for eyes. Beneath her head is a rhomboid breast with irrational shading; indeed, her whole torso is regenerating as geometry. At bottom right squats a prostitute with another mask-like head, turned 180 degrees and cupped in a shovel of a hand. The nose of this figure is again striated, appearing to bend leftwards as if following the mouth.

Nothing tells the spectator where these figures are, what they are looking at, or what event prompts the figures at the edges to come in. The rapturous Arcadia of Matisse's *Le Bonheur de Vivre*, a world of sexual pleasure without sin, seems another universe. Instead, the viewer is confronted by piercing stares and grotesque bodies. The implication is that the onlooker is the client, sitting at the phallic table pentrating the space. Picasso worked hard to achieve this effect of painting-as-assault. In the first version of the painting, known as a result of infra-red photographs, it seems that he had painted all the figures and their heads in the same radicalised 'Iberian' style still evident in the two figures in the centre with pointing elbows raised.[12] At a late stage Picasso hurriedly repainted the heads and parts of the bodies of the two figures on the right, together with the figure on the extreme left wearing some kind of negligée and raising the curtain with one arm.

One of the earliest published descriptions of the evolution of Picasso's painting was by André Salmon. His 'Anecdotal History of Cubism' of 1912 remains evocative. Describing Picasso in the throes of an anxiety about his Rose Period success, labouring to achieve a new kind of figuration, and outlining the two phases of work on the painting, Salmon writes: 'For the first time in Picasso's work, the expression of the face is neither tragic nor passionate. These are masks almost entirely freed from humanity.' For Salmon this meant in particular the opening up of a 'geometrical' or 'mathematical' attitude to representation, implying the dispassionate and austere science of depiction that he saw in Cubism. Yet he knew that the *Demoiselles* was far from dispassionate and could not

easily be assimilated with hindsight to later Cubist work. Furthermore, many art-world insiders who came to see the painting in the studio were disconcerted by what Matisse called an outrage; 'it was the ugliness of the faces that froze with horror the half converted', wrote Salmon, invoking the Classical myth of Medusa, a gorgon woman with hair replaced by writhing snakes and a gaze that can turn men to stone.[13]

Like many Classical myths, that of Medusa has been interpreted as a powerful metaphor for the perceived sexual threat of woman by, amongst others, Freud in his studies of sexual anxiety. A decade after Picasso painted his picture, Sigmund Freud wrote about a patient who had a recurring dream of being frozen with fear at the sight of six or seven staring wolves in a tree. For Freud, his patient, known to us as 'the Wolf-Man', suffered from intense anxiety over his sexual knowledge.[14] As a child he had accidentally seen his parents having sex, and now feared that revenge would be taken for his 'spying' on them. Freud believed that children use bodily metaphors in expressing their anxieties; in this case the Wolf-Man feared castration (i.e. punishment) by the wolves in his dream. The important thing for thinking about Picasso is that the case revolved around the supposed power of sight. The Wolf-Man had seen his parents' lovemaking, and his anxiety was that he would be caught (seen) and punished. The wolves in the dream, with their burning eyes, both return his secret look and threaten to punish him for it. In 1922 Freud explicitly connected these ideas to the Medusa myth, arguing that at an early age male subjects regard the female genitals with terror, since in the mother's lack of a penis they see an image of castration.[15] The Medusa myth is thus interpreted as a series of metaphors for the castration complex. Medusa's gaze catches her victims in the act of looking, and being turned to stone (castrated) is their punishment that happens simultaneously with the act.

While neither Picasso nor Salmon could have known of Freud's research, the context for Salmon's reference to the Medusa myth – the terrifying gazes of the 'Demoiselles' – makes Freud's interpretation highly relevant.[16] Picasso's painting was after all devoted to the threat and power of female sexuality: rich in distortion and facial torpor, it is replete with staring eyes and eye sockets. As a painter Picasso was morbidly fascinated by the threat of blindness (as is evident in such Blue Period pictures as *Old Blind Guitarist*, fig.25), and he had an exaggerated notion of the power of sight, as is implied in his wide-eyed *Self Portrait* of 1907 (National Gallery, Prague), or his *Self Portrait* of 1972 (fig.83). *Les Demoiselles d'Avignon* makes a strong connection between seeing, desiring and punishment, and goes further, making us, as spectators, the recipients of that punishment. The chaotic or apparently unresolved visual style of the painting stands for the trauma of the immersion in the gaze of the women. This was perhaps just the petrifying experience that Salmon attributed to the 'half-converted' who

came to Picasso's studio expecting to see something wilfully modern but still beautiful, of the kind that Picasso had been painting only months before.

If Salmon's Medusa metaphor evokes the shocking ugliness of the *Demoiselles*, how does he account for it? For Salmon, horror is only a by-product of a new 'geometric' art where 'the human effigy appears to us so inhuman and inspires in us a sort of terror'. The source of this geometry was non-Western art. Picasso's enthusiasm for black African and Oceanian art 'was not based on any trivial appetite for the picturesque', Salmon insists, 'The images from Polynesia or Dahomey appeared to him as "reasonable" [rational]'. Notwithstanding Picasso's later trenchant denials of the role of non-Western art in the repainting of *Les Demoiselles d'Avignon*, there is little doubt that he was inspired to do so by a visit to the ethnographic collections of the Musée du Trocadéro, possibly as early as March 1907, made at the suggestion of Matisse or Derain, both collectors of tribal objects.[17] Although great efforts have been made to locate the particular objects Picasso saw there, he clearly did not copy them directly: rather, he adapted their morphology, colour and decoration in order to conjure up what Salmon called their 'barbarity'.[18] Later, in his Cubism, Picasso made a different, 'reasonable' use of aspects of non-Western art (see Chapter 5). In the *Demoiselles*, however, he recruits the notionally 'primitive' and 'savage' to a scene of gross sexuality as a provocation, deploying racist as well as misogynistic stereotypes in the despoiling of artistic tradition.[19]

Although the painting met with incomprehension and distaste from some who saw it, when Kahnweiler came to write about it during the First World War he focused not on its shock value but on its failure as a composition. He believed that, although tremendously important for inaugurating Cubism, the art he so admired, it was in his view unfinished, being 'inconsistent in style' and 'not developed into a unified whole'.[20] It was, perhaps, in just such a spirit of aesthetic disjunction that Breton reproduced the painting in the fourth issue of *La Révolution surréaliste*: its 'primitivism' and its deformations of the body certainly took on a different meaning for Picasso in the context of Surrealism.

Like *Les Demoiselles d'Avignon*, *The Three Dancers* also drew upon non-Western art – possibly Papua New Guinean masks – thus marking Picasso's renewed interest (after his Neo-Classicism of the early 1920s) in 'primitive' art as inspiration for the reinvention of the human form.[21] In both paintings Picasso had arguably invoked it as a means to represent Dionysian energies of violent eroticism. Certainly by 1937, when André Malraux talked to him about the role of his first 1907 visit to the Trocadéro Museum in the creation of *Les Demoiselles d'Avignon*, Picasso was happy to oblige with a description that owed much to Surrealism:

. . . it was disgusting. The Flea market. The smell. I was all alone. I wanted to get away. But I didn't

leave. I stayed. I stayed. I understood that it was very important: something was happening to me, right?

The masks weren't just like any other pieces of sculpture. Not at all. They were magic things ... The Negro pieces were *intercesseurs*, mediators ... They were against everything – against unknown, threatening spirits. I always looked at fetishes. I understood; I too am against everything. I too believe that everything is unknown, that everything is an enemy! Everything! Not the details – women, children, babies, tobacco, playing – but the whole of it! ... all the fetishes were used for the same thing. They were weapons. To help people avoid coming under the influence of spirits again, to help them become independent. They're tools. If we give spirits a form, we become independent. Spirits, the unconscious (people still weren't talking about that very much), emotion – they're all the same thing. ... *Les Demoiselles d'Avignon* must have come to me that very day, but not because of the forms; because it was my first exorcism painting – yes absolutely![22]

Although Malraux no doubt embroidered Picasso's words, the reference to 'the unconscious' places them firmly in the realm of Surrealism. Breton had come across Freud's ideas when working as a medical orderly during the First World War, and as early as July 1922 he linked Freud's name to Picasso's: two 'first-rank fanatics' in the intellectual realm of Surrealism.[23] Yet in Picasso's statement to Malraux the emphasis on a quasi-anthropological or ethnographic attitude to tribal and other non-Western artefacts is a clue to Picasso's close

friendship with Michel Leiris. Leiris was an ethnographer and writer who belonged to a group now known as Dissident Surrealists, including artists André Masson and Joan Miró and the philosopher Georges Bataille, who distanced themselves in the late 1920s from Breton's project.

Breton's publication of Picasso's paintings was part of his strategy to demonstrate the possibility of Surrealist painting, as well as to co-opt Picasso to the new movement.[24] He wrote an important text on Picasso, published in 1925, which later became the first part of his book *Surrealism and Painting* (1928).[25] Breton succeeded in both up to a point, although Picasso always remained an associate of the movement rather than an adherent; the same is true of his relations with the Dissident Surrealist group around Bataille. Picasso's understanding of Surrealism as a concept was always heavily influenced by Apollinaire throughout his life – once he even claimed to have invented the term: 'I am intent on resemblance, a resemblance more real than real, attaining the surreal. It was in this way that I thought of Surrealism', he told André Warnod in 1945.[26] This could mean that Picasso thought of Surrealism as merely a heightened form of realism. Much later, Breton appeared to agree with this view: 'what constantly created an obstacle to a more complete unification of [Picasso's] views and ours is his unswerving attachment to the exterior world and the blindness which this tendency entails in the realm of the dream and imagination.'[27]

Granted, Picasso had a profound attachment to visible things, but if he was driven by an obsessive engagement with the object-world, his work from *The Three Dancers* until the early years of the Second World War nevertheless often demonstrates a ruthless will to deform, disfigure and disrupt the everyday appearance of people and objects, an undermining of reality that chimed with Surrealism's emphasis on the role of the unconscious.

Sometimes, for example, he approached the body as an agglomeration of elements to be assembled and reassembled, giving rise to a powerful sense of hallucinatory transformation from inanimate to animate.[28] His series of pencil drawings known as *An Anatomy*, reproduced in the first issue of the luxurious Surrealist magazine *Minotaure* in 1933, comprised thirty sheets improvising on the female body. (Many years later the German artist Hans Bellmer, whose 'doll' photographs first appeared in *Minotaure* in 1935, described his own motivation in terms that fit Picasso's *Anatomy* perfectly: 'The body can be compared to a sentence that invites you to dismantle it, so that, in the course of an endless series of anagrams, its true contents may take shape.')[29] In Picasso's drawing *An Anatomy: Three Women* (fig.32) the figure on the left has a button for a head and a ball for a stomach, on which leans a board with two projectile breasts and lathe-like arms. Beneath another tilted board signifying the pelvic bone is an inverted book representing the vagina. Each figure in the drawing reinvents the body in a similar way; for example, breasts are variously signified by hanging balls and empty cups. On every page in the series three creatures stand in a row, as if parading in a clothing catalogue.

Alongside these drawings, the first isssue of *Minotaure* also featured a remarkable sequence of photographs of Picasso's sculpture studio in the Château de Boisgeloup by the Hungarian photographer Brassaï, accompanied by an essay by Breton entitled 'Picasso in his Element'. Picasso had, of course, also designed the cover of the magazine. The *Anatomy* sequence was thus placed in a close relationship to sculpture; indeed, Picasso had been heavily involved in metal and plaster sculpture since 1927, partly in an effort to develop a model for a monument to Guillaume Apollinaire (see figs.62, 63 and Chapter 5) and partly in a creative exchange with the 'sculptural' in drawings and paintings. The purchase in 1930 of Boisgeloup, about 45 miles north of Paris, enabled Picasso to have a proper studio where he created an astonishing number of female heads, serene but sometimes phallic. These in turn owed their bulbous forms to drawings and paintings made during summers at the beach in Cannes (1927) and Dinard (1928, 1929) featuring bathers with beach huts, balancing beach balls, or simply disporting themselves to various degrees in monstrous contortion. The sculptural imagination of these drawings and paintings was informed by a fascination with the forms of flotsam and jetsam: bones, pebbles and driftwood that were readily to hand at

the tide-line, and perhaps also the skeletons he saw years before in the palaeontology gallery of the Jardin des Plantes in Paris or reproduced in magazines and books.[30]

Picasso's figure paintings of the late 1920s and early 1930s show a similarly remarkable and varied determination to reinvent the human form, as in, for example, *Large Nude in a Red Armchair* (fig.33) of 1929 or *Female Nude in a Garden* of 1934 (fig.34). Both paintings manipulate the subject's body as if boneless, limbs becoming fleshy and vestigial outgrowths. The earlier painting exudes paroxysmal anguish, the upturned animal maw emitting an inarticulate shriek, while the 1934 painting has an air of post-coital bliss: a mass of sleeping pink flesh is mirrored in a pool, the woman's head resting on an exotic red and gold pillow, the vegetation and water suggesting some steamy oasis. This erotic painting is a late addition to a series begun in 1932 of poised women in armchairs, as in Tate's curvilinear *Nude Woman in a Red Armchair* (fig.35), while others are caught reading (e.g. *The Reading* 2 January 1932, Musée Picasso, Paris) or more often asleep (e.g. *Nude in a Black Armchair* 9 March 1932, Private Collection, and *The Dream* 24 January 1932, Collection Steve Wynn, Las Vegas). Picasso made a number of paintings of this blonde type sleeping, sometimes observed by a male figure.[31]

Mirrors often play a part too, as in *The Mirror* 12 March 1932 (Private Collection), complete with phallic reflection of part of the woman's body, and, famously, *Girl Before a Mirror* 14 March 1932 (Museum of Modern

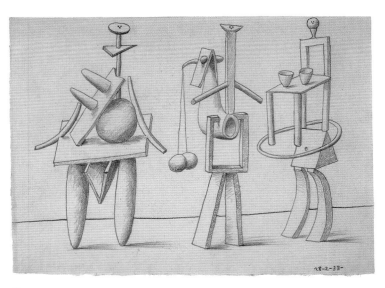

32
Une anatomie: trois femmes (An Anatomy: Three Women) 1933
Pencil on paper, published in *Minotaure*
19.7 x 27
Musée Picasso, Paris

Art, New York). These works share a stock vocabulary: mirrors are employed to double the figure, a traditional motif stretching back to at least the Middle Ages, usually in order to condemn vanity by opening a gap between present beauty and future decay; armchairs, according to the artist, were there to pinion these women 'like birds in a cage', to suggest 'old age or death' – either that or the armchair was, as Picasso told Malraux (recalling the exorcism theory for the *Demoiselles*), 'there to protect her . . . like Negro sculpture'.[32] The armchair-seated and sleeping women of these years have been compared to Matisse's Odalisques from the 1920s, or to the Surrealism of Picasso's fellow Spaniard and close friend Joan Miró, whose semi-abstract paintings of vegetal and animal metamorphoses impressed him.[33] The tactile eroticism of many of the sleeping nudes recall Picasso's comment to Kahnweiler: 'I want to paint like a blind man, who does a buttock by feel'.[34]

The *Large Nude in a Red Armchair* has also been related to the work of Matisse, but as a form of satire or 'daemonisation' of the decorative diffusion of the older artist's *Odalisque with a Tambourine* 1926 (Museum of Modern Art, New York). According to this reading the flowers in the background of Picasso's painting are meaningless space fillers – they fail, deliberately, to produce a decorative effect.[35] Another reading sees Picasso responding to the March 1928 issue of *La Révolution surréaliste*, which featured a double-page spread celebrating 'The Fiftieth Anniversary of Hysteria', illustrated with photographs of a 'hysteric' taken in the clinic of Freud's teacher Jean-Martin Charcot. For Breton and Eluard, who wrote the accompanying article, hysteria was by no means an illness but rather 'a supreme means of expression', operating in the mental space of mutual seduction.[36] The adoption of the hysteric's convulsing body, open mouth and head thrown back in rage were here a means for Picasso to achieve another shock effect. In addition, the liquid limbs of his figure borrowed from a painting by another fellow Spaniard, and rising star in Surrealism, Salvador Dalí, whose *Female Bather* 1928 (Salvador Dalí Museum, St Petersburg, Florida) he may personally have shown to Picasso.[37]

Part of the problem of Picasso's position as a Surrealist is once again his determination to construct his own 'Picasso' story. His prominence in *Minotaure* during 1933 led to his later insistence that he was a Surrealist only at that point, his deeper involvement in the movement a result, he claimed, of the stress of his deteriorating relationship with Olga Khokhlova.[38] Thus he forced the narrative of his work back on his own personal circumstances. Or at least up to a point: even in 1955, when he made this claim, he still did not mention his mistress of the period, Marie-Thérèse Walter, whom he had met outside the Galeries Lafayette department store on 8 January 1927 and who had borne him a daughter, Maya, in 1935. The opposition of Khokhlova and Walter has been cited as the reason for the swings between intense eroticism and violent

33
*Large Nude in a Red
Armchair* 1929
Oil on canvas
195 x 129
Musée Picasso, Paris

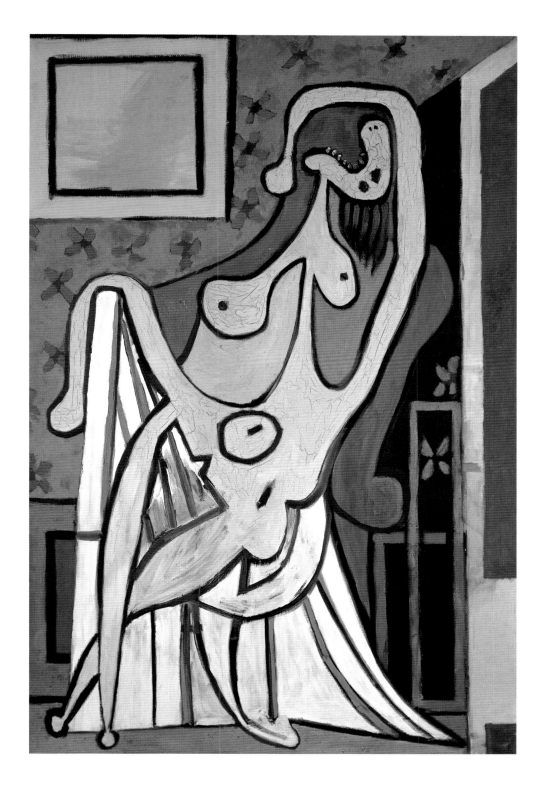

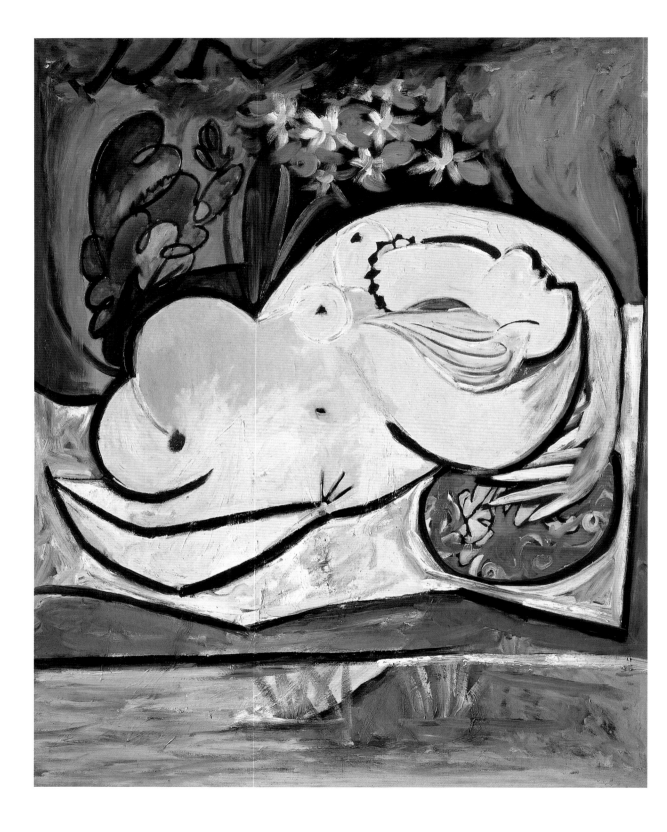

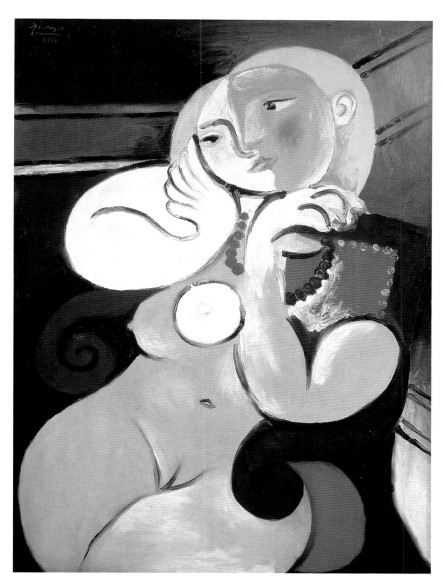

34
*Female Nude in a
Garden* 1934
Oil on canvas
162 x 130
Musée Picasso, Paris

35
*Nude Woman in a
Red Armchair* 1932
Oil on canvas
130 x 97
Tate

hysteria in his Surrealist representations of the female figure. The superficially compelling nature of these identifications of the two figure-types – on the one hand the sickly, skinny and increasingly resented *beau-monde* wife, and on the other the virginal, pneumatic blonde mistress – does little to open our eyes to Picasso's achievement, however. Instead, it resists interpretation and fixes it forever in relation to certain 'events' or 'facts'. So it is claimed that after Khokhlova spent months in and out of a clinic in late 1928, her return home in early 1929 was the inspiration for the frenzied grotesquery of *Large Nude in a Red Armchair* (fig.33).[39] Yet we know that Picasso had been planning a large painting of a nude in an armchair in sketchbooks of 1927, so Olga's particular condition in 1929 can hardly have prompted the painting.[40] The 1934 painting (fig.34), when viewed as a direct representation of Marie-Thérèse, becomes fixed as an image of her fecundity, as if the spectator could be privy to the erotic intensity that preceded the conception of Maya in December 1934.

Whether or not we view *Large Nude in a Red Armchair* as a complex response to Matisse, Dalí and the Charcot 'hysteric' photographs, or as an exorcism of Khokhlova's depressive rages, there is no doubt that the monstrous deformities Picasso achieved in the painting were recycled in very different contexts, both pictorial and intellectual, over the next few years. The figure appears in two further striking works: *Crucifixion* and *Woman with Stiletto*.

The *Crucifixion* (fig.36), unlike *Large Nude in a Red Armchair*, is a small painting and, like portable religious works of the medieval and Renaissance eras, is painted on panel rather than canvas. The painting invites detailed scrutiny and summons biblical and apocryphal texts to aid the process. Some figures are not easy to identify; others can be recognised by their context. On the cross in the centre is the bulb-headed figure of Christ. Beneath him is a harridan with the same vacant scream as that emanating from the red armchair. To the left the shrunken figure of a soldier nails Christ to the cross, while from some impossibly distant hillock a mounted soldier spears his side. On the far left is an enormous, strange-headed or helmeted figure often described as a centurion. A red bird flies down and away to the far left. Below the centurion are prone bodies, presumably of the thieves crucified alongside Christ. Two soldiers throw dice on a drum in the centre foreground, casting lots for Christ's robe. On the far right is another disproportionately large figure, mantis-headed and cloaked, possibly one of the Three Marys, with yellow arms raised high, perhaps in mourning. A sun/moon-faced creature is tucked under Christ's arm, a profile and head outlined in red with a yellow triangle suggesting, perhaps, the volume of the head. Further to the right is a most bizarre yellow figure with two neat yellow feet, multicoloured fringing and an oddly shaped red centre containing dotted features like those of Christ. Overall, the virulent colour highlights the blankness of

the white hybrid of Christ and shrieking Mary, which has been identified as Christ's mother, the Virgin Mary.[41]

The *Crucifixion* project started in earnest with drawings in mid-June 1929, although Picasso had drawn an extraordinary naked female figure on sheets dating from 25 May (fig.37), sometimes considered the offspring of the falling, semi-conscious acrobats that he had painted earlier that year (for example *Acrobat*, 19 January 1930; Musée Picasso, Paris). This figure disappears in the painting, but compositional drawings show that she occupied a position at the foot of the cross, her hands grasping at Christ's body. Overcome by anguish and sorrow, she arches her back, to drop her inverted head as if about to collapse or somersault endlessly backwards down the hill of Golgotha. The sexuality of this figure suggests that she is Mary Magdalene. The link between this figure and the normal position of the Virgin Mary provokes doubts as to the identification of the ghostly paroxysmal mourner beneath Christ: could she be the Magdalene in another guise? On closer examination, the integrity of some bodies unravels: legs are hard to allocate to a particular figure, colour unbinds space (sky blue on the extreme left; fiery red on the extreme right; the same colours disrupting the mass of the bodies as they thread through yellows and pallid greens), just as the biblical incidents represented unbind narrative unity. Searching for clues as to theological identities and events, historians have drawn attention to potential sources,

both visual and textual, that might unlock the significance of Picasso's enterprise. In 1969 Ruth Kaufmann connected the sun/moon-faced figure with that of the Roman god Mithras, an identification that has been widely taken up, since it offers a connection between compositional drawings for the *Crucifixion* (featuring a bullring) and the anthropologically informed discourse of 'sacrifice' that centred on the short-lived Dissident Surrealist journal *Documents*.[42]

Documents ran a special issue subtitled 'Homage to Picasso' in 1930, which included one of Georges Bataille's densely wrought aphoristic notices on the phenomenon of a 'Rotten Sun'. The noonday sun is a symbol of the highest of human aspirations: stare at this sun, however, and the eye is blinded while the mind is blighted with madness. Bataille associates the sun with Mithras the executioner, and the man who is blinded by the sight of this god's glory is linked to the bull, the sacrificial beast that will die under the mithraic knife. Thus 'the summit of elevation is in practice confused with a sudden fall of unheard-of violence'. Bataille's essay ends with a bravura attempt to transfer these ideas to painting, and to Picasso:

It is possible . . . to say that academic painting more or less corresponded to a lofty cultivation of the spirit. In contemporary painting, by contrast, the search for a conclusive rupture in this elevated culture, and for an almost blinding revelation, has a part to play in the creation or in the decomposition of forms. This search is truly perceptible only in the painting of Picasso.[43]

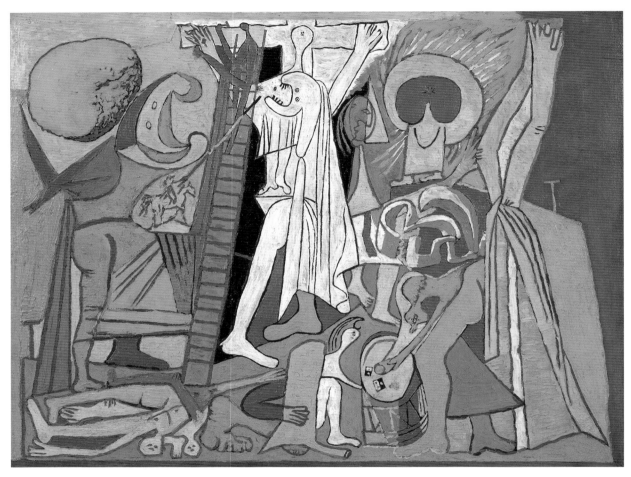

36
Crucifixion 1930
Oil on panel
51.5 x 65.5
Musée Picasso, Paris

Bataille's essay was published after Picasso's *Crucifixion* was completed, so text must have depended on image rather than vice-versa.[44] Charles Miller draws attention to an earlier Bataille essay, which connects a collapse from the high-minded ideal to low violence to the aberrations of form in Picasso: '... when Picasso paints, the dislocation of forms leads to that of thought, that is to say, that the immediate intellectual movement, which in other cases leads to the idea, aborts.'[45] Miller suggests that the 'dislocation of forms' in the confusing *Crucifixion* ruins thinking and leads to an 'apocalypse of representation'.[46] One notable case in point might be in the white of the central motif, set off against blackness, where the arms of the shrieking Virgin/Magdalene seem to multiply irrationally those of Christ.[47]

The Picasso illustration facing Bataille's 'Rotten Sun' in *Documents* was not the *Crucifixion* but *The Three Dancers*. In the 1960s, when the English Surrealist Roland Penrose was negotiating to buy *The Three Dancers* for Tate, he suggested to Picasso that the two works were closely connected. The central figure in *The Three Dancers* adopts a crucified pose, and there is ambiguity in the figuration of the dancers that presages the uncertainty of the later picture. Leiris and Bataille viewed the figure of Christ as just one example of a self-sacrificing god of the kind that was central to the anthropology of James G. Frazer's *The Golden Bough*, a text they both admired. Leiris and Picasso were close in this period

and, just as Breton's juxtaposition of *Les Demoiselles d'Avignon* and *The Three Dancers* in 1925 must have changed Picasso's relationship to his earlier work, the publication of *The Three Dancers* in 1930 alongside Bataille's incendiary prose altered the significance of that work in turn. (The *Crucifixion* remained a silent partner, unillustrated in *Documents*, but it was exhibited two years later in a retrospective that travelled from Paris to Zurich.) The *Documents* 'Homage to Picasso' was the result of a battle in 1930 between those loyal to Breton's Surrealists and the group that gravitated to Bataille, including Robert Desnos, Leiris, Masson (all recently excommunicated by Breton) and Miró. This tug-of-war over Picasso was only an aspect of mutual invective regarding the politics and aesthetics of the opposing group.[48] One dimension of the conflict was Bataille's description of Breton as a romantic idealist, and Breton's equally limited caricature of Bataille as a lover of all things gross, vile and faecal.[49] Bataille certainly embraced what he called a 'base materialism', but with the intention of disrupting received linguistic metaphors for all forms of knowledge and moral truth. Just as his 'Rotten Sun' might have been inspired by Picasso's *Crucifixion*, so his text 'Mouth', published in mid-1930, seems to echo the feral *Large Nude in an Armchair*:

... terror and atrocious suffering turn the mouth into the organ of rending screams ... the overwhelmed individual throws back his head while frenetically stretching his neck in such a

37
*Crucifixion study: Mary
Magdalene* 1929
from sketchbook 38,
folio 41r
Pencil on paper
23.5 x 30
Musée Picasso, Paris

way that the mouth becomes . . . an extension of the spinal column, *in other words, in the position it normally occupies in the constitution of animals.*[50]

The bestial scream appeared again in Picasso's work at the end of 1931. His *Woman with a Stiletto (Death of Marat)* (fig.38), finished on Christmas Day 1931, is clearly inspired by Jacques-Louis David's great painting, *Death of Marat* of 1793 (Musée des Beaux-Arts, Brussels) and its poorer second version in the Louvre. The Brussels painting was exhibited in Paris in the spring of 1928, but Picasso would have known it through countless reproductions.[51] David's painting depicts the moments after Charlotte Corday, a royalist from the provinces, has stabbed the Jacobin radical Marat in the chest; his parted lips and the quill and papers dropping from his fingers make it clear that we witness the moment at which he gives up the ghost. There is a majestic and terrible darkness above him. Picasso's version of the scene is in striking contrast. In a modest, raftered room Marat lies in his bath, holding the same letter and quill, while a slug-like Corday, adopting the form of Picasso's armchair monster and biblical Mary, oozes through the green door and fills the room with a terrible shriek, her hair standing on end. She nails Marat, a pinheaded, big-footed blank whose blood snakes absurdly round the corner of the room. A French flag hangs over the end of the bath.

Just as David contrived the pose of his Marat and the sublime space above him to recall the Christ of the Lamentation, Picasso revisits his own parodic *Crucifixion* with the two central characters now replaying their roles in a modern (political) version of sacrifice. David's political sublime is certainly 'brought low': his transfiguration of Marat as the Christ of the People is parodied with hysterical and bestial violence, now in a claustrophobic setting. This debasement of the revolutionary masterpiece is also a ruination of the founding myths of the French Republic: violent irruption replaces metaphor. 'History' is disfigured.

Bataille's writings in *Documents*, and the illustrations that accompanied them, illuminate many other instances of Picasso's disfiguration. A 1930 essay on eighteenth-century prints of anatomical anomalies entitled 'The Deviations of Nature' showed Siamese twins with doubled faces and prompted the idea that even a notionally normal bodily form 'escapes [the] common measure [of Classical beauty] and is, to a certain degree, a monster'.[52] In his piece entitled 'Human Face' of 1929 Bataille contemplates a wedding photograph of 1905 and finds in it 'acute perturbation of the human mind' that negates 'the existence of human nature'. For Bataille, in vernacular portrait photography 'the human form stands out as a senile mockery of everything intense and large conceived by man'.[53] Throughout the 1930s and into the 1940s Picasso winkled deformity out of the everyday in paintings such as his 1939 *Head of a Woman* (see fig.27), but also in drawings and even such spontaneous doodles as a

38
Woman with Stiletto
(*Death of Marat*) 1931
Oil on canvas
46.5 x 61.5
Musée Picasso, Paris

39
Ouvrières au travail
(*Women Factory Workers*)
1941
24.5 x 18
Pencil on newspaper
Musée Picasso, Paris

Bataillean disfiguration of two newspaper photographs of 1941 (see fig.39).

In the absence of a convincing ideal of human nature, proportion and beauty, the monstrous and the Classical were for Picasso mere modes for the expression of the immeasurable nature of the human, a symptom of the gulf between the false idealism of the human self-image and the 'deviations' of actual appearance. His 'deviations' from human form in turn suggest the bankruptcy of notions of a common humanity or of a god-given 'moral' existence. His late paintings of figures dressed as 'Musketeers' (fig.40) were, according to a contemporary catalogue, images of the profound essence of mankind.[54] Any such universalising and humanist claim is mistaken: Picasso's monstrous idiom here harks back to a Surrealism that is also a derailing of such versions of 'reality'. If Bataille found 'acute perturbation' in portrait photography, the gigantism of the 'Musketeers' and their looming features reflects Picasso's fascination with film and television close-ups, where the face of the 'star' is both sublimated but also strangely, menacingly distended.

Surrealism inspired Picasso's disfigurations of the late 1920s and 1930s, and it also made him pay renewed attention to non-Western cultures. But most strikingly, perhaps, it forced him to reflect upon the nature of his contribution to the understanding of humanity. One symptom of this was his practice, from

1928 onwards, of giving the exact date of completion of his works, and sometimes, as in *Woman with a Stiletto*, the commencement date as well. The motive for this precision was, he told one interviewer in 1932, the acknowledgement that his work 'is a way of keeping a diary'.[55] This statement borrows an idea from the 1930 'Homage to Picasso' in *Documents*, where Louis Pierre-Quint wrote that Picasso's canvases, when viewed in the sequence they were painted, 'form the diary of a dramatic life by a possessed painter'.[56] Such an idea has often been invoked to support the biographical reading of Picasso's work: *Woman with a Stiletto* invokes Picasso's attitude to Khokhlova over Christmas 1931, for example, while another work of 22 January 1932 (*Repose*, Private Collection, New York) is even cited in evidence, as a reliable record, of specific bouts of her illness and attendant rages.[57] But close attention to Picasso's extended discussion of the diary metaphor suggests a different meaning altogether. In 1943 he explained his thinking to Brassaï:

Why do you think I date everything I do? Because it is not sufficient to know an artist's works – it is necessary to know when he did them, why, under what circumstances . . . Someday there will undoubtedly be a science – it may be called the science of man – which will seek to learn more about man in general through the study of creative man. I often think about such a science, and I want to leave to posterity a documentation that will be as complete as possible. That's why I put a date on everything I do.[58]

The language of this statement is redolent of Picasso's friendship with Leiris, the editorial assistant on *Documents* and close ally of Bataille. As Christopher Green has argued, the idea of a 'science of man' echoes the development of modern social anthropology and the renaming and reinvention in 1937 of the Trocadéro museum as the Musée de l'Homme (Museum of Mankind), a project in which Leiris again was a participant.[59] More importantly, Leiris engaged Picasso as a critic of his own diary, ostensibly an autobiography but one couched in terms not of the transparency of desire, dream, and confession, but rather acknowledging that all desires, dreams and confessions stand in need of an allegorical figuration to make them cohere. In his diary, published in 1939 as *L'âge d'homme* (*The Age of Majority*) Leiris chose two paintings by Cranach the Elder (of *Lucretia* and *Judith*) to stand in place of coherence of the self. Picasso's 'diary' is full of allegories: of minotaurs, Christ, Harlequin and Marat, for example. But Picasso wanted these allegories to point to the *problem* of human being, and of the self – problems raised by Bataille, Leiris, and indeed by Breton (who famously asked at the beginning of his novella Nadja, 'Who am I?') – rather than the 'life story' of Pablo Picasso.[60]

In the case of a picture of such potency as *Weeping Woman* (fig.41), painted on 26 October 1937, there is no question of ignoring the fact that it draws upon a portrait type that Picasso identified with his

40
Seated Musketeer with Sword 1969
Oil on canvas
195 x 130
Maya Ruiz-Picasso Collection, Paris

new lover, Dora Maar. Indeed, Maar herself acknowledged this when, in one of several similarly remarkable acts of resistance, she reappropriated it, painting her own unfinished version and signing it at top right in bold green letters.[61] However, the terms of Picasso's identification are again worth pausing over: 'For me [Dora Maar] is the weeping woman', he said. 'For years I gave her a tortured appearance, not out of sadism, and not without any pleasure on my part, *but in obedience to a vision that had imposed itself on me*.'[62]

Such visions 'impose' themselves, of course, on a 'possessed painter', an artist who is, in his work, already several selves: a fragmented self. The *Weeping Woman* compresses strange metaphors from over thirty-six paintings and drawings on the theme, made during the course of the preceding months in the context of the development of *Guernica* (see fig.46). The subject's face shudders and refracts in a layering of conceits: eyes cupped in toy boats from which tears overflow, or perhaps prised from their orbits by a spoon whose handle is also the tear contouring the cheekbone. The eyes teeter on the two peaks of the white handkerchief formed by the fingers underneath. Her sharp fingernails are at the same time blue-white tears. The vibrancy of complementary colours – orange and blue, purple and yellow – pushes this grimace towards us and heightens its intensity. Yet the centre of the painting, like that of the *Crucifixion*, falls into photographic monochrome. *Mater Dolorosa*, Our Lady of

Sorrows, sits against the wood panelling and dado rail of a Paris café or a dingy flat. The corner to the right is kinked space; every element of the woman corrugates, deploying that visual armoury first developed for *Les Demoiselles d'Avignon* (a black jacket with stitching crystallizes; a hat with a flower prickles; a forehead buckles).

The *Weeping Woman* was bought directly from the artist, the paint scarcely dry, by Roland Penrose. In 1938–9 it toured England with *Guernica* and its related studies, appearing in London, Oxford, Leeds and Manchester, and finally in London again at The Whitechapel Art Gallery. The woman's tears evoked the suffering of Spain, but they could not stop more bombs from falling.[63]

41
Weeping Woman 1937
Oil on canvas
60.8 x 50
Tate

Three Women

If *Les Demoiselles d'Avignon* remained little known for many years (until 1939, when it was bought by the Museum of Modern Art, New York), this is even more true of a second major work of the period, *Three Women* (fig.42). The painting was shown in Paris in 1954 in a remarkable exhibition of Picasso's Cubism, alongside his most recent work, but not again in the West until after 1970. Until then hardly published and not known by a wider public until after 1980, when the Museum of Modern Art, showed it at a major Picasso retrospective, the work was a victim of Cold War politics. *Three Women* languished in the Hermitage Museum, having been expropriated by the Soviet government from its second private owner, the Russian collector Sergei Shchukin, during the Russian Revolution. Before this the painting was bought directly from Picasso by Gertrude and Leo Stein some months after its completion.

At 2 metres tall the painting is an ambitious sequel to the *Demoiselles*. At first glance it is another depiction of life-size nude women in an oppressive space, with similarly angular raised elbows, disporting poses similar to those in the earlier painting. But gone are the strong pinks and blues, the Medusa eyes and the monstrous faces. Instead Picasso works here in rich brown, burnt umber, rusty orange, and grey-green.

He began this work in late 1907 but left it for a while before embarking on two further campaigns of work on it in the spring and then the summer of 1908. The first state of the picture, known from a photograph of André Salmon standing in front of it in the Bateau-Lavoir, was closer in style to the *Demoiselles* – more 'primitive' and with stronger contrast. During the second phase of work Picasso considered expanding the composition or starting a new painting altogether, placing the three figures in or partly in a boat near a river in a forest, on which stand two embracing or interlinked figures (the two figures appear in a painting that was also bought by Shchukin, to which he gave the title *Friendship*). The vestiges of the boat's prow can be seen at bottom right in the final state of the painting,

where Picasso has darkened his picture and unified it with a faceting and colouring that resembles carved wood. It has been suggested that Salmon's 1912 discussion of Picasso's struggles with the *Demoiselles* may have confused the development of the earlier painting with this one, particularly in the frequent reference to 'geometry', which makes more sense in the case of *Three Women*. Certainly, he seems to have this work clearly in mind when he talks of Picasso composing 'a rich palette for himself, with all the tones favoured by old academics – ochre, asphaltum and sepia – and ... several formidable nudes, grimacing and perfectly deserving of execration'.[64]

So what does this painting show? In an important essay on the painting Leo Steinberg argues that the picture represents the sexes struggling for definition, contending that the central figure is androgynous, a creature yearning for sexual identity, with a male figure on the left and a female figure on the right. The blank eyes signify a lack of self-awareness; the 'masks' are a sign for the 'primitive' in the sense of the primordial forest that gives birth to sexual difference. The striving of the figures on left and right deforms them, allowing them to emerge from an undifferentiated origin in the centre of the composition into their separate identities. More than that, Steinberg argues, the energy of the struggle is that of libido, a sexual energy.[65]

Steinberg called his essay 'Resisting Cézanne', countering the view of William Rubin, who interpreted *Three Women* as Picasso's attempt to come to terms with Cézanne's paintings of bathers exhibited in Paris in 1906 and 1907. Rubin believed that *Three Women* was a crucial painting in Picasso's co-invention of Cubism with Georges Braque, who had engaged with the legacy of Cézanne earlier in 1907. What is at stake in the disagreement is the degree to which Picasso's solution to this painting asserts that the forms demanded by different kinds of human figure or object cannot be subsumed within a homogenising painting procedure (like Cézanne's), or, by contrast, is achieved by absorbing aspects of Cézanne's

42
Three Women 1908
Oil on canvas
200 x 178
The State Hermitage
Museum, St Petersburg

practice (in the merging of planes that make up the composition, as in the thigh of the figure on the right) and blending them with faces and bodies taken from to non-Western art. In support of the latter view, Rubin offers a possible source for the morphology of the central head in masks made by the Fang people of modern Gabon. Seeing Picasso as bringing together here a Cézannean 'method', mediated by Braque, and a sculptural language loosely based on tribal masks, would mean that *Three Women*

sits firmly in the familiar narrative of the birth of Cubism in 1908. The risk here is of seeing a picture in terms of what came after it, of setting it back into a comfortable 'story' of modern art.[66] How Picasso and Braque arrived at what we call Cubism is indeed a long story. Suffice it to say that after *Three Women* it would be more than another decade before Picasso again harnessed disfiguration to libidinal energy – in his painting called *The Three Dancers*.

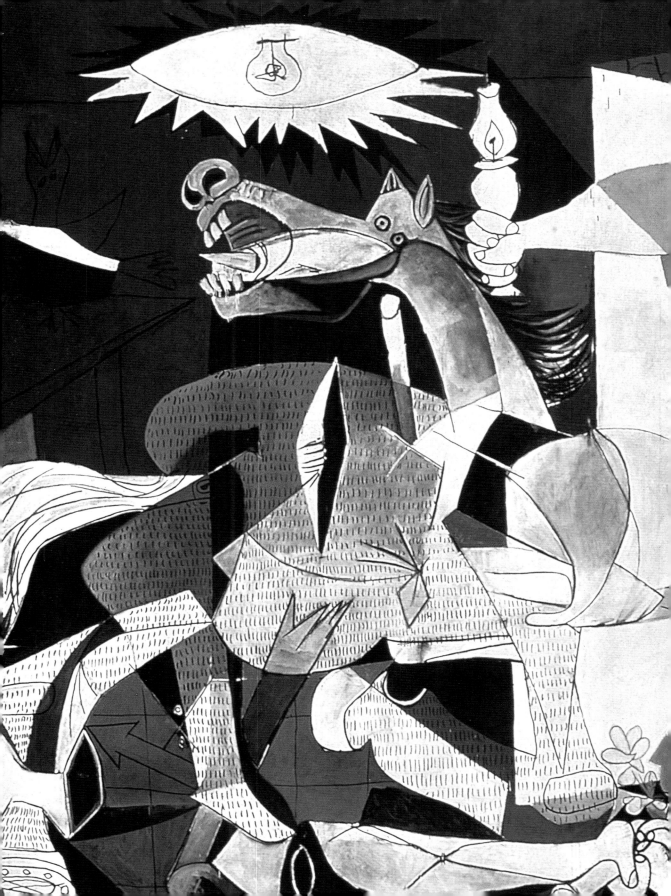

One of the Cubist paintings Breton cited in his discussion of Picasso in *Surrealism and Painting* was a still life from which he remembered the phrase 'VIVE LA' (fig.43). The phrase is part of a rebus, where crossed tricolours stand for 'France', which appears on a white (souvenir?) wine glass: 'VIVE LA FRANCE'. Picasso made this work in late 1914, mixing sand into his oil paint to heighten texture while, perhaps, enhancing the effect of collage. The painting belongs to a phase in Picasso's Cubism where parodies of collage coexisted with nods in the direction of *trompe-l'œil* (as in the playing cards, and the painted wallpaper and dado patterns) and pointillism. This period coincided with the beginning of the First World War; it is unclear, however, whether the jauntily patriotic glass with its nationalist slogan is an expression of support for the French war effort or a playful embrace of the rebus as a comparator for the bottle of rum (LA NEGRITA) next door.

Picasso sometimes doodled patriotic slogans on letters to Apollinaire and to Salmon, who were fighting at the Front, yet his work during the First World War can hardly be said to be notably patriotic or militaristic – indeed, during this period he avoided making political or national statements in his art.[1] (It has been argued that he took anarchist ideas seriously in his youth in Barcelona, and that these informed aspects of his Cubism, but the evidence for this is at best inconclusive.[2]) The situation was very different between the mid-1930s and the early 1950s, however, when Picasso became involved first as a supporter of the Republican side in the Spanish Civil War, then as a tacit critic of Nazi occupation and the Vichy government, and finally as a signed-up Communist. During these years Picasso frequently took moral and political positions in his art and as a public figure, which presented certain problems as he attempted to make his art unambiguously political, socially engaged or 'committed'.[3]

He was led to political awareness partly through his involvement with Surrealism: his first political act was to sign a petition supporting Louis Aragon against a conviction for incitement to violence in his 1931 poem 'Red Front'. The real turning point, however, the event that politicised Picasso, was the Spanish Civil War, which broke out on 17 July 1936. Socialists and Communists from across Europe and North America travelled to Spain under the aegis of 'International Brigades', formed with the support of Joseph Stalin, in order to defend the newly elected Popular Front Republican government against the right-wing Nationalists. During the summer of 1936, when the Nationalists already held one third of the country, efforts became focused on Madrid, and a siege began that lasted three years. The siege of Madrid began with bombing raids in August. It was at this point, in September 1936, that Manuel Azaña, the Republican President, asked Picasso to become an honorary director of the Prado Museum, using the artist's international profile as a form of propaganda against the cultural vandalism

4 Histories of Bombing

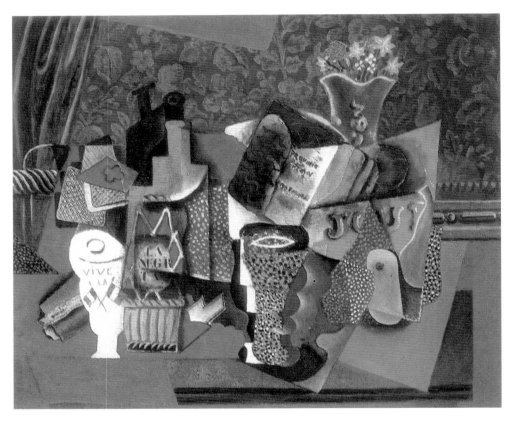

43
*Playing Cards, Glasses,
Bottle of Rum ('Vive la
France')* 1914–15
Oil and sand on canvas
54 x 65
Leigh B. Bloch Collection,
Chicago

of the Nationalist army. Having been worried about his family in Barcelona, Picasso was thus gradually drawn into the war as a political participant, eventually helping to arrange for the Prado's collection to be moved out of Spain to Geneva for safekeeping.

Central too to Picasso's politicisation were his relationships with two key individuals, Paul Eluard and Dora Maar. Although Eluard had known Picasso since the early 1920s, it was only in 1935 that they became close. In May 1936 Picasso dedicated two of his poems to Eluard, inscribing them on a copper plate and decorating them with etched figures. Eluard wrote his optimistic love poem 'Grand Air' ('Open Air') on another plate and Picasso again added figures, producing, with the help of his master printer Lacourière, a new form of collaborative print. As their friendship developed over the summer Eluard began to write poems dedicated to the artist, and in November that year, when Eluard took the step of publishing a poem designed to agitate in favour of the Republican cause in Spain, the two men entered into a period of intense exchange. The publication caused a rift with Breton, who opposed the co-option of art by politicians, even while, as a polemicist, he railed vigorously against the Moscow 'show trials' and campaigned for French intervention in the Spanish Civil War. At the end of 1936 poet José Bergamín visited Paris and told Eluard and Picasso of the terrible events in Spain that he had witnessed first-hand as a combatant.

Photographer and artist Dora Maar (1907–97) was active in radical leftist groups in the early 1930s.[4] Her liaison with Picasso lasted from autumn 1936 until 1943, and it was she who made the detailed photographic record of the making of *Guernica*, and whose features prompted aspects of the *Weeping Woman* series (see fig.41). When Eluard introduced her to Picasso in the autumn of 1935, Maar was already immersed in radical politics: she was a signatory of the 'Call to Arms' issued by Breton and Eluard in response to the extreme right-wing demonstrations of 6 February 1934, and a member of the left-wing October Group of actors and writers whose objective was to bring theatre to working-class audiences. The October Group rehearsed in a vast attic on the rue des Grands Augustins, the meeting place the following year for another radical group of which Maar was a member, Contre-Attaque ('Counter-Attack'), formed in October 1935. In January 1937 Picasso moved here from his studio in rue de La Boétie, having surrendered the Château de Boisgeloup to Olga Khokhlova under the terms of their separation.

It was against this background that Picasso made one of his most inventive works of satire: two prints called *Dream and Lie of Franco* (figs.44, 45). They were originally conceived of as a series of postcards that could be sold individually in aid of the Republican government, but in the end the prints were issued in an edition of 850, accompanied in a portfolio by a colour lithograph of a prose poem by the artist.

44
Dream and Lie of Franco (*I*)
1937
Etching and aquatint on
Montval, edition of 850
31.7 x 42.2
Musée Picasso, Paris

45
Dream and Lie of Franco (*II*)
1937
Etching and aquatint on
Montval, edition of 850
31.7 x 42.2
Musée Picasso, Paris

Since etchings produce a reverse image when printed, the dates appear in mirror writing. Picasso seems to have drawn the nine scenes of the first plate and some of the first five scenes of the second on 8 January 1937 (this date appears top centre on both plates), and the remaining first five scenes of the second plate on 9 January (dated bottom right), leaving the remaining four compartments on the second plate blank. The sequences etched on those two days were then shaded using aquatint. The second plate was completed on 7 June 1937; these four scenes are unshaded and different in content from the preceding fourteen.

The scenes read from right to left, in rows. The first scene of plate 1 shows a grotesque creature riding a smirking, disembowelled horse and carrying a sword and a banner with a picture of the Virgin. This monster is Franco, recognisable from his absurd moustache. The following scenes depict his exploits during the early phase of the Civil War, and refer to the ideology of Falangism, the Spanish Fascism founded in 1933 that Franco co-opted and combined with other right-wing symbols and prejudices. In the second scene the Franco-monster is virile, able to tightrope walk with the aid of a harnessed cloud. His fez is a reference to Franco's command of Moroccan mercenaries in African legions of the Spanish army. Sporting a bishop's mitre in the third scene, Franco destroys a Classical statue with a pickaxe, a reference to the bombardment of Madrid and the damage to the Prado. His exploits in subsequent scenes draw

on a Spanish literary tradition, including the work of seventeenth-century writers Cervantes and Caldéron, and Goya's print series *Caprices* and *Disasters of War*: indeed, Picasso's title adapts a popular Spanish saying from Calderon, 'In this life all is truth and all lies', making it unclear whose dream we see – Franco's or the artist's.[5] Franco is exposed not as a superman but a monster raping Spain, his fantasies of power and his lies laid bare. However, Picasso may even have meant that both dream *and* lie are the artist's: in an interview of 1923 he stated that 'Art is a lie that makes us realise truth'.[6]

The reason why Picasso left the second plate unfinished on 9 January 1937 is not known. He finished it in June, after an intense period of work during which he painted *Guernica* (fig.46). That same January he had been approached by a delegation, including architect Josep Lluis Sert, Spanish cultural commissioner Max Aub and Louis Aragon, seeking to commission a large painting for a Republican pavilion at the forthcoming World's Fair in Paris. The pavilion was intended to show that the Republican government was the true representative of Spain, its people and its resources, and to celebrate the heroism of Spanish farmers and workers and the resistance of Republicans to the threat of Franco. Artists already engaged in the project included Miró, film-maker Luis Buñuel and sculptor Julio González (see Chapter 5). Picasso does not appear to have begun to think about this commission until early April, working instead on portraits of

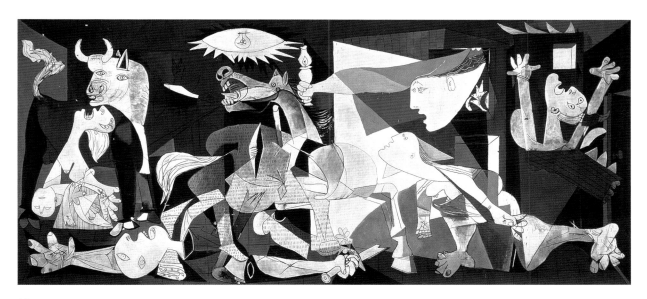

46
Guernica 1937
Oil on canvas
349.3 x 776.6
Museo Nacional Centre de
Arte Reina Sofia, Madrid

his mistress Dora Maar, and more private paintings and drawings of Marie-Thérèse and his daughter Maya, who were by now installed in a house and studio at Le Tremblay-sur-Mauldre to the west of Paris.

His first ideas for the pavilion, sketched at Le Tremblay on 18 April, were for a painting of an artist and model; the following day he considered adding a raised arm clutching a hammer and sickle, a crude political gesture in the direction of Popular Front imagery. He did nothing more until 1 May when, back in Paris, he was galvanised by horrifying news of the brutal destruction of the Basque town of Guernica by German bombers. On 26 April 1937, in the course of three and a half hours, 52 bombers released 70,000 kilos of explosives over Guernica, while fighter planes strafed people running from the town. After an initial bomb run and the machine gunning, a second run released incendiaries that left the town in flames. For a week after the bombing, Picasso read newspaper accounts and studied black-and-white photographs of the desolation, the same reports that inspired the largest May Day demonstration in Paris for years. His reaction, that afternoon, was to make a sequence of sometimes deliberately crude drawings on cheap blue paper. The third drawing (fig.47), in a sequence of over sixty drawn and painted studies executed throughout May and into early June, shows how he used his existing repertoire of imagery as a means of expression in this entirely new context.[7] The woman leaning out of a building at top right, holding out a lamp or candle with her extended arm, combines the standing candle-bearer and the women gazing down from a window in *Minotauromachia* (see fig.5). The scene this angel illuminates is a hellish chaos: three deformed equines and a child (as drawn by a child) occupy discrete spaces, the two horses on the left and the child collapsing as they spill their entrails. The motif of the disembowelled horse, also visible in *Minotauromachia* and *Dream and Lie of Franco*, frequently appeared in Picasso's Surrealist bullfights of 1933–4, which drew on a fascination with the sacrificial, sometimes eroticised dynamic of bull, horse and toreador.[8]

Picasso began work on the largest canvas he had ever attempted single-handed in the attic of rue des Grands Augustins on 11 May.[9] Dora Maar photographed the initial charcoal sketch on the canvas that day and took many subsequent photographs over the next three weeks, representing roughly ten distinct stages in the evolution of the painting, capturing moments in the artist's struggle to resolve *Guernica*.[10] The photographs comprise a remarkable document of various stages and adjustments, the artist moving the horse's head from low position to its final upward strain between third and fourth stage, applying patterned wallpaper to figures between stages five and six, some alterations being evolutionary and some sudden *volte-face*. Picasso told Sert to collect the painting for the Pavilion on 4 June, still uncertain as to whether or not it was finished.[11]

47
Guernica Study III 1937
Pencil on blue paper
21 x 26.8
Museo Nacional Centre de
Arte Reina Sofia, Madrid

In describing *Guernica* it is important to say what it does not show: bombers delivering their payloads or fighter planes spitting bullets, or even identifiable monuments of the Basque town. Instead there are bodies, upstretched arms and heads tilted back in unbearable pain, a burning building and a tiled floor, the blinding light of an electric lamp. The near-monochrome of the painting (the blacks, greys and whites are subtly tinted) was perhaps a response to the need to make the painting leap into view *in situ* (fig.48) against the visual disturbance of Alexander Calder's *Mercury Fountain* and the open-air auditorium, complete with living tree, in the same area.[12] But it also suggests a deliberate return to the high austerity of Cubism's best years, while at the same time resonating with the black-and-white mediation of the bombing's aftermath in grainy newsprint. Just as with *La Vie*, the implication of an allegory (made by lighted candle, the presence of the bull, the horse and the bird between them) and the artist's self-conscious resort to the effects of grand history paintings of violent events has inspired many different interpretations of *Guernica*. In 1969 Anthony Blunt described it as a modern Massacre of the Innocents.[13] Its stage-like space and vestige of ancient Rome in the broken sword in the centre foreground have been linked with Cervantes's tragedy *The Siege of Numancia*, staged during the weeks in which Guernica fell and Picasso first sketched his ideas.[14]

Two key issues remain that have dogged *Guernica*'s reception from the outset: its achievement as a work of art and its status as a political painting. Picasso's drawings were exhibited with the painting on its fundraising tour. Among Maar's photographs, already published, were two showing that between the second and third major states Picasso had removed a vertically raised arm with clenched fist. He could not persist with this kind of political symbolism; his painting was to be political simply by historical context. But the title, Picasso's own, begs the question: how does this painting represent the destruction of Guernica? Juan Larrea, poet and information minister for the Spanish Embassy in France, later confessed that the government felt that *Guernica* was not specific enough in its propagandist mission, and that its sublimation of the bombing as a human tragedy lacked political effect.[15] A much more forceful version of this view came from Anthony Blunt in 1938, describing the work as 'the expression of a private brainstorm which gives no evidence that Picasso has realized the political significance of Guernica'. He then accused Picasso of producing a vague painting incomprehensible to working-class people who did not have the leisure to study it.[16] He was countered by English Surrealist Herbert Read, who considered *Guernica* 'a modern Calvary' comparable to the work of a Van Eyck or a Bellini, but appropriate to an age 'of disillusion, despair and destruction'.[17]

In May 1937 Picasso sent a telegram to New York in support of a sale of Republican

posters organised by the Spanish Refugee Relief Campaign:

The Spanish struggle is the fight of reaction against the people, against freedom. My whole life as an artist has been nothing more than a continuous struggle against reaction and the death of art. How could anybody think for a moment that I could be in agreement with reaction and death? When the rebellion began, the legally elected government of Spain appointed me director of the Prado Museum, a post which I immediately accepted. In the panel on which I am working which I shall call *Guernica*, and in all my recent works of art, I clearly express my abhorrence of the military caste which has sunk Spain in an ocean of pain and death . . .[18]

The very fact that Picasso's painting generalises his 'abhorrence of . . . pain and death' caused by the unleashing of mechanised warfare on civilians subsequently turned it into a symbol of resistance for various anti-war groups and protests, into the twenty-first century.[19] Indeed, its political dimension is arguably more effective now than it was in 1937. As one recent book puts it, 'not for nothing will the century go down to posterity as that of Picasso', since 'bombing is a constitutive feature of modern life'.[20] Its very abstraction as a political statement means that *Guernica* responds effectively to contemporary politics and military interventions, condemning industrialised brutality with authentic imagery of a bleak European history. Picasso understood the potency of his work as a

48
Pablo Picasso's *Guernica* in situ in the Spanish Pavilion, Paris World's Fair, 1937
Frances Loeb Library, Harvard Design School

means to embarrass Franco's government, and in 1969 he re-stated his view that *Guernica* could only return to Spain once a democratic republic was restored.

But what of *Guernica* as a work of art? Picasso referred to his wall-sized and site-specific work as a 'panel', thinking perhaps of French public buildings where large-scale canvases were pasted onto board or onto a wall (*toile marouflée*). Alfred Barr, mindful of the politicised work of the Mexican muralists Diego Rivera and David Alfaro Siqueiros, of which Picasso was aware, called it a 'mural' in 1939. Among its mural characteristics are the frieze-like composition and related shallow pictorial space, and its strong, graphic character. The painting's muddling of a composition of violent action with the dominant but incongruous bull and horse seem to some critics the confused product of Picasso's attempt to make official art, combining elements of his artistic vocabulary and favourite subjects in the format of a grand history painting.[21]

Picasso's *Guernica* problem – making a modern art that could also address contemporary events and incite resistance to oppression of all kinds – did not go away in the following years. Almost immediately after handing over the painting to Sert he took up the second plate of *Dream and Lie of Franco* and finished it, etching four pared-down scenes, a weeping woman followed by three variants of mother and child victims (see fig.45). A week later he began the prose poem that would accompany the prints.[22] It

is written in Spanish in a style that mixes an unpunctuated stream of consciousness with a flood of bizarrely juxtaposed images, a form of writing that appeared a vivid form of Surrealist automatism. The opening images seem to describe the Franco monster, but the text concludes with imagery directly related to the silent screams that fill *Guernica*:

 – the light covers its eyes in front of the mirror that apes it and a piece of nougat of flames bites the lips of the wound – cries of children cries of women cries of birds cries of flowers cries of wood and rocks cries of bricks cries of furniture . . .[23]

When it was first published at the very end of 1935, Picasso's poetry had been fêted by Breton in the pages of the magazine *Cahiers d'Art*. In the same issue Georges Hugnet suggested that 'Picasso knows, we all know, that we shall be among the first victims of Fascism, of French Hitlerism. That movement does not underestimate us'.[24] For Picasso, at least, this turned out not to be true. The years after *Guernica* saw him return to smaller works with intimate personal subjects, 'portraits', nudes and still lifes, painted in many different locations as he moved back and forth between Paris, Le Tremblay, and summers in the South of France. Some impressive *memento mori* still-life paintings featuring bulls' heads were painted in response to the death of his mother in January 1939 (he would resort to the same subject twice in April 1942 after Julio González died). His *Night Fishing in Antibes* (Museum of Modern Art, New

York), a large canvas painted in the Côte d'Azur during the summer of 1939, is often interpreted as an augury of the war.[25] When the Nazi-Soviet non-aggression pact was signed late that same summer, he headed back to Paris to arrange for his work to be stored in a large safety deposit room in a major bank.[26] The outbreak of the Second World War saw him partly in Royan on the Atlantic coast, with Marie-Thérèse Walter and Maya; by then Maar and Walter had been forced into an uneasy personal accommodation by Picasso's refusal to deal with emotional conflict. In Royan Picasso bought sheeps' heads to feed his Afghan hound, and these formed the centrepieces of a number of harrowing still-life paintings. In 1940 Picasso had to secure a residence permit to remain in Royan, and in this period of misery prompted by the seemingly relentless advance of Germany and its allies he painted a 'repellant' female nude, *Woman Dressing her Hair* (Museum of Modern Art, New York), a picture often interpreted as a testament to the Phoney War.[27]

In August he returned to Paris with Dora, where he remained for the rest of the war, in the rue des Grands Augustins in the Nazi 'Occupied Zone'. He retained his apartment in rue La Boétie, which became a refuge for various friends. The circumstances were dire: Paris was occupied on 14 June 1940 and France signed an armistice with Germany a week or so later, after which a notionally neutral French government under Marshall Pétain, based in Vichy, collaborated with its policies. Once again – as in the First World War – Picasso was a citizen of a technically 'neutral' country. While no heroic activist in the French Resistance, he was certainly no collaborator. His high profile protected him to some extent, but it also meant that he had to be careful: after all, before the war his work had featured in exhibitions and publications on 'Degenerate Art', as the Nazis termed avant-garde art. Some of his paintings had already been sold off at an auction of 'degenerate art' in Switzerland.

Meanwhile, Picasso's apartment, and the attic studio above it, continued to be a meeting place for writers, philosophers, performers and painters. Here he was able to provide artistic, moral or financial support both to old friends – such as Eluard who joined the Communist-led Resistance in 1942, or Robert Desnos who was to die in a concentration camp in 1945 – and new acquaintances actively engaged in the Resistance effort. *Guernica* was a public declaration of his Republican and leftist sympathies, and any further gesture that Picasso made, such as statements and publications (since he was unable to exhibit at this time) was risky. For those of his associates who were committed opponents of the Nazis, life under the Occupation was full of moral paradoxes: effective resistance often meant double agency, getting close to the enemy.[28]

Picasso's work during the war swung between extremes of burlesque and great seriousness. In 1941 he wrote a farcical play, *Desire caught by the Tail*, which was performed as a reading in March 1944 by

an illustrious cast including Albert Camus, Simone de Beauvoir and Jean-Paul Sartre, while Georges Braque and Jacques Lacan were in the audience. Meanwhile, in these first grim years of the German Occupation his deliberate embrace of impoverished materials was evident in sculptures such as *Head of a Bull* (fig.49), and in objects such as incised pebbles, cigarette packets and carved bones. The beamed ceilings of his attic are sometimes visible in 'portraits' such as one of Dora Maar in an armchair (fig.50), another monstrously twisted head painted in the dull colours that he often favoured during these years (see fig.27).

His most important wartime painting was *L'Aubade* (*The Dawn Serenade*, Musée d'Art Moderne, Centre Georges Pompidou, Paris; see fig.66), finished on 9 May 1942, a revisiting of the female artist and female model idea he had abandoned in favour of the subject of *Guernica* in 1937, and a grim mutation of Titian's *Venus and Lute Player* c.1565–70 (Metropolitan Museum of Art, New York). But the simple equation of the 'prison' atmosphere here, or the contorted bodies and monstrous faces of his other paintings during these years, with wartime conditions or experiences is debatable. Picasso himself spoke eloquently on this question:

I have not painted the war, because I am not the kind of painter who goes out like a photographer for something to depict. But I have no doubt that the war is in these paintings I have done. Later on perhaps the historians will find them and show

49
Head of a Bull 1942
Bicycle saddle and handlebars
33.5 x 43.5 x 19
Musée Picasso, Paris

50
Woman with a Hat sitting in an Armchair (Dora Maar) 1941
Oil on canvas
130.5 x 97.5
Kunstmuseum, Basle

that my style changed under the war's influence. Myself, I don't know.[29]

Whatever his own attitudes to the way the war influenced his paintings, those sympathetic to the German occupiers and the Vichy regime saw his work as paradigmatic of the degenerate condition of modern art. In 1942 Maurice de Vlaminck, a former Fauve colleague of Matisse who had for decades been active as a reactionary critic and was now a Nazi lickspittle, unleashed a tirade of abuse:

Pablo Picasso is guilty of dragging French painting into a moral impasse, a state of indescribable confusion. From 1900 to 1930 he has led painting to negation, impotence, and death. For, in and as himself, Picasso is impotence made human . . .[30]

A number of artists and others leapt to Picasso's defence, but his own response seems to have been to begin work on a major sculptural project that asserted his own Classical roots while at the same time offering a humanist vision of suffering and wartime sacrifice. The result, after 100 drawings and a year's work, was the over life-size *Man with a Sheep* (fig.51), originally modelled in clay but almost immediately cast in plaster. The dynamic relationship between the sheep and the man is of course ambiguous: is the man a shepherd bearing his charge to safety, or a priest bringing it to the slaughter? There are echoes of the *Moskophoros*, a Greek sculpture of a man carrying a calf to the temple (reproduced in *Cahiers d'Art* before the war), and of a Roman *Good Shepherd*.[31] Although Picasso resisted any notion that the sheep or lamb carried any specific (quasi-Christian) message of redemption, he nevertheless claimed to have 'expressed a human feeling [of the beautiful], that exists now as it has always existed'.[32]

After the war he felt increasingly compelled to provide such universal symbols of hope, or of vile acts of imperialism. Sometimes he turned to European masterpieces for inspiration. The *Bacchanal: Triumph of Pan, after Poussin* (fig.52) was begun as street fighting in Paris gave way to ecstatic celebrations; Picasso always remembered 'the glorious, beautiful, insurgent faces I saw in those August days when Paris rose'.[33] The painting was a fairly close rendition of Poussin's painting (National Gallery, London), with one notable variation: a satyr becomes a bearded man wearing a sort of French Revolutionary 'Phyrgian' bonnet. The *Bacchanal* is thus made to stand for Dionysian revolutionary energy, a loud and wild release of human libido in the moment of political freedom. Picasso cannot resist comedy in this liberation, as a dainty female foot becomes a gross white lump in the centre of the composition. The *Bacchanal* was a personal moment of joy, accompanied by Picasso's loud and tuneless trumpeting on his military bugle from the rooftop near Marie-Thérèse Walter's apartment; it remained in the artist's collection until death.

Another painting made in the aftermath of the Occupation was very different,

51
Man with a Sheep
1943
Bronze
222.5 x 78 x 78
Musée Picasso, Paris

featuring the unfolding drama of atrocities committed in the wake of the retreating German Army, and of the Concentration Camps (photographs and descriptions of which were published in France as early as January 1945).[34] *The Charnel House* (fig.53), begun in February 1945, shows a triangular mass of three bodies, a man, a woman and a baby, in what appears to be a burning kitchen (note the still life on the table at upper left and the flame rising up on the right). The palette, like the fragmentation of the figures in a monochrome Cubism, is that of *Guernica*, with large areas of the canvas left unpainted. This was another ambitious canvas attempting to address current events through universal images of suffering and brutality, echoing Western iconography of the Crucifixion. As Dora Maar had during the creation of *Guernica*, Christian Zervos photographed *The Charnel House* during its development over the course of a year. Picasso allowed the different stages of drawing and painting to remain visible by leaving the painting apparently unfinished. Zervos's first photograph shows a crowing cockerel at upper left, perhaps a symbol of the renewal of France (the Gallic Cock) or perhaps a sacrificial symbol. Picasso abandoned a depiction of the baby with open eyes and sucking its thumb, in an unambiguous indication that it survives, in favour of an infant with eyes closed, either surviving or alternatively drowning in the fountain of blood pouring down upon it from its mother's side. Only in the final state did Picasso clench one of the bound

52
Bacchanal: Triumph of
Pan, after Poussin 1944
Watercolour and gouache
on paper
30.5 x 40.5
Private Collection

53
The Charnel House
1944–5
Oil and charcoal on
canvas
199.8 x 250.1
Museum of Modern Art,
New York

fists of the dead man in a gesture that could, perhaps, be read as deathly defiance.

The Charnel House was first shown in March 1946 at an exhibition entitled *Art and Resistance*, described in the catalogue as 'a gesture . . . of justice toward all those who have fallen so that France may live'.[35] The exhibition was sponsored by the French Communist Party, and Picasso donated the painting to a Communist charity supporting former members of the Resistance. *The Charnel House* did not receive universal praise, however, since (as with *Guernica*) many on the Left believed that art should provide a clear message of optimism for the masses, a victory in the struggle towards triumphant Socialism.

Picasso was sensitive to such criticism, not least because, on 4 October 1944, he had joined the French Communist Party (PCF), with the support of Party members Aragon and Eluard. His membership was announced to great fanfare the following day in the Communist newspaper *l'Humanité*. Although he remained a card-carrying member for the rest of his life, it was in the next five or six years that he showed his greatest public commitment to the Party. His membership was a major coup: he could be used to demonstrate the existence of progressive cultural attitudes in the Party, and to attract support and new members from among the intelligentsia. To begin with he attended many PCF events and made public declarations underlining the earnestness of his decision, issued in French and English:

I have become a Communist because our party strives more than any other to know and to build the world, to make men clearer thinkers, more free and more happy. I have become a Communist because the Communists are the bravest in France, in the Soviet Union, as they are in my own country, Spain. I have never felt more free, more complete than since I joined. While I wait for the time when Spain can take me back again, the French Communist Party is a fatherland to me.[36]

His first artistic outing as a PCF member was the opening of the autumn Salon, the 'Liberation' Salon. Apart from his works shown in the World's Fair in 1937 (including *Guernica*), Picasso had barely exhibited in France since 1932, so his contribution of nearly eighty pieces was momentous. Crowds jostled to see the work of this 'foreigner', now a Communist, at an exhibition usually dominated by artists who were French nationals. Picasso showed his art of the war years, including the grand *L'Aubade* (see fig.66) and his *Head of a Bull* (fig.49). His paintings prompted angry protests, probably led by artistically conservative students from the Ecole National des Beaux-Arts, including the removal of the *Head of a Bull* from the wall and the burning of copies of Picasso's works on the steps outside the exhibition. As a result police were asked to provide security in the Picasso displays.

At first Picasso's Communist loyalties demanded his attendance at numerous demonstrations, marches and conferences and the donation of large sums of money –

or paintings given for the express purpose of raising cash at auction – to veterans, Communist projects and strikers. He was also active in calls for the punishment and public humiliation of collaborators. It is possible to see *The Charnel House* in these terms, as a painting designed to enforce the sense of outrage that was necessary for acts of retribution. But his most significant contribution to the Communist cause was as the official image-maker and leading artistic representative of the Peace Movement. It was Aragon who, searching for an appropriate image for the World Peace Congress to be held in Paris in April 1949, came across one of Picasso's lithographs of Milanese pigeons recently given to the artist by Henri Matisse. 'Here is our poster; the dove of peace!', Aragon declared (fig.54).

The Peace Movement united many on the Left, appalled in particular at the advent of the atomic bomb and at the US foreign policy known as the 'Truman Doctrine', which funded military and other interventions across the world in order to promote US notions of freedom. Actively supported by the Soviet Union, the Movement thus became a key theatre for the ideological battles of the Cold War. Picasso's 'dove of peace' image and its variants were synonymous with the Peace Movement, featuring widely on billboards and posters, and reproduced on postcards, scarves and jewellery. Picasso was also a figurehead, attending conferences in Wrocław, Paris, Rome, Nice and Sheffield between 1948 and 1950, signing tracts,

54
Poster for the World Peace Conference, Paris, 20–23 April 1949, using the lithograph *Dove of Peace* 1949
Offset and letterpress, printed by Mourlot, Paris
60 x 40
Private Collection

giving speeches and issuing statements.

One project in particular expressed Picasso's opposition to the Truman Doctrine: his *Massacre in Korea* (fig.55). The painting was also an awkward attempt to deliver a Picasso for 'the masses', following the artistic directives of the Party – specifically the notion of Socialist Realism, the official style of the Soviet Union codified in the 1930s. This was an adaptation of nineteenth-century representations of heroic workers or 'peasants', now to be shown embracing productive modern technology. Central to the debate was criticism of 'decadent aestheticism' and 'individualism', and exhortation to make work that would reach out to 'the masses'. Picasso (and Matisse) had been strongly criticised in the Soviet newspaper *Pravda* on 11 August 1947, reported a few weeks later in France: 'It is intolerable that, alongside our healthy Soviet Realism, there can exist in our country a movement represented by lovers of decadent bourgeois art who consider the French formalists Picasso and Matisse their spiritual masters'.[37] This underlined Picasso's struggle to fulfil the roles of both Communist and modern artist. For a few years the PCF was much more liberal than the Soviet Communist Party in its attitudes, and valued Picasso's contribution; but by 1950 its position had hardened, and Picasso felt the need to respond, particularly following unfavourable comparisons between his work and that of André Fougeron, the leading French Socialist Realist artist, following rival exhibitions during the winter of 1950–1.

Two days after Fougeron's show opened – to PCF acclaim – Picasso commenced work on *Massacre in Korea*.[38] The Korean War, which had begun in June 1950, demonstrated the devastating nature of modern warfare, bombing campaigns, napalm and the US threat to deploy atomic weapons. The war developed around a confrontation of UN forces, supporting South Korea, and Chinese forces supporting North Korea, with Soviet backing. While attending Communist Party conferences during 1950 Picasso would have heard emotional reports of the massacres of thousands of left-wing activists and their families, including women and children, by South Korean and US forces.

Massacre in Korea depicts a group of armoured but semi-naked soldiers on the right, bristling with futuristic machine guns yet commanded by a vaguely Roman or medieval sword-bearer on the far right, about to execute a group of naked women and children. In the distance a plough stands idle and on a hilltop is a bombed-out building. The rigid division of the composition, its confrontation of aggressive virility and helpless, weeping femininity, echoes the didactic art of Jacques-Louis David just before the French Revolution; the firing-squad format acknowledges both Goya's *Executions of the Third of May 1808* 1814 (Prado, Madrid) and Manet's *Execution of the Emperor Maximilian* 1868–9 (Kunsthalle, Mannheim). Painted on panel in a grisaille and green palette (the grisaille harking back to *Guernica* and implying the authenticity of reportage photography), Picasso titled

his painting with the intention that its topicality could not be mistaken and sent it to a Communist-sponsored exhibition in May 1951. The Party was not impressed by his efforts, however: they disapproved of the relentlessly tragic nature of the scene, which offered no ray of hope for the future or celebration of Communist heroism, and they deplored what they regarded as its unacceptably modern style. Moreover, given that Socialist Realist painting should communicate unambiguously with blue-collar workers, they criticised Picasso's failure to specify the identity or uniform of the soldiers, robots that could easily be interpreted as belonging to either side or as generic representations of a 'universal' brutality.[39] The painting did nevertheless achieve some impact as a political work when a reproduction was displayed in a Warsaw street during Polish protests at the Soviet invasion of Hungary in 1956. This reversal of political polarity only serves to underline Picasso's inability, or unwillingness, to produce art firmly anchored in a specific political moment.[40]

It was, however, not a history painting like *Massacre in Korea* that eventually brought an end to Picasso's activity as a Communist painter, but an obituary portrait of the Soviet leader Joseph Stalin (fig.56). published on the front page of a Communist cultural newspaper on 12 March 1953. He drew the portrait on 8 March, three days after Stalin's death, probably using a photograph of the leader in his youth as a basis for what is meant to resemble a funerary bust. It is hard to understand now why this drawing caused outrage within the Party: but a barrage of letters, prompted by official demands for apology, declared the drawing disrespectful of Stalin's humanity. Fougeron condemned the 'sterile tricks of aesthetic formalism'.[41] Picasso received copies of all the negative correspondence in a package; this remained unopened, but he told his friends that 'this detestable matter ... has done me more harm than one imagines'.[42] Nevertheless, he continued to support the PCF until close to the end of his life, when the Soviet invasion of Czechoslovakia in 1968 prompted a final decline in his faith in the Communist cause.

During the late 1950s and through the 1960s Picasso became close to the Communists Edouard Pignon (a painter) and Hélène Parmelin (a writer).[43] Pignon engineered Picasso's return to the subject of war in 1962, inviting him to contribute to the 1963 May Salon on the theme of Delacroix's vast painting of desolation, *The Entry of the Crusaders into Constantinople* 1840 (Musée du Louvre). Picasso ignored this suggestion, instead sitting down one night in October 1962 with Pignon and Parmelin to study slides of other French 'masterpieces' projected on his studio wall: David's *Intervention of the Sabine Women* 1799 (Musée du Louvre) and Poussin's *Massacre of the Innocents* c.1628 (Musée Condé, Chantilly). He later added a reproduction of a third picture into the mix: Poussin's own *Rape of the Sabines* c.1636 (Musée du Louvre). He then set about filling three sketchbooks and making eight paintings on the theme of the Rape of the

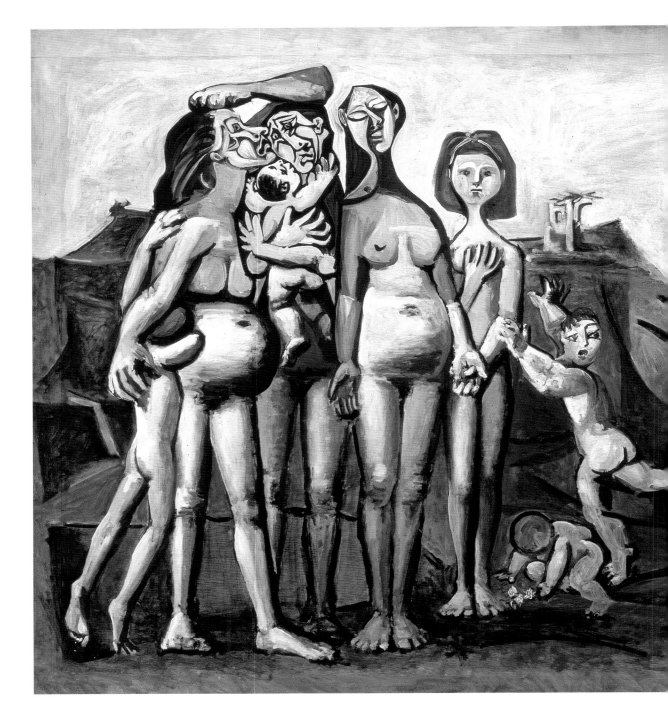

55
Massacre in Korea 1951
Oil on wood
110 x 210
Musée Picasso, Paris

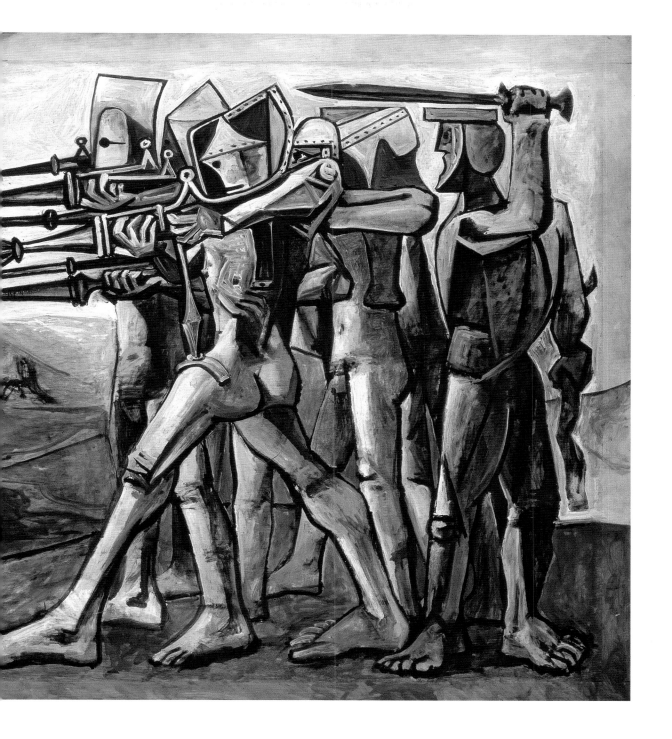

Front page of *Les Lettres Francaices* (literary supplement from *L' Humanité*), 5 March 1953, featuring portrait of Stalin by Picasso
Musée Picasso, Paris

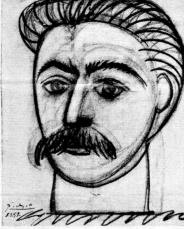

Sabines, freely combining aspects of the David and the two Poussins and interjecting his own peculiar mix of humour and violence.[44] In one painting in the sequence (fig.57). he introduces a bullring alongside a classical temple, a foreshortened figure in the foreground reminiscent of Mantegna's *Dead Christ* c.1480 (Pinacoteca di Brera, Milan), and juxtaposes a woman and dead child remembered from *Guernica* with a ludicrously naked warrior copied from David's depiction of Romulus: her upturned mouth wails beneath his dangling testicles. The *Sabines* project has been related to contemporary political events: the Cuban Missile Crisis and international tension over the threat of nuclear war. The final work in the series (1963; Boston, Museum of Fine Arts), exhibited the following May, renders horrifying violence in terms not dissimilar to, though much more impressive than, *Massacre in Korea*. In the painting illustrated here, however, Picasso is engaged in a gleeful virtuoso battle with great painters of the past, exploring their works satirically in order not so much to wring out their essence (though such works do reveal much about their art-historical models) as, perhaps, to assert his own presence.

One ironic coda to Picasso's politicisation was his first proper commission, to paint a 'mural' for the new UNESCO building in Paris (fig.58). This opportunity arose from his previous 'mural' pieces and his now double profile as a peace campaigner and stellar artist. Painted on forty plywood panels in Vallauris, it was unveiled there before being transported to Marcel Breuer's new building, where it remains installed in the Delegates' Lobby. The irony is this: after a false start as a picture of an artist's studio, the work developed into a celebration of simple human pleasures – sunbathing on rocks and diving into the Mediterranean. A Communist newspaper review saw the inverted spindly figure on the left as a schematic representation of US plane threatening atomic destruction. Georges Salles, in charge of artistic commissions for UNESCO, presented it programmatically as symbolising life and the spirit (the bathers) triumphing over evil (the black figure read as defeated Satan). Salles was also a little later the source of the idea that the picture represented the 'Fall of Icarus'.[45] Once again, Picasso's underdetermined visualisations permitted a gap to open up between his idea and public reception. In this case, however, he was happy to adapt to Salles's final interpretation, and he reused the motif in his bathing picture in set designs for Serge Lifar's ballet *Icare* in 1962.[46]

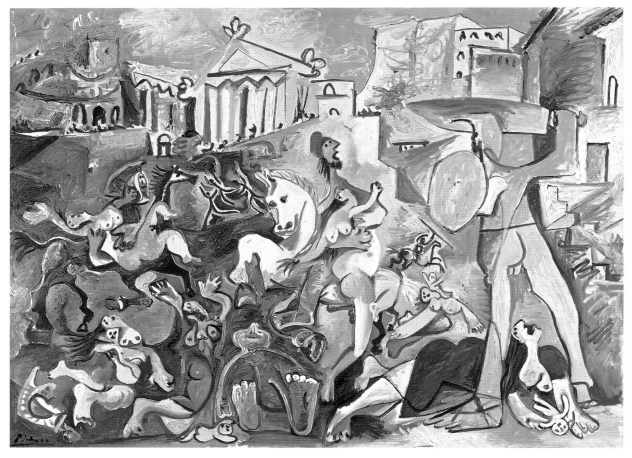

57
Rape of Sabines
(*after David*) 1962
Oil on canvas
97 x 130
Musée national d'art
moderne, Centre Georges
Pompidou

58
Fall of Icarus 1958
Oil on plywood panels
910 x 1060
Delegates' Lobby, Palais
de l'Unesco, Paris

War and Peace

Like the UNESCO commission, these two compositions are not true murals, but painted on plywood panels affixed to the wall.[47] They comprise two parts of a decorative scheme for a twelfth-century abandoned chapel in the town centre of Vallauris. Picasso had donated a bronze cast of his *Man with a Sheep* (see fig.51) to the town, and this originally stood in the same chapel before it was moved to the square in front of it. Town leaders encouraged Picasso in his idea, first expressed in 1950, to paint murals in the chapel, no doubt a part of his ongoing competitive exchange with Matisse, who had just exhibited designs for chapel decorations at nearby Saint-Paul-de-Vence (the Matisse project was completed by June 1951).[48] Unlike Matisse's chapel, the ruined Vallauris building had long since ceased to fulfil a religious function, so the atheist Picasso no doubt delighted in reinventing its use for the secular Communist cause of 'Peace'.

Initial investigations proved that the damp conditions would make true mural paintings impossible. As a result of Picasso's other commitments, it was not until July 1952 that the work on the paintings started. After experiments with fibrocement, a material that he had used a few years earlier, the solution was to paint on plywood panels that would then be bent and fixed to latticework on the chapel walls. The panels were first fitted to the latticework to test the idea, then removed and remounted on a flat framework in a large barn studio nearby. During 1951 and 1952 he made over three hundred drawings for the project, developing his initial ideas towards a confrontation across the nave of the chapel, representing 'War' and 'Peace'.

As with *Guernica*, Picasso continued to make drawings on the theme even after completing the paintings. Each composite painting was larger in area than *Guernica*, however, and he needed to work from a specially constructed tower. He was mindful of the need to work swiftly and to avoid decisions of the kind he often made when working on modest canvases, but which would necessitate repainting the entire work. The paintings were completed in 1952 and, before being installed in the chapel, were exhibited in 1953 as free-standing panels in the National Gallery of Modern Art in Rome and then the Palazzo Reale, Milan. They travelled, in an exhibition of the kind now more or less unthinkable, with *Guernica* and *Massacre in Korea*: an ensemble of mural-type paintings that attempted to address the central issues of modern war – and press the case for universal peace. The comparisons invited between these three ambitious works was testing, and the *War* and *Peace* panels were found wanting: their comparatively crude daubing and allegorical clumsiness paled alongside the dynamic synthesis of theme and visual invention in *Guernica*. This lukewarm reception may have been a factor

59
War 1952–3
Oil on plywood
470 × 1020
Temple de la Paix,
Vallauris

in the long delay in the public inauguration of the chapel in Vallauris. During 1953 Picasso had to pretend to be painting the murals all over again, this time *in situ*, for the Italian filmmaker Luciano Emmer.[49]

The central motif of *War* was a dark hearse driven by the diabolic figure of War clutching a bloodstained sword. On his back is a net full of skulls, and in his hand a dish releasing germs – a clear reference to the development of chemical and biological weaponry. Behind the black horses pulling the chariot and trampling on a book representing culture are shadow men engaged in hand-to-hand combat with swords and axes. War is confronted by a warrior for Peace, clutching the scales of justice and bearing a shield on which appear Picasso's *Dove of Peace* and the suggestion of a divine female face. The palette is virulent: blood red, strong blues and greens.

The panel opposite, *Peace*, shows a series of typical Arcadian motifs: women breastfeeding, people cooking and children playing. Some idiosyncratic elements have been introduced: a child using Pegasus to plough the sea; another child tightrope walking while balancing a surreal bowl of birds and a cage of fish, his head surmounted by an owl; a multicoloured sun radiating branches or ears of corn. The palette deliberately contrasts with *War*: pastoral blues and greens, and a cast of characters in pure white.

In some ways Picasso's theme in the *War* and *Peace* panels was a modern echo of Lorenzetti's fresco cycle, *Good and Bad Government* 1337–9 in Siena, and the various contrasting representations of the 'Age of Gold' and 'Age of Bronze' described by Ovid. Like Rubens, in his *Peace and War* 1629–30 (National Gallery, London), Picasso attempted to deploy allegorical figures in order to express each theme. The chariot of War and his pose – indeed the whole composition – also parody Titian's *Bacchus and Ariadne* 1520–3 (National Gallery, London). Among modern inspirations might be Henri Rousseau's *War* c.1894 (Musée d'Orsay, Paris), acquired by the French state in 1946.

The *War* and *Peace* panels were clearly more ideologically programmatic than the UNESCO painting, and it was only after working on the latter project that Picasso finally completed a smaller, composite panel painting for the east end of the chapel, showing the world community reaching up to the dove of peace. In 1970 this was vandalised by a Spanish artist, Salvador Izquierdo-Torres, who daubed his own composition over it with the sole aim of coming face to face with Picasso.

Known locally as the Temple of Peace, the War and Peace Chapel was finally inaugurated in 1959.

60
Peace 1952–3
Oil on plywood
470 x 1020
Temple de la Paix,
Vallauris

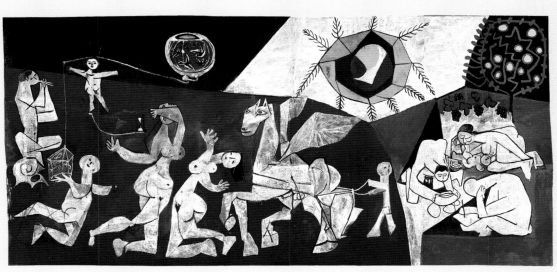

'Now I am ready to tell how bodies are changed into different bodies.'[1] So begins Ovid's *Metamorphoses*, a text written in the time of the Roman emperor Augustus, at the turning point in ancient civilisation from the pagan into the Christian era. In 1930, in collaboration with a young publisher, Albert Skira, Picasso chose Ovid's *Metamorphoses* as a text to illustrate with a series of prints. Picasso experimented with various approaches. Some versions of particular episodes, such as a dynamic depiction of *The Death of Orpheus* (fig.61), were rejected in favour of a sparse, beautiful but nevertheless subversive linear Classicism. The motif of Orpheus torn limb from limb by jealous Ciconian Women, who also attack oxen in the fields, was a familiar symbol of the notional suffering of the artist, whose skills are identified with the enchanting power of Orpheus's lyre music, while public resentment of artistic gifts leads to critical dismemberment. In 1907 Apollinaire had asked Picasso to illustrate his own *Bestiary, or Procession of Orpheus* (Picasso did not complete the project); he made Picasso a key figure in one of his invented terms for an aspect of Cubism painting, 'Orphic Cubism'.[2]

In Ovid's recounting of the death of Orpheus, the Ciconian Women are punished by Bacchus (the Roman Dionysus): stretching their toes and plugging them into the soil, he transforms them into roots and thus the women into trees. Ovid's stories, in the words of poet Ted Hughes, 'establish a rough register of what it feels like to live in the psychological gulf that opens at the end

of an era'.[3] Such thinking was also part of the Surrealist milieu in which Picasso's Ovid illustrations were born, and which often coloured the metamorphic transformations in his art from the mid-1920s to the mid-1940s.

Picasso's central sculptural project of these years was his monument to Apollinaire, begun in 1920, two years after the poet's death. He took years to produce his first design for the grave in Père Lachaise cemetery: his first submissions to the organising committee in 1927 were sketchbook drawings made in Cannes, showing monstrously phallic female bathers and figures made of dots and lines. Soon afterwards he presented two maquettes, sculptural models for the tomb, called *Metamorphosis* I and *Metamorphosis* II, representing a tumescent and distended female body.[4] These two versions of the same idea were the first fully three-dimensional sculptures he had made since 1914.[5] The following year Picasso and Catalan sculptor Julio González, who was skilled in metalwork, together invented a radically new kind of metal sculpture, constructed rather than cast from modelled or carved originals in the traditional way. Picasso first made a brass and iron *Head* (the configuration of which he also used on the right-hand side of his *Painter and Model*, fig.77); this began in his drawings as a representation of two faces locked in a kiss, and metamorphosed into a spiky hieroglyph on a tripod.[6] He followed this with yet another idea for the tomb: four

5 Gifts of Metamorphosis: Sculpture in Play

61

*The Death of Orpheus
(illustration for ' The
Metamorphoses of Ovid')*
1930
Etching
31.2 x 22.1
Musée Picasso, Paris

sculptures created, probably by González, by welding wire rods to make a geometry that transforms in and out of being a human figure as one moves around them (fig.62). Here metamorphosis occurs through the shifting perspectives of a 'mobile spectator', a literal fulfilment of an idea that is one key to Picasso's Cubist paintings. These wire works evoke drawings he made in 1924 using a 'dot and line' conceit to suggest at once guitars and constellations.[7] Kahnweiler coined the notion of 'drawing in space' to describe the wire figures.[8] This evocative phrase is frequently reused to describe diverse kinds of contemporary sculpture, most recently by Antony Gormley.[9]

Picasso's burst of sculptural invention driven by the tomb commission continued through to 1931 with three further welded sculptures, *Head of a Man* 1930 (Musée Picasso, Paris), *Head of a Woman* 1929–30 (Musée Picasso, Paris) and *Woman in a Garden* (fig.63).[10] The first of these, constructed of fabricated bronze, iron and brass, makes strong references to non-Western objects – and indeed to those aspects of Picasso's Cubism based on the same objects. The two sculptures of women combine manufactured metal forms with found or readymade elements. In the case of *Head of a Woman* the volume of the head, behind a concave face with basic signs suggesting features, is formed by two kitchen colanders joined to make a perforated sphere. *Woman in a Garden* 1929–31 is the effective climax to Picasso's attempts to make a modern sculpture appropriate for the tomb of his

friend Apollinaire. Its improvised and coarse detailing suggests that he made this sculpture largely without the assistance of González, combining all manner of metal scraps – including nails – from the forge, together with folded, bent and beaten sheets and strips of iron. The result is a larger than life-size female figure, an assemblage of elements anticipating his anatomical drawings of two years later (see fig.32), where the tilted pelvis doubles as a garden table. Picasso painted both *Head of a Woman* and *Woman in a Garden* white, resisting their metallic patina and imitating the painted surfaces of some tribal objects. Unlike the wire figure sculptures, the metamorphosis here occurs in the imagination, in the transmogrification of brute metal fragments into realised sketchbook fantasies, demonstrating Picasso's power to conjure up the human form while at the same time deforming it. *Woman in a Garden* is also important as an example of Picasso's interest in sculpture with pictorial qualities (for which there are many precedents in the history of sculpture), binding us to view it frontally rather than in the round.

Head of a Woman and *Woman in a Garden* were both included in Picasso's dazzling retrospective in Paris in 1932. Photographed by Brassaï at the Château de Boisgeloup, they were illustrated in the Surrealist magazine *Minotaure* in 1933 alongside the massive plaster heads that, ever versatile, he had made at the same time as he grappled with metal constructions.[11] He never submitted the constructions to the committee in

62
Figure (maquette for a Monument to Guillaume Apollinaire) 1928
Iron wire and sheet metal
50.5 x 18.5 x 40.8
Musée Picasso, Paris

63
Woman in a Garden
1929–31
Iron, soldered and painted white
206 x 117 x 85
Musée Picasso, Paris

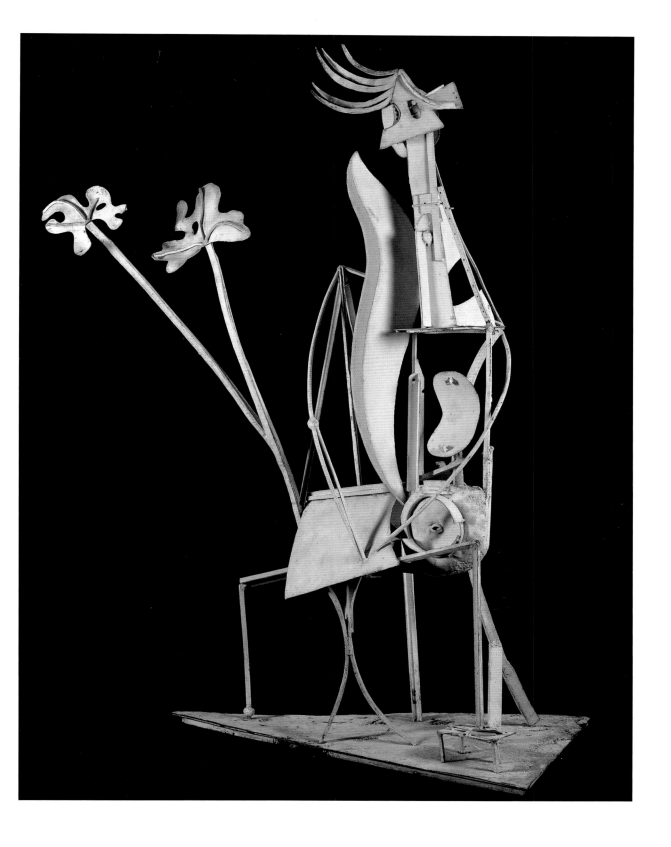

charge of the Apollinaire monument. The long story of his commission and his failure to fulfil it only came to an end in 1955, when a bronze cast of his *Head of Dora Maar* 1941 was mounted on a stone pedestal in a garden next to the church of Saint-Germain-des-Prés, Paris, and inscribed simply 'To Guillaume Apollinaire 1880–1918'.[12]

Picasso's facility with constructed sculpture, and his inventiveness in moving back and forth between sculptures conceived 'in the round' and those echoing the representational strategies of painting and drawing, owed much to his Cubist work. It was also through making Cubist constructions and picture-objects that he developed a complex dialogue with non-Western tribal masks. Having made several sculptures that translated pictorial Cubism into a fragmented three-dimensional object world, in the autumn of 1912 he began work on *Guitar* (see fig.64), a radically new kind of sculpture, first with cardboard and then sheet metal. This object was the sculptural twin of Picasso's activity in *papiers collés* (see Chapter 2): photographs taken by the artist at his studio on boulevard Raspail in November and December 1912 show groups of *papiers collés* pinned on the wall around the cardboard *Guitar*, as if it were the key, outcome or origin of their inventions.

In his book on Picasso's sculpture, Kahnweiler linked the *Guitar* with Picasso's purchase, probably in August 1912 in Marseille, of an African mask made by the Grebo people of Ivory Coast and Liberia (fig.65). This mask represents a face in a way unfamiliar to Western viewers at that time: the mouth is a sandwich-like block jutting forward from the flat wooden shape of the face; the forehead/eyebrows are a prominent rectangle and the eyes protruding dowels. In studying this mask Picasso realised that art – as a creation of 'signs', like writing – could become something like an emblem for the external world, rather than the windowlike illusion of it so central to European art. In this way Grebo masks evoke a visual experience of a face without resorting to pictorial illusionism.[13]

Crucially, according to art historian Yve-Alain Bois, Picasso also realised that 'sculpture is not necessarily massive, and indeed that African sculpture, for the most part, abandons the Western equation of volume equals mass'. Most importantly, he came to see that 'signs are arbitrary' and have no 'natural' or 'real' point of reference – in an age of illusionistic representation when representations and reality are easily and dangerously confused.[14] In the *Guitar* he represents the volume of the guitar without making a solid object or 'mass' conforming to its body. Instead, working forward from a ground plane that is, like that of the Grebo mask, partially shaped to give the *contour* of the body, he creates 'volume' through a series of jutting perpendicular and parallel elements: one contoured sheet at bottom right suggests the front surface of the guitar's body, but the rest of that foreground surface is read from the front of the sound hole/cylinder

64
Guitar 1912
Cardboard, string and wire (restored)
65.1 x 33 x 19
Museum of Modern Art, New York

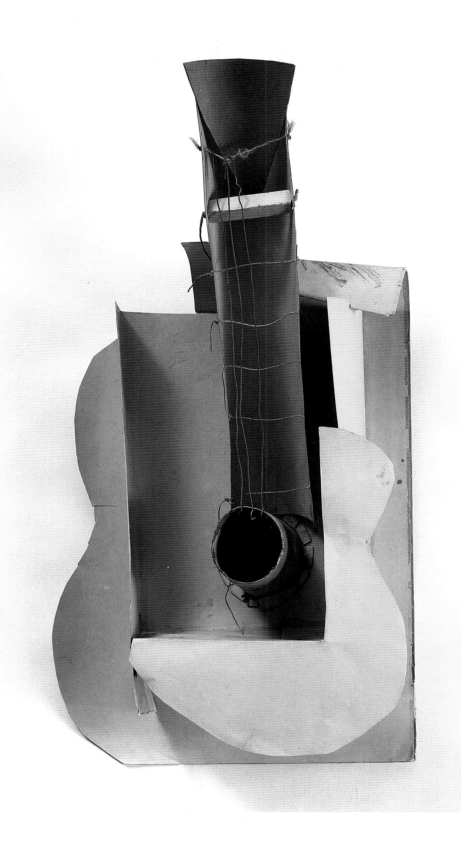

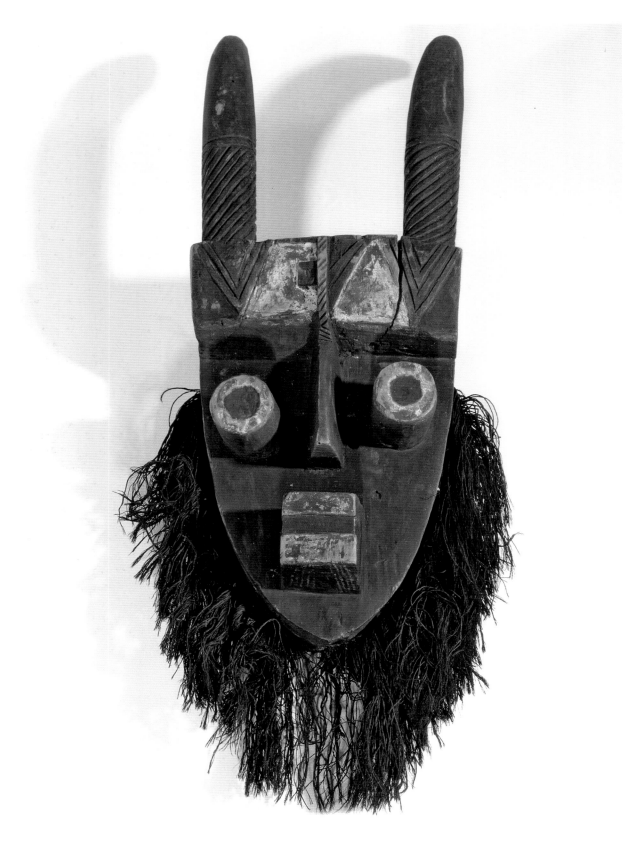

65
Grebo Mask Ivory Coast
or Liberia
Painted wood and fibre
Height 37
Private Collection

and the leading edges of the perpendicular elements to left and right. The idea of inverting what should be a hole into a 'solid' cylinder is a powerful way of demonstrating how an arbitrary visual sign can still be representational by means of context and contrast. The cylinder is in opposition to the open, 'empty' space around it, framed by the other elements in order to transform it in the viewer's perception not only into the sound box that is the guitar's body, but also, remarkably, into the rest of the solid plane of its front. This oscillation between void and surface happens before our eyes, as the signification of empty space shuttles back and forth, powered by the imagination.

We do not know whether, in 1912, Picasso talked in terms of 'signs'.[15] Certainly in 1945 he expressed similar notions in an interview with writer André Warnod:

Nature is one thing, painting another. Painting is an equivalent of nature. The image that we have of nature is something we owe to painters. We only perceive it through them. We usually accept the image of nature found in the classical painters, the painters of the seventeenth century, Poussin. The image they provide is accepted as being what nature really looks like . . . But there's no proof that this image of nature is any more true than the images created in other epochs. Really, it is just a matter of signs. It has been agreed that this sign represents a tree, this other one a house, a man, a woman – just as, in language, the word 'man' evokes the image of man in our minds; the word 'house', a house and so on in every language, although it's a different word in every language.

It is a convention that's been agreed on; we communicate by using these customary signs.[16]

Although it was arguably the semiotic character of a West African mask that led Picasso to an entirely new kind of sculpture, the *Guitar* itself reveals no more than small clues as to its origin, such as the echo of the Grebo mask's eyes in the stovepipe sound hole. However, other aspects of the mask fed into important practices in Picasso's constructed sculpture. Its combination of hybrid elements suggested sculptural materials such as wood, cardboard, paper and string, as opposed to clay, stone or bronze. It also introduced the possibility of using found and readymade objects, with which Picasso played like a poet, making new metaphors with surprising word chains, putting them into relationships to spark significations. Thirdly, the mask helped Picasso invent a hitherto unimaginably modern sculptural practice, abandoning the tradition of centuries of modelling and carving, pretending to make things rather than illusions of things, engineering an environment of materialised imaginary objects, wearing workers' overalls instead of a sculptor's smock. This sense of constructed sculpture as a heroically modern invention was, perhaps, underlined when Picasso made a second version of the original cardboard *Guitar* in sheet metal and wire (Museum of Modern Art, New York).[17]

Yet there is another dimension altogether to the story of the mask and the *Guitar* and the development of constructions. The

debate has to do with the existence of visual resemblance in artistic representations, an aspect of Picasso's artistic imagination that has recently been described as central to his acts of metamorphosis.[18] What is remarkable is that the Grebo mask still looks like a face, despite the fact that its visual language is so remote from European pictorial illusionism. There are similarities, however minimal, between the circular forms of the dowels and eyes, and between the horizontal bands painted on the wooden block below that make it a mouth, or lips. Picasso had for a long time been playing with such minimal signs in his Cubist work, so that in making his *Guitar* he translated the diverse iconography of his painting and drawing into sculpture.

As early as spring 1912 Picasso appears to have imagined making figures out of planar elements, with cylinders for breasts, or using frame-like materials, something like wooden canvas stretchers – these drawings may even be the real origin for *Woman in a Garden* and *An Anatomy* so many years later. Certainly the mask's signs were just as elastic, ambiguous and versatile as the planes, lines and shadows of Picasso's Cubism, but its purchase in 1912 may not fully explain Picasso's turn to construction. His motive could have been simply to make relief constructions that related to his ideas for paintings, or to make the compressed spaces of Cubist paintings 'real'. At the same time, however, he tested the semantic flexibility of the imagined elemental constructions in his sketchbooks. This, according to art historian

Pepe Karmel, fed an imagination that aimed 'to reinvent human anatomy on the model of inanimate objects', a metamorphic creativity that sometimes led figures in paintings to become 'still-life' constructions.[19] The strength of this argument is its insistence on Picasso's preoccupation with the object world, his quest for outlandish, even disturbing representational metaphors that could grasp at things and bodies with a paradoxical sense of realism. As early as 1916 Apollinaire seems to have come to the same conclusion:

The word *table* that represents this piece of furniture resembles it to such an extent that it brings it to mind as soon as the word is pronounced, yet there are no apparent analogies between the word *table* and the piece of furniture itself. Don't you think that a painter might represent someone the same way in their portrait? But in Picasso's art there is something of true realism that can be seen immediately.[20]

Yet Bois convinces when he argues that Picasso's Cubism after 1912 acknowledges that pictures or sculptures are only ever collections of conventional artistic signs, 'arbitrary' in the sense that they are world-inventing not world-giving. Thus when Picasso, in that 1945 interview, states that he always 'insists on likeness' – which might make us think that he is talking about the realism of iconic resemblance – he adds that what he means is a 'more profound likeness, *more real than the real*'.[21]

Whatever the role and value of the Grebo

mask, we know that Picasso's metamorphic idea of incorporating readymade elements in his art began in May 1912, with the introduction of a found element into painting (see fig.12). The effect of this new practice of collage in his paintings was quite different from his use of readymade elements in his Cubist sculpture: the former was in a general sense a metamorphosis of everyday reality into the logic of pictorial space, while the latter, as Picasso himself suggested, presented an irreconcilable clash of different realities.[22] His Cubist sculpture developed sporadically over a few years after 1912, with one famous milestone being the use of an absinthe sugar spoon in his freestanding sculpture *Glass of Absinthe* 1914 (Musée National d'Art Moderne, Paris, and elsewhere). It is clear that he was playing as much with the nature of sculptural tradition as he was with the question of reality in art; this wax sculpture was cast in an edition of six bronzes just like any academic piece, but Picasso then added six real spoons and a bronze lump of sugar. Furthermore, each sculpture was then painted in either jaunty or sombre Cubist colours, in one case mixed with sand.

Picasso's synthesis of opposing realities in a sculpture, incorporating readymade elements alongside visual symbolism, came into its own much later, with his seemingly effortless *Head of a Bull* (fig.49). This readymade assemblage was made during the Occupation in spring 1942, when he was forced to scavenge from discarded rubbish for sculptural materials. He once said that he saw the bicycle saddle and handlebars on a scrap-heap on his way to a funeral (possibly that of Spanish sculptor Julio González), collecting them on the way home. Whether the story is true, the sculpture is in any case a fitting memorial to González, being a Spanish icon made using the welding technique that Picasso learnt from his deceased friend.[23] The sculpture was featured on the cover of an illicitly published Surrealist magazine that year, *La Conquête du monde par l'image* (*The Conquest of the World by the Image*), under the title 'Object'. It was one of five sculptures included in the controversial Liberation Salon of 1944, when it hung above a painting like a matador's trophy. Picasso kept the original work and also had it cast in bronze. He often talked about this piece, both for his achievement in crafting practical objects into such a recognisable likeness, but also with the idea that those objects continued to retain their identity:

One day I took the seat and handlebars. I put one on top of the other and I made a bull's head. Well and good. But what I should have done was throw away the bull's head. Throw it in the street, in the stream, anyway, but throw it away. Then a worker would have passed by. He'd have picked it up. And he'd have found that, perhaps, he could make a bicycle seat and handlebars with that bull's head. And he'd have done it . . . That would have been magnificent. That's the gift of metamorphosis.[24]

Elsewhere he described this as a 'double metamorphosis', the recycling of the cycle

parts back and forth in a chain where they are one day an image and another day saddle and handlebars. Their different 'realities' are constituted nowhere else but in these distinct human practices. Moreover, even when Picasso's craftsmanship dominates and the objects become the *Head of a Bull*, this is a *Head* suspended somewhere between pictorial resemblance and objecthood.

The emergence of Picasso's constructed sculpture raises the question of the relationship between sculpture and painting in his work. Painting, an essentially abstract art where three-dimensional 'reality' is represented on a flat surface, was for Picasso the subject of an intense struggle as he sought to gain 'possession of things in their totality' (to make them 'more real than real'). Sculpture was, by contrast, a relaxing activity for him. Thus he kept nearly all of his sculptures in his own collection and treated them like familiars or children.[25] We can sense these contrasting attitudes in an intriguing photograph taken by Brassaï on 13 December 1946, showing a theatrical confrontation staged by Picasso between one of his sculptures and one of his major paintings (fig.66). On the right is his harrowing wartime painting *The Dawn Serenade*. On the left, dressed up for the occasion in an artist's painting overall and holding a 'useless' Pyrex palette (sent to him from the United States and barely visible), complete with brushes, stands the *Woman in a Long Dress* of 1943.[26] This sculpture incorporated various readymade elements, principally the woman's body itself, an old

66
Brassaï, *mise-en-scène* set up by Picasso, including *Woman in a Long Dress* (1943) and *The Dawn Serenade* (1942) 1946
Silver gelatin print, printed c.1950
25.6 x 17.9
Musée Picasso, Paris

wooden dressmaker's dummy bought in a flea market. Picasso made a head and right arm for the figure, but for the right forearm he introduced a non-Western object, a fragment of an Easter Island statue, joining it to the torso with a roughly modelled upper arm. It is possible that Picasso seized upon this dummy in a reaction to the 1938 International Surrealist Exhibition, where bizarrely dressed and decorated shop mannequins were used to stand in for the artists involved.[27] In this case the studio set-up here can be seen as playful (self) mockery: the dressmaker's dummy is dressed up once again, this time as a stand-in for Picasso.

The confrontation of painting and sculpture in the photograph defuses the horror of *Serenade* with wry humour, but it also plays upon many levels of metamorphosis that carry particular meanings. In a Surrealist manner the *Woman in a Long Dress* becomes a *male* artist and the artist becomes a sculpture. Moreover, this artist, a three-dimensional figure with a more or less 'natural' appearance, contemplates an otherworldly product of his imagination: real space and bodies but subject to the fundamental abstraction of the two-dimensional medium of painting. Brassaï's photograph, presenting *The Dawn Serenade*'s canvas in its trenchant flatness as a result of deep perspective recession, underlines the contrast.

In the years after the Second World War Picasso's use of metamorphosis became increasingly playful, distant from the violent, Surrealist-inspired disfigurations

that led to his *Metamorphosis* sculptures in the early days of the Monument project and flowered in *Woman in a Garden*. His post-war levity coincided with his relationship with Françoise Gilot and his experience of the joys of fatherhood in his mid-60s: Claude was born in 1947 and Paloma in 1949. In this familial context painting could seem less serious, more like child's play. Even after his relationship with Gilot collapsed, a painting of Claude and Paloma made in 1954 (fig.67) still captures in carefree ways the concentration of a child wielding a crayon and the fantastical images of ordinary things that float somewhere between mind and paper.

Picasso met Gilot, a young painter, in the only restaurant on the rue des Grands-Augustins in May 1943, and they began a relationship towards the end of the year (it was around this time that Picasso wove his stories about the *Vollard Suite* minotaurs discussed in Chapter 1). His relationship with Dora Maar continued until early 1946, when, following a period of mental illness provoked in part by Picasso's conduct, Maar settled in a house he had bought for her in Ménerbes in the Lubéron: it was then that Gilot became his public companion. Her face provided the model for the metamorphosis of the 'Dove of Peace' into the 'Face of Peace', an image of the dove bearing a woman's features on its breast. He used this device again in the shield of the peace warrior in his 1952–3 *War* panel (fig.59), but in the intervening years presented her, in a series of paintings, as a 'Woman-Flower', her features

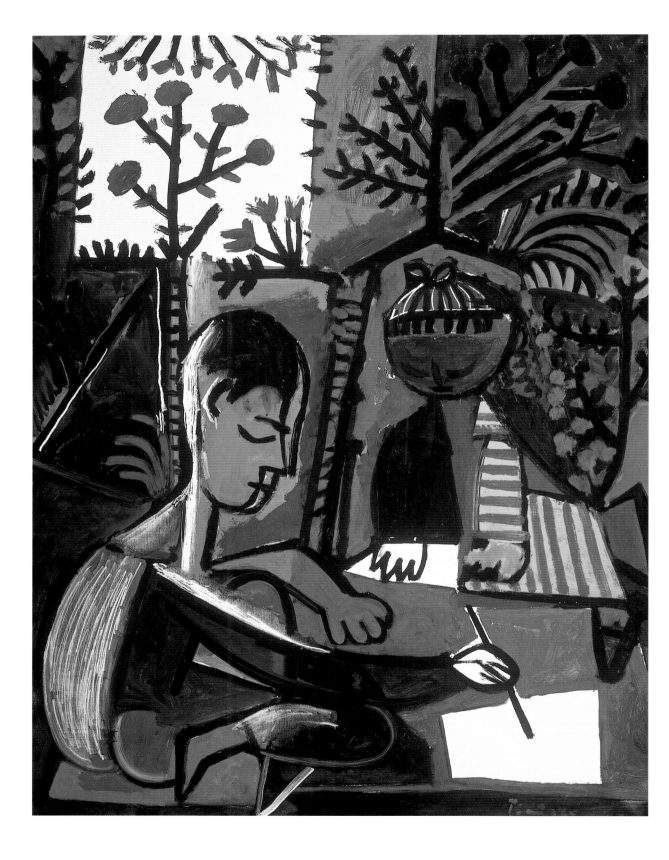

forming the bloom of a tall, semi-human plant: he thus transformed her into a natural phenomenon, a bird or a plant, treating what might seem predictable gender stereotypes with a beguiling metamorphic energy. The organic ideal of blossoming woman was related to Picasso's rediscovery of the ideal of a Mediterranean Classical culture at this period. His life with Gilot coincided not only with his Communist and Peace movement involvements, but also with his discovery of ceramics and exuberant animal sculptures in the former Roman town of Vallauris on the Côte d'Azur.

Before becoming deeply involved in ceramics, Picasso was encouraged by the curator of the Château Grimaldi, a medieval castle on the shore in Antibes, to occupy it as a studio. During October and November 1946 he and Gilot lived in the castle, and he produced large numbers of paintings, many of which also depicted animals and sea creatures, and a gleeful composition called *La Joie de vivre* (Musée Picasso, Antibes), a reference to Matisse's *Le Bonheur de vivre* of 1906 (fig.29), which had affected him so much as a young man.[28]

Picasso discovered ceramics at the Madoura pottery in Vallauris in the summer of 1946. This was in a sense a rediscovery, since he had tried his hand at it very early in his career in Paris. What he was offered in Vallauris was a much more attractive proposition: the opportunity to work with master potter Jules Agard, who could provide him with any clay forms he wanted, which he could then shape and decorate

prior to firing. Picasso's involvement with Madoura and its owners, Georges and Suzanne Ramié, began in earnest in the summer of 1947; in 1948 he bought an ugly villa outside Vallauris called 'La Galloise', allowing him easy daily access to the pottery and to the workshop of Hidalgo Arnera who printed his lithographs and linogravures. Picasso initially approached Agard with his ideas for zoomorphic pots, concepts that he had developed in sketchbooks. This 'conceptual' approach has been compared to the pre-visioning implied in his accounts of the 1942 *Head of a Bull*.[29] Among the creatures that Picasso formed with his own hands from shapes offered by Agard were birds, goats, centaurs and bulls. By 1949 he also took to modelling in clay: he made a *Dove* that way, using tools to draw feathers, beak and eyes into the wet clay (fig.68). His doves were by then, of course, the official symbol of the Peace Movement, so it is not without a certain grim humour over becoming a 'poster artist' that he famously remarked, when making a dove from a vase form thrown by Agard, 'You see, to make a dove you must first wring its neck'.[30] Ceramics also gave him the chance to paint on various curved and textured surfaces, using coloured glazes to play eye-fooling tricks with, for example, the shallow oval form of a serving platter that he could render as if a circular plate seen in perspective.

In 1949 Picasso rented a large disused perfume warehouse in Vallauris, dividing it into two studios, one for sculpture, the other for painting. Here he completed both

69
Goat 1950
Wicker basket, ceramic
ware, palm leaf, metal,
wood, cardboard and
plaster
120.5 X 72 X 144
Musée Picasso, Paris

War and Peace, and the UNESCO panels, and a sequence of metamorphic animal and human sculptures. Much of the ceramic junk, kiln furniture and broken pots, which he incorporated into these sculptures was found in a skip nearby. In 1950 he made sculptures of a *Goat* (fig.69) and a *Woman with a Pram* (fig.70), and the following year *Baboon and Young* (fig.71). The *Goat* was made rapidly and with determination. According to Gilot, she would wheel an old pram behind Picasso as he traipsed from dustbin to dustbin on the way to the dump, searching for items that could be integrated in – or rather comprise – the anatomical elements of the goat he imagined.[31] The objects were compiled on a wooden framework and pasted into place with plaster. The backbone of the goat is a palm branch that he had been hoarding; the abdomen, apparently pregnant, was made from a frayed wicker basket; the dugs were two terracotta milk bottles; and the horns and goatee beard were fashioned from pieces of vine. He made the nanny goat's vagina with a tin lid bent double, and the anus with a metal pipe. The naturalism of the *Goat* is remarkable in two ways: like a caricature, it captures the unmistakable essence of the goat, and this is achieved through a wildly heterogeneous assemblage.

Picasso developed this sense of fun in his *Baboon and Young*, for the head of which he purloined two toy cars – a Renault and a Panhard – that were a gift from Kahnweiler to his son, Claude (no doubt to the consternation of the little boy). The Baboon's ears were two teacup handles, its

71
Baboon and Young 1951
Ceramic ware, two toy
cars, metal and plaster
56 x 34 x71
Musée Picasso, Paris

tail a car-spring, and its belly a huge ceramic jar. Picasso was enormously proud of this creature and its cuddling offspring – he called it 'the ancestor'.[32]

The theme of maternity runs through many of the sculptures that he made in this period, including a freestanding *Pregnant Woman* (Musée Picasso, Paris) completed in 1950 but significantly revised in 1959. The *Woman with a Pram* was less problematic, completed in 1950 and again constructed with a mix of made and found elements. The principal readymade components are the decorative plaques from heating stoves that form the torso, the ceramic elements that make up the baby, and the metal parts cobbled together to make the pram. This preoccupation with fertility and motherhood is often given a biographical explanation, since Picasso – while conducting several affairs – was apparently urging Gilot to have a third child. But the theme also links the fecundity of nature with that of his own imagination: *Baboon and Young* has been called 'one of Picasso's most strikingly successful metamorphoses'.[33]

Picasso's dazzling, crowd-pleasing performances in these junk sculptures bore out the popular perception that he was an artistic genius. Accounts of his activities in the Madoura pottery describe his remarkable facility for manipulating the clay forms given to him by Agard.[34] Meanwhile, his public profile burgeoned: an exhibition of his Cubism and his recent work was staged in Paris in 1954, and was followed by the runaway success of Maurice Jardot's retrospective of 1955, which had 128,000 visitors and travelled from Paris to Munich, Cologne and Hamburg.[35] His growing fame was also thanks in part to other factors: his PCF and Peace Movement activity; international publicity (including newsreels) covering the inaugurations of the *Man with a Sheep* sculpture and the UNESCO panels; and the increasing importance of photographers (Magnum agency photographers such as Robert Capa, Henri Cartier-Bresson and Herbert List, as well as André Villers, Edward Quinn and others) who provided the world press with images of the artist in his studio and, notionally, in private, with Gilot. Picasso clowned for the photographers, dressing up and making a show of himself and his family at the bullfight or on the promenade in Cannes.

Perhaps one of the most revealing documents from this period is the film *Le Mystère Picasso* (*The Picasso Mystery*), shot in 1955 in the Victorine Studios in Nice under the direction of Henri-Georges Clouzot. Picasso had known Clouzot since the 1920s in Paris, and when much later, as a successful director, he moved to nearby Saint-Paul and showed Picasso some of his own paintings, the idea formed of making a film in collaboration. The film is an attempt to record the processes of drawing and painting, to 'witness the work of creation'. At first Picasso wanted to provide a script, but Clouzot insisted that the film should be a confrontation of two distinct crafts, painting and cinema, and resisted the temptation to include biographical material. After

an experimental short, Picasso contacted Clouzot to tell him about new indelible felt-tip pens that were potent enough to stain through canvas. This enabled Clouzot to make a long sequence in the film where Picasso draws on the other side of paper or canvas from the camera, and the drawing appears as if by magic. Clouzot injects drama in other ways. The film is shot largely in black and white, but colour is suddenly introduced when Picasso begins working on a large painting. There are Picasso's 'real time' high-wire acts, where the artist continually transforms images in front of the lens while a countdown is announced as the camera runs out of film (fig.72). Although Picasso's wish to provide a script was rejected, Clouzot nevertheless agreed some planned dialogue with the artist, including the moment when he suggests making the larger paintings. This then demands that Clouzot adopt the wider cinemascope format, and he films long time-lapse sequences showing the evolution of several paintings, including *Bathers at La Garoupe* 1955 (National Museum of Modern Art, Tokyo), a work that drifts rather unconvincingly through various permutations. During the film there is little supporting dialogue apart from clumsy attempts to reinforce the image of Picasso as an undiminished power despite his age, full of energy, inventing new methods and changing materials even when the camera is rolling. Most of the 78 minutes are silent, but some sections are accompanied by a vivacious score written by Georges

Auric. The project was an audacious essay in the visualisation of Picasso's 'gift of metamorphosis', and won a jury prize at the Cannes Film Festival, where it was first shown in 1956.

Picasso was now a celebrity as well as an artist, but his 'gift of metamorphosis' seemed to many to have lost its way and become mere entertainment since the heady days of Cubism and the *Guitar*, or Surrealism and *Guernica*. An artist associated with the new COBRA group, Michel Ragon, put it this way as early as 1950:

And Picasso? Picasso who they talk about so much! Picasso adulated film star, who attracts as many tourist as the Eiffel Tower . . . attracts idiots. Where is his influence? Picasso recedes. The young generation detach themselves from this encumbering genius.[36]

Picasso's attempts to come to terms with his position as the most prolific, innovative artist of the twentieth century and at the same time as an ageing and increasingly isolated figure are among the subjects of the final chapter of this book.

72
Le Mystère Picasso 1956
Director: Henri-Georges
Clouzot, Pablo Picasso

Vénus du Gaz

The *Vénus du Gaz* was one of Picasso's only true readymade works, incorporating a burner appropriated from a large pre-war gas stove. That said, his use of readymade elements, founded as it was on a practice of visual metaphors and the metamorphosis of ordinary objects into art, was driven by very different motives when compared to the gestures of the greatest practitioner of the readymade, Marcel Duchamp.[37]

Picasso's title – for as Duchamp often did, Picasso here depended on a title to complete the work – surely recalls prehistoric objects such as the *Venus of Lespugue*.[38] This so-called 'Venus', carved in mammoth ivory around 25,000 years ago, was discovered in 1922 and lodged in the Musée de l'homme, Paris, where it remains today. In a conversation he dates to 25 October 1943, Brassaï remembers Picasso talking him through some of the contents of his display case, a sort of Picasso *Wunderkammer*. Brassaï writes:

. . . in this display case is a mould of the *Venus of Lespugue*. There are actually two copies of it: one conforms to the damaged model; the other is whole, restored. Picasso adores this very first goddess of fecundity, the quintessence of female form, whose flesh, as if called forth by male desire, seems to swell and grow from around a kernel.[39]

The surface of the *Vénus du Gaz* may owe something not so much to the Venus of Lespugue 26,000–24,000 BC (Musée de l'Homme, Paris) as to the Willendorf Venus 24,000–22,000 BC (Natural History Museum, Vienna), a rough and pockmarked figure with a strange ball of plaited hair that is echoed in the vents on the 'belly' of the gas ring. However, what matters here is the connection being forged between the Stone Age and the modern age: Picasso's *Vénus du Gaz* is regarded by several commentators as an uncharacteristically literal reference to the emerging imagery and narrative of German concentration camps and the gas chambers.

A sketchbook drawing of 17 January 1945 shows the *Vénus du Gaz* standing amid the flames of a fireplace, like some monstrous sentinel, and is thus closely linked with Picasso's painted massacre or 'Holocaust', *The Charnel House* (fig.53).[40] The initial euphoria in France over the Liberation gave way to enormous shock and profound nihilism when details and photographs of Nazi concentration camps, and of the atomic bombings in Japan, filtered out into the public domain. Picasso made ominous comments to his friends in the period:

We have not done yet with the Nazis. They have given us the plague. Many have been contaminated, without even realizing it.

Even if all the present suffering will pass, it will all come back again and encircle the world from pole to pole.

It's all going to be worse and worse. Something is broken in us.[41]

The *Vénus du Gaz*, with its crude forms and charred iron surface, a readymade with an aura of a minimal gesture, seems to reflect this cultural pessimism. But what was the

force of the equation made between the Palaeolithic and the concentration camps, or between the earliest art and contemporary moral disaster? This was an equation that had considerable currency when Picasso made his piece. For example, Jean-Paul Sartre wrote a preface for a Giacometti exhibition at the Pierre Matisse Gallery in 1948, and in an echo of the association in Picasso's *Vénus* he referred to the Paleolithic art of both Altamira in Spain and Les Eyzies de Tayac in France when mentioning the victims of Buchenwald.[42] Indeed, the *Vénus du Gaz* embodied the same knowing embrace of gross materiality and deskilling that was so admired by French intellectuals of the Left in work by artists including Jean Dubuffet, Jean Fautrier and Wols. According to the writer Jean Paulhan, their work signalled a return to an artistic 'Stone Age' that would, in its very brutality and crudeness, rejuvenate art in the post-war world.[43]

Perhaps Picasso too, with his *Vénus*, sought moral renewal with artistic trauma. If so, he expressed it only obliquely in a sort of parable, reported by Gilot. He imagined archaeologists digging up his *Vénus* thousands of years later, and assuming that, 'at our period, people worshipped Venus in that form'.[44]

73
Vénus du Gaz 1945
Cast iron conduit and
gas-jet for a gas cooker
25 x 9 x 4
Private Collection

At the time of the revelatory exhibition of Picasso's sculpture that was staged in 1967 at London's Tate Gallery, one visitor, now a leading Picasso expert, recalls believing that Picasso must already be dead.[1] In fact, he would live for another six years. The history of European art is peppered with the names of titanic artists who outlived most of their peers: Michelangelo, Titian, Rembrandt all saw the world with the eyes of old men long after many of their contemporaries had died. Picasso is another such figure – but unlike these predecessors, as an artist who conceived of himself as a *modern*, in his later years he had to face the paradoxical prospect of already appearing to be a thing of the past. One by one many surviving friends from the triumphant years of his modernism disappeared: Eluard in 1952, Matisse in 1954, Braque and Cocteau in 1963, Sabartés in 1968, and both Christian and Yvonne Zervos in 1970.[2] The death of Eluard hit Picasso particularly hard, coming as it did as his relationship with Françoise Gilot foundered in the midst of his affair with Geneviève Laporte. Gilot finally left Picasso in September 1953, and he found himself without a female companion (a very rare circumstance) at the villa La Galloise that winter.

Later describing this as one of the worst times of his life, he set about making hundreds of apparently confessional drawings showing grotesquely ugly artists with youthful nudes, monkey painters, short-sighted connoisseurs – nearly all set in an artist's studio. The following year 180 of these drawings were published in the magazine *Verve*. They mark a significant change from his years of involvement in the Communist Party in favour of an examination of the world of the artist, interpreted as at once comic and glorious, ribald and tragic. This ambivalent attitude to the social role of the painter is one of the strongest currents in Picasso's work after the mid-1950s: although always trying to convince himself of his immortality, he could hardly have expected then that nearly two decades more of work lay ahead.

At the centre of Picasso's explorations of the subject of art is the figure of 'the painter'. On a sketchbook used while working on *Les Demoiselles d'Avignon* in 1907 he wrote: *Je suis le Cahier Appartenant à Monsieur Picasso Peintre, 13 rue Ravignan, Paris XVIIIe* ('I am the notebook belonging to Monsieur Picasso Painter . . .').[3] Similarly, in 1911 he drew a palette inscribed with the phrase *Picasso, Artiste Peintre, 11, Bd de Clichy, Paris*.[4] We do not know whether he was adopting this professional epithet seriously, or even which of its many social resonances he intended. The term *artiste-peintre* sprang up in the nineteenth century to distinguish practitioners of the liberal art of painting from decorators of houses. The term carried a range of references. Some *artistes-peintres* were Members of the Academy, finely turned out and well heeled, living in bourgeois apartments in the fashionable areas of the city. But *artistes-peintres* were also dandies, living the 'Bohemian' life immortalised in the sentimental novels of Henri Murger

6 Dream and Lie of Picasso

and Puccini's *La Bohème*. The *artiste-peintre* was often a tortured soul, living in poverty and alienated from the values of bourgeois society, a kind of social outcast associated with alcoholism and debauchery.

Certainly later on in life Picasso liked to play at being an *artiste-peintre*: he asked Brassaï to photograph him thus in 1944 (fig.74). The photograph shows Picasso in front of a large oil painting of a reclining nude recently bought from an antique dealer with the original intention, given the shortage of materials during the war, of reusing the canvas for one of his own paintings. On the floor is the actor Jean Marais, partner of Jean Cocteau, imitating the pose of the nude, while Picasso poses with a palette and brushes as if at an easel, an approach to the mechanics of painting that he hardly ever adopted. His dog lurks in the corner like something out of a Frans Hals portrait. In his account Brassaï also describes Picasso's ambivalent feelings towards the cultural elevation of the artist:

The *artiste-peintre*! . . . There is nothing [Picasso] abhors so much as the artistic – 'ivory tower' he calls it – attitude towards life . . . How many times have I heard him say: 'I do what I can. I am not an *artiste-peintre*', as if he wanted to clear himself of slander. And yet, in front of some panorama of the sea, some landscape, he has frequently repeated: 'Oh, if only I were an *artiste-peintre*.'[5]

If it was indeed at the moment of his arrival as a modern artist, when painting the *Demoiselles* and then in the deep in the mercurial creativity of Cubism, that he first started mocking the world of the *artiste-peintre*, it was nevertheless as this period came to a difficult crossroads with the onset of the First World War that he first depicted what seems to be an artist and model in the studio (fig.75). This small, unfinished painting, important for its turn in the direction of an ostentatiously awkward Neo-Classicism, remained unknown until after it entered the collection of the Musée Picasso, Paris, after the artist's death. The model is a nude clutching drapery; behind her is a painting on an easel and a palette hanging from a nail. The male figure is a sudden return to 'normality' for a 'seated man' often painted in the previous year or so in a Cubist manner. His pose is, perhaps, directly borrowed from Cézanne's famous *Card Player* series, while the distended anatomy of the Neo-Classical nude harks back to Ingres, thus producing a confrontation of two incompatible sources for Picasso's art.[6] The stature of these two artists as manifestations of the two kinds of *artiste-peintre* (bohemian and bourgeois respectively) in Picasso's imaginative universe grew steadily over the years. In 1959 he bought the Château de Vauvenargues at the foot of Mont-Sainte-Victoire, a mountain Cézanne made his own in dozens of late paintings; Ingres returned as a source for Picasso's art during his final years.[7]

The turning point that led to Picasso's sustained engagement with the theme of the artist's studio was the invitation to provide illustrations for a centennial edition of a story by Honoré de Balzac, set in seventeenth-century Paris.[8] In fact some of

the 'illustrations' were made from drawings executed before the commission, as Picasso later explained:

Illustration? I have never really illustrated anything, you know ... there are things of mine that they added to a text which they more or less resembled ... it was Vollard who had some of my engravings and then he asked Cendrars and Cendrars said 'why don't you put them with *Le Chef d'oeuvre inconnu* by Balzac' and so there you are ... that was that ... but in the end it wasn't proper illustration.[9]

Despite Picasso's blasé account, the Balzac 'illustrations' did include etchings that were made after he had read the story in about 1926, and some of them echo its themes. The one that seems most directly inspired by Balzac shows an artist drawing a seated woman knitting (fig.76). The swirling patterns on the canvas not only pun on the problem of abstraction, suggesting the forms of the ball of wool, but also allude to *Le Chef d'oeuvre inconnu* (*The Unknown Masterpiece*) at the centre of Balzac's story.[10]

However arbitrary the beginnings of his 'illustrations', Picasso seems to have found Balzac's story significant later on. He made a great deal of the fact that his studio from 1936 to 1955, the attic of 7 rue des Grands-Augustins, appeared to be the very studio in which Balzac's action unfolds.[11] *The Unknown Masterpiece* opens with the young Nicolas Poussin visiting an older painter, François Porbus, and encountering the mysterious artist Frenhofer. Frenhofer mentions the

74
Brassaï, Picasso posing as an *artiste-peintre* with Jean Marais as his model
1944
Silver gelatin print
22.5 x 33.5
Musée Picasso, Paris

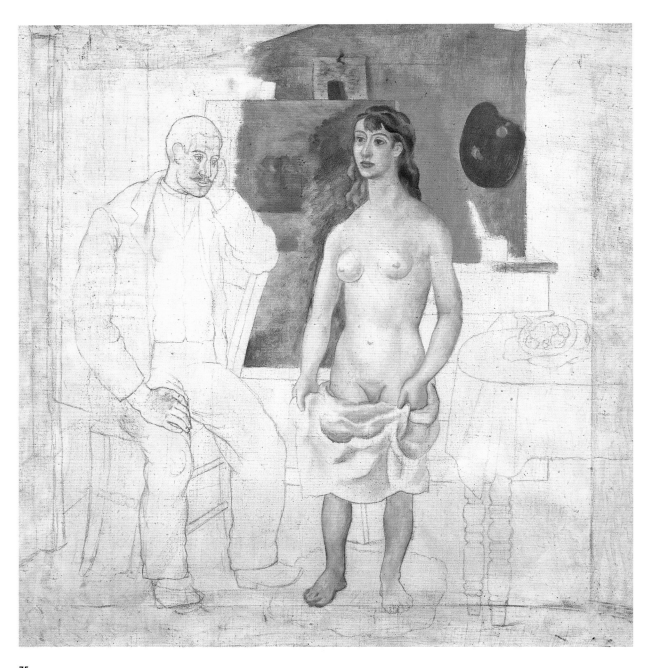

75
Artist and Model 1914
Oil and pencil on canvas
58 x 55.9
Musée Picasso, Paris

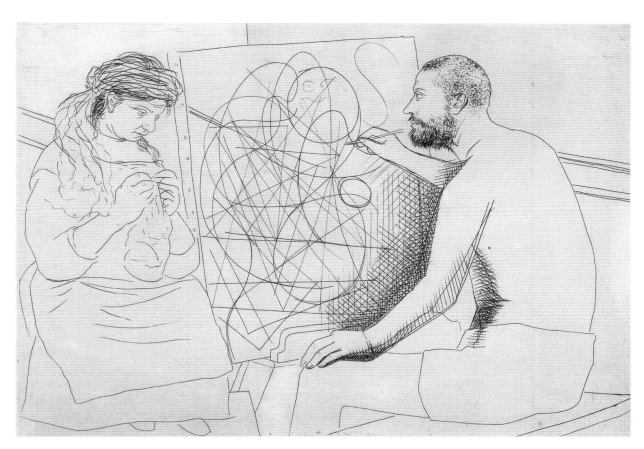

76
*The Painter and his Model
Knitting* 1927
Plate IV from
Le Chef-d'oeuvre inconnu
by Honoré de Balzac
(published 1931)
Etching
25.2 x 32.5
Museum of Modern Art,
New York

secret painting on which he has been working for ten years, the figure of a nude based on a model now lost to him. For want of a perfect woman to model, Frenhofer has been unable to bring the painting to conclusion. Porbus and Poussin collude in persuading Frenhofer to show them his painting by offering him the chance to compare it with the naked form of Poussin's beautiful lover, Gillette. Frenhofer, ecstatic to see that his creation is superior to Gillette's beauty, unveils his masterpiece to the two artists, who are shocked at what they see:

Coming closer, they discerned, in one corner of the canvas, the tip of a bare foot emerging from this chaos of colours, shapes, and vague shadings, a kind of incoherent mist; but a delightful foot, a living foot! They stood stock still with admiration before this fragment that had escaped from an incredible, slow, and advancing destruction.[12]

Frenhofer is outraged and then distraught at their reaction; he finally rediscovers his belief, accusing his friends of trying to steal his ideas: 'But I can see her! I see her, she's marvellously beautiful!'[13] That night Frenhofer burns his canvases and dies – we never learn in what circumstances.

Balzac's tale had a lasting impact on Picasso.[14] He linked himself to the sense of doubt central to modern art when, in an interview in 1935, he said to Christian Zervos:

It's not what the artist does that counts, but what he is . . . What forces our interest is Cézanne's

anxiety – that's the lesson; the torments of Van Gogh – that is the actual drama of the man. The rest is a sham.[15]

By the time he made these remarks he was sufficiently besieged by doubt about his own work as to resort to writing poetry. Some years earlier he had made a sequence of paintings on the theme of the painter and model in the artist's studio, which may owe something to the denouement of Balzac's tale, when Frenhofer's masterpiece is unveiled as a 'chaos of colours and shapes' from which emerges a vestige of beauty in the form of a woman's foot. His studio paintings of 1926–9 hardly qualify as direct representations of either chaos *or* Classical beauty, but they do represent the idea of a sublime artistic flight into fantasy that is also ludicrous, satanic or insane.

The central work of the series is *Painter and Model* of early 1928 (fig.77). Whereas the Balzac print (fig.76) represents the artist and model according to a broadly Classical language of art while the work on the artist's easel becomes a Frenhofer-like abstraction, in *Painter and Model* Picasso reverses the equation. The artist and model have now become bizarre ideographs: she is part sculpture, a sort of chess piece or bust, as well as a standing figure, while he is borrowed from one of Picasso's (sheet metal) objects of the same period (see Chapter 5). The artist sits on a tasselled floral chair, one arm extending upwards from his groin, equating brush and penis, the other a stick holding a palette. In the centre are his easel and canvas, the tacks along the stretcher edge plainly visible. The image made by this

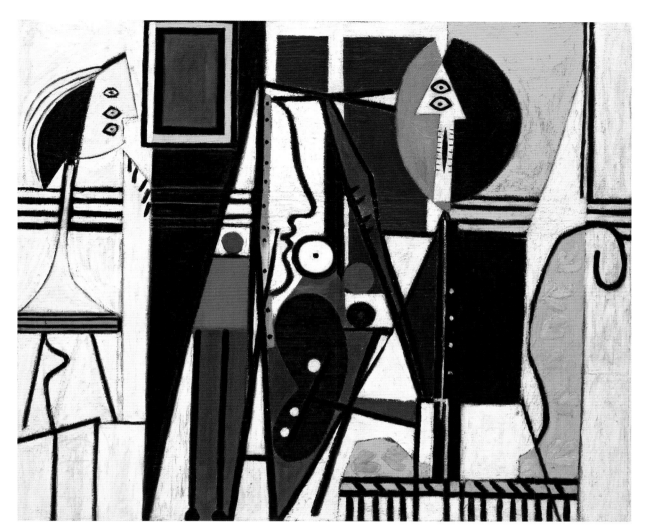

77
Painter and Model
early 1928
Oil on canvas
129.8 x 163.1
Museum of Modern Art,
New York

monster painter of this monstrous woman is, paradoxically, a simple, Classical profile. The coloured circles on the canvas stand for the idea of fruit in a bowl on what could be a table behind (with a red tablecloth?), for the breasts of the painted woman, and for the colours on the palette floating freely. The painter, whose face resembles that of Kota reliquary figures from Gabon collected by Picasso, was at first given a handlebar moustache (still visible close up), a feature which has been tentatively linked to Henri Rousseau, an *artiste-peintre* whom Picasso had known, admired and mocked.[16] Yet alongside the Surrealist inventions of the arrow face and vertical mouth of the painter, or the stacked eyes of both painter and model, is a domestic space made of coloured planes recalling the 'neo-plasticism' of Dutch artist Piet Mondrian.[17] On the wall behind the figures is a gold-framed blank, possibly a mirror, or perhaps an austere abstract painting.[18]

The notion that Picasso was interested in the studio as a kind of magical or ritualistic space, site of an otherworldly geometry of primary colours and re-imagined bodies, fits with a composition painted during the winter of 1927–8 (fig.78). Here the painter stands in place of the model of the second work, having the same three stacked eyes and framed by a vast yellow canvas (his brush is the only line to break the edge of its darker yellow frame). In the centre is a table with red cloth, upon which sits a geometric bowl with a single fruit. On the right end of the table, or perhaps on a dark plinth, is a white bust. Two rectangular framed objects, mirrors or pictures, occupy the upper centre. The painter is poised to begin his work, a still life with plaster bust worthy of Frenhofer, or perhaps of a bourgeois *artiste-peintre*, even if the pictorial reference may well be the late Cubism of Picasso's friend and fellow Spaniard Juan Gris, who died on 11 May 1927.[19] That particular artist's world may have passed, but here Picasso pays homage to his Cubist universe with an appropriately fantastic and mobile space.

The juxtaposition of ordered space and monstrosity in the 1928 *Painter and Model* has been described as a play between 'architectural' and 'vertiginous'.[20] This is an idea that draws in part upon the German art theorist and critic Carl Einstein, who argued that what such works represent is a 'tectonic hallucination', or a visualisation deriving from a clash of ordering and spontaneous mental impulses, rather than the study of reality according to received ideas or norms, and certainly not resulting from any kind of realism.[21] Einstein's is an impressive approach to Picasso's achievement in these paintings, but it does not capture Picasso's artistic Frenhofer fantasy, of an excessive or sur-real realism where the quest for beauty leads to madness.

Einstein had, perhaps, seen *The Studio* and *Painter and Model* at Paul Rosenberg's gallery in 1929. They were shown on several occasions then and in 1930, and both featured in Barr's major retrospective in New York's Museum of Modern Art in 1939.[22] The permanent presence of the two paintings in New York was of major importance for many young painters: Arshile

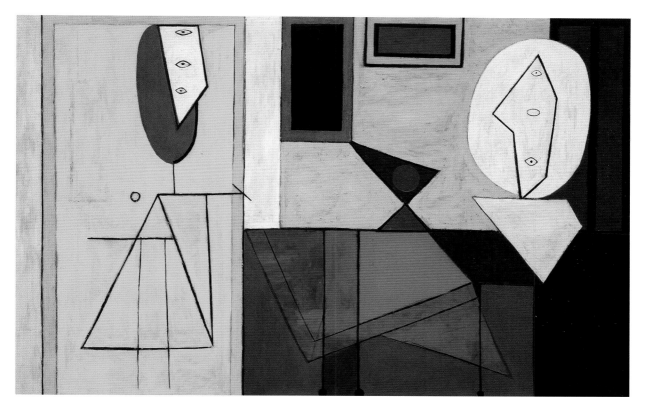

78
The Studio
1927–8
Oil on canvas
149.9 x 231.2
Museum of Modern Art,
New York

Gorky, for example, painted his *Organisation* 1933–6 (National Gallery of Art, Washington, DC) partly under the impact of *The Studio*.[23]

Even if these two works achieved a very high profile, several other major statements in this series remained hidden. A painting called *The Artist and his Model* of 1927, almost as large as *Les Demoiselles d'Avignon*, has remained little known while cloistered in the Tehran Museum of Contemporary Art. Meanwhile, *The Studio* (fig.79), painted during the winter of 1928–9, was retained by Picasso for his personal collection and only became known with the settlement of the estate in the late 1970s. The picture shows the artist standing in front of or behind an easel, leaning out to expose two vertically stacked eyes. A malformed sculptural bust sits on the table in the centre. On the right is a shadow profile – as if an echo of the pictorial reality once so taken for granted.[24] This painting has none of the vivid colouring of the two predecessors discussed here; rather, it is a grey and rusty brown affair that is laterally compressed, evoking psychological intensity.

Picasso showed several of his great studio paintings in his retrospective in Paris in 1932. One critic, mindful no doubt of his Balzac illustrations, thought that he would end up like Frenhofer.[25] It was an identification that Picasso continued to ponder in later years:

That's the marvellous thing with Frenhofer … At the end, nobody can see anything except himself. Thanks to the never-ending search for reality, he ends in black obscurity. There are so many realities that in trying to encompass all of them one ends in darkness.[26]

Picasso said this in 1959, two years after completing, or in a sense failing to complete, one of his most sustained studies of the artist's practice: variations on Velázquez's *tour de force* of realism, *Las Meninas* (fig.81). His project was one of a number of attempts to investigate, reinterpret and defy major works of European art, a practice that began in earnest in late 1954, after the death of Matisse and the arrival in Picasso's life of a new lover (Jacqueline Roque), with variations on Delacroix's *Women of Algiers*. The second major suite of variations was based on *Las Meninas*, which had a special place in Picasso's heart: he had first seen it in Madrid in 1895 in the company of his father, and again in October 1937, when the painting was in storage in Geneva.

Las Meninas is a monument in Spanish art, lauded in early accounts as 'reality, not painting'.[27] It depicts the daughter of Philip IV of Spain with ladies-in-waiting, dwarf clowns, chaperone and bodyguard, with the queen's chamberlain in the doorway behind them. Behind a large canvas on the left is the figure of Velázquez himself. The question of what the artist is painting has long been debated – is it the scene we see, or a double portrait of the king and queen, visible as blurry presences in the mirror at the back of the room, or neither? After the 1940s *Las Meninas* became increasingly interpreted as a paean to the

79
The Studio 1928–9
Oil on canvas
162 x 130
Musée national d'art moderne, Centre Georges Pompidou

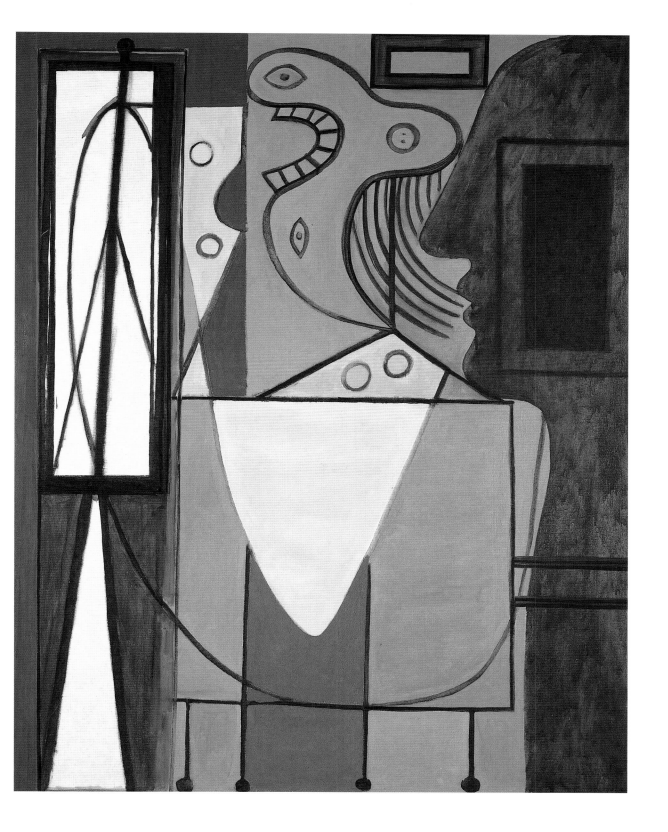

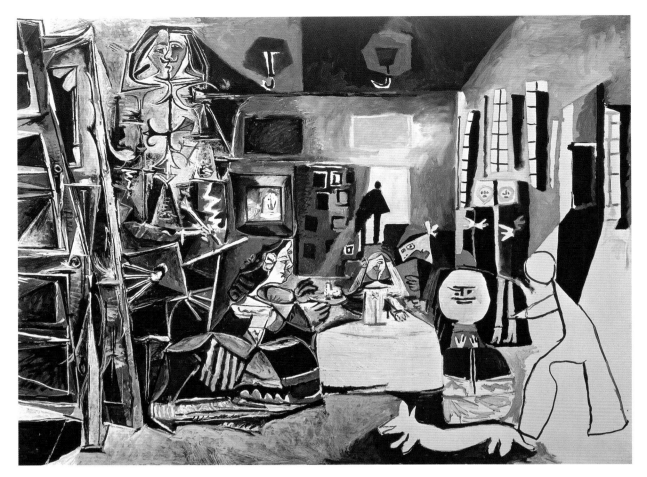

80
After Diego Rodriguez de
Silva y Velázquez
Las Meninas 1957
Oil on canvas
194 x 260
Museu Picasso, Barcelona

81
Diego Rodriguez de Silva
y Velázquez
Las Meninas 1656
Oil on canvas
318 x 276
Museo del Prado, Madrid

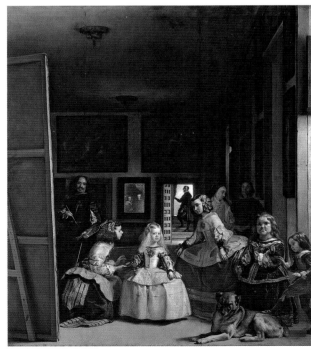

art and philosophical value of painting, and a triumph of self-portraiture. As one of the most impressive and puzzling representations of the artist and his models, the painting was a natural target for Picasso's ambition.

As with his later *Sabines* variations (see Chapter 4), Picasso worked from photographs, in solitude on the upper floor of his La Californie villa. Between 17 August and December 1957 he made 45 *Meninas* paintings, the first (fig.80) being his largest work on canvas since *Guernica*, which may account for the photographic monochrome and the quirky choice of a landscape format.[28] This first picture is the most elaborate response to the composition; most subsequent variations focus on individual characters and neglect the figure of the artist. This may be because Picasso intuited what is now believed: that the figure of Velázquez was added shortly after to what would have been a slightly more conventional royal portrait. But the suppression of the painter also reflects Picasso's frustration: he even tried to dismiss Velázquez as an *artiste-peintre*. 'It's going badly', he told Hélène Parmelin during the process,

Everything's going badly! It's *Las Meninas*. That bastard Velázquez. If he were only a really intelligent painter . . . Or even the greatest among the great . . . But he's not that at all. He's just Velázquez, he said, with all that implies. Fine bits of painting and the rest which sinks the lot. It's neither El Greco nor Goya; it's that bastard Velázquez.[29]

The first variation is faithful to Velázquez's record of the vast room in the Alcazar palace, complete with hooks hanging from the ceiling, but Picasso has the shutters on the windows open to let the light stream in. He adopts different modes of representation for almost every figure: white or black silhouettes; Cubist doublings of faces and profiles; childlike signs for facial features; bodies as boxes or coffins. Velázquez becomes a Cubist giant behind a shuddering canvas, while the mastiff is identifiably a dachshund, like Picasso's dog, Lump. The subject here is Velázquez's remarkable performance of pictorial space. Picasso's experiments with the chain of visibility, the ripple of gazes and gestures in the original painting, focus on Velázquez's capturing of a temporal moment rather than the conventional eternity of portraits of royal figureheads.[30]

Despite his frustrations, Picasso persisted with *Las Meninas* because it showed painting as 'an art that is intelligent about itself'.[31] He had said this of bullfighting, but for him bullfighting and painting were both reflexive arts, and for him the kinship of bullring and studio adds a sense of drama, of (mortal) risk, to this reflexivity. During his confrontation with Velázquez he said: 'One always thinks that to do a painting is just to paint . . . And yet it's worse than death in the bullring; it is death in the ring.'[32]

Escaping his work on *Las Meñinas* in autumn 1957, Picasso went to Arles (a town where he often watched a bullfight in the restored Roman arena), where his hotel

room had a small reproduction of a Van Gogh painting on the wall. He stayed up enthusing about the Dutch artist's life and struggles, bothering the guests in the neighbouring room and becoming increasingly bitter at the derisory treatment of Van Gogh's reputation, his art reduced to a mere hotel-room decoration. Picasso asked the curator of the town's museum for any mementos of Van Gogh's stay in Arles, site of the infamous incident where the artist severed a part of his ear. Picasso was given a copy of a contemporary newspaper cutting:

Picasso was much struck with this . . . He looked at it constantly, and said he was going to have it framed. This was how Van Gogh had been known in Arles, and with his name misprinted into the bargain. And now one could see *The Man with the severed Ear* in every shop window. All the painter's bitterness and his daily death were summed up in this, and for Van Gogh it was the literal fact.

Picasso often said: 'People think it's easy, I really don't know how people can think it's easy . . .'.[33]

During his last decades, Picasso expressed his earnest belief in a closed community of painters, a chain of 'masters' passing on the torch of painting through the ages. 'The true heirs are us, the painters, those who continue to paint. We are the heirs of Rembrandt, Velázquez, Cézanne, Matisse.'[34] Yet, with typical self-irony, he referred to the archetypal painter who is continually reincarnated to save painting from the hideous production of *artistes-peintres* as the 'Little Man' or 'Poor Chap'.[35] The irony was

necessary: in 1956 Clouzot's film *Le Mystère Picasso* (see Chapter 5) had to compete with Vincent Minelli's oscar-winning *Lust for Life*, with Van Gogh played by Kirk Douglas. Now, in the new era of mass cultural entertainment, 'the torments of Van Gogh' would themselves become a Hollywood 'sham'; Frenhofer's authentic quest once again turns back into tragicomedy.

Picasso had great fun with the tragicomic story of the 'Little Man' and his model in a series of paintings made in 1963–5, and then in *Suite 347*, a set of etchings completed in 1968. These etchings – and a subsequent suite of 156 made in 1970–2 – were the fruit of Picasso's collaboration with printer Aldo Crommelynck and his elder brother Piero. Picasso met Aldo in the 1930s, but it was not until 1963 that the brothers set up a print workshop in Mougins, near Picasso's main home after 1961, the farmhouse called Notre-Dame-de-Vie. In 1965, following an operation in Paris, he began painting his 'musketeers' (see fig.40), characters which feature heavily in the *Suite 347* prints. For Picasso printmaking was a medium in which he felt relaxed, taking pleasure in working with skilled technicians and able to distance himself from the intensity of his relationship with painting.

In early September 1968 he added a further dimension to his depictions of the artist's struggle, making explicit the erotomania that is only hinted at in Balzac's novel. The pretext was Ingres's own imagining of a Renaissance artist falling in love with his model, *Raphael and La Fornarina*

1814 (Fogg Art Museum). Years before, Picasso had made Paul Eluard read aloud the chapter on Raphael from Vasari's *Lives of the Artists*, but his real interest was in Ingres's fascination with Raphael. To this Picasso added the fascination of Michelangelo for Raphael's artistic achievement, imagining Michelangelo to have a voyeuristic interest in Raphael's sexual prowess.[36] A print made on 5 September 1968 (fig.82) shows Raphael and La Fornarina copulating on a bed at top right. As elsewhere in this series, Raphael multi-tasks, brandishing his palette and brush while adopting a challenging sexual position.[37] The painter's equipment is thus a thinly disguised metaphor for his sexual 'equipment'; painting and copulating are equated.[38] Meanwhile, beneath the bed lurks a peeping Tom – Michelangelo; an ageing Pope Leo X sits on a chamber pot on the left, warming his hands in a muff. In the centre of the print is a comically small tondo of a seated nude woman in an armchair. This completes the long equation: painting = sex = looking = art.[39]

The absurdity of the equation of painting and sex here shows Picasso's theatrical defiance in the face his own predicament as an old man no longer capable of sexual acrobatics, an ageing painter viewing the antics of a suave young artist. For some writers this is the nature of Picasso's 'Endgame', an explosion of painting and drawing in the last few years of his life.[40] Much of his late output is erotic in nature, many paintings rejoicing in pleasures of the flesh. Some of the drawings,

however – grotesque images of old women masturbating – certainly do not share the humour of *Suite 347*.

In March 1961, at the age of 80, Picasso married Jacqueline Roque. After the death of Sabartés in 1968 she became his principal protector, managing the stream of visitors in order to ensure that Picasso had as much time as possible to work. He made over two hundred paintings between September 1970 and 1 June 1972, and after that worked on paper, producing self-portrait drawings showing himself at the age of 90, with an unshaven, emaciated face, staring down death.[41] The coloured wax crayons in the example illustrated here (fig.83) lend a vivid energy to a face seen as if pushed right up to the surface, a pictorial close-up, warts and all. The return of self portraiture in Picasso's work (he made very few after 1907[42]) links a dread in the face of mortality to a self-analysis as Frenhofer, for Picasso can now imagine himself, like Frenhofer, as condemned to die alone as a result of the overbearing magnificence – or perhaps even the incoherence – of his achievement.

These late self portraits, precisely dated and showing Picasso as a 'Death's Head', invite us once again to consider his works as diary entries. It is tempting to recall his teenage bargain with the Devil over the life of his sister Conchita: as she lay dying, he supposedly promised never to paint again should she live; his biographer John Richardson speculates that he may have broken the vow before Conchita died on 10 January 1895, casting a long shadow

of guilt across his life that rendered him pathologically obsessed with his own death.[43] 'He is very disturbed. For him death is a ghost', Jacqueline told Joan Miró.[44] Yet however terrified, he knew that his art could not be assimilated to his own being, physically or emotionally. Pierre Daix describes how, when Picasso first showed him his self portrait of 30 June 1972, he held it up next to his face to prove that the fear in the picture was invented, a fiction.

Picasso thought he had found something new with this drawing: three months later he was studying it again: 'You see', he told Daix, 'I really did catch something with this one'.[45] What Daix termed Picasso's 'easy, neutral' reflections on it continued into the autumn – but what was it that he thought had been caught or found there? What did he see? Picasso once insisted that he did not merely make his work, but lived it; in this sense the drawing formed an image in which the threshold of dying could be experienced.[46] 'We assume that life produces the autobiography as an act produces consequences, but can we not suggest, with equal justice, that the autobiographical project may itself produce and determine life?'[47]

This production of a lived life, not its reflection, is the central purpose of Picasso's vast oeuvre. He is sublimated as 'Picasso', a manifestation of lived life, now full of meaning. This is why, even in his nineties, he could surprise himself with a new dream image. For such dreams are also lies that open one's eyes to truth.

82
Raphael and la Fornarina XIX, the Pope on a potty and Michelangelo hiding under the bed
5 September 1968
Etching, edition of 50
15 x 20.5
Bibliothèque nationale de France

83
Self Portrait 1972
Wax and coloured crayons on paper
65.7 x 50.5
Fuji Television Gallery, Tokyo

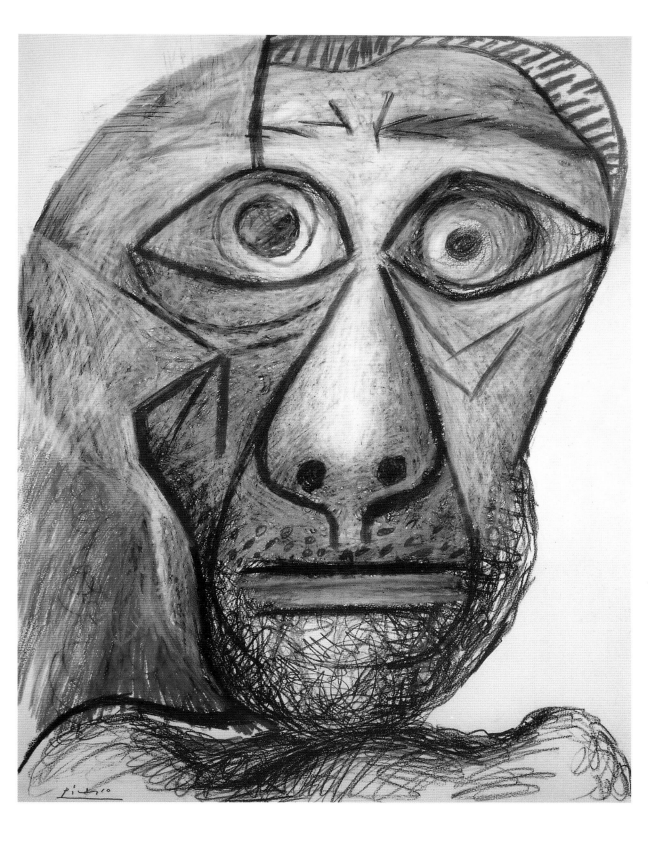

Reclining Nude Woman and Head

Painted on a standard canvas size that Picasso used for numerous other works in the early 1970s, this is one of his last large-scale works. Dated 25 May 1972, it exhibits many characteristics of his Mougins period: broad brushwork; a highly accented surface, with pools, crevices, encrusted areas and thin glazes of paint; bodies rendered in simple shorthand shapes; frontal composition; and strange colour schemes. The painting's present title (not Picasso's) suggests that what we see is the vestige of two figures. There are two heads: the central one is more easily read than that on the left, signalled by a single eye and nose. Beneath this left-hand head is what could be a torso: two dots in a pink field partially covering a black-edged rhombus. On the right is a huge flexed shape, perhaps a leg. The most legible element is a pink vulva dead centre, fringed with daubed black hairs, represented as a vertical line terminating in a dot: the vagina and anus as exclamation mark.[48] This element is typical of Picasso's late nudes – he spoke in these last years about reducing painting to a kind of sign language: 'I would like to invent a catalogue of "signs", in which you could simply look up something when you need it. Say you need a breast – zoom, you get it out of the catalogue.'[49] 'I want to say the nude. I don't want to do a nude as nude. I only want to *say* breast, *say* foot, *say* hand or belly. To find a way to say it – that's enough. I don't want to paint the nude from head to foot, but succeed in *saying*.'[50]

Picasso's 'saying' in this picture was far from predetermined, since there is plenty of evidence of major revision. The white-dotted field of blue, perhaps a foaming sea, is partially painted over, but the rest of the painting has been boldly blanked out in white, creating a strong sense of lateral space and leaving visible traces of buried forms. These adjustments and revisions are evidence of the process of painting, and in particular of the speed of execution, doubtless another symptom of Picasso's race against mortality. 'I have less and less time', he said, 'and I have more and more to say'.[51] It has been suggested that the sense of urgency in these late works may

reflect a ruthless imposition of a time limit on each painting, which might explain the extraordinary differences in apparent technical skill between prints and paintings in the last years.[52] There is also, however, a strong argument for viewing the provisional and clumsy appearance of the late paintings as a deliberate tactic to 'say worse', invoking a powerful sense of immediacy by eschewing technical fluency: not so much an urgency driven by fear of death, but by a desire to 'preserve the directness and spontaneity of [the] first rush of inspiration'.[53]

Reclining Nude Woman and Head was exhibited in Picasso's second (and posthumous) exhibition at the Palais des Papes, Avignon, in 1973, under the title *Figures*. Unlike the exhibition in the same venue three years earlier, no examples of the technical fireworks and assured handling of drawings and prints were included this time: the second show featured paintings only.[54] The invective heaped upon the work in this show was merely a continuation of a critical trend already established in Picasso's lifetime. The magazine *Arts* produced a special issue on the occasion of Picasso's eighty-fifth birthday. Principal among the concerns of various critics was an unfavourable comparison with another old man: Marcel Duchamp. Leading avant-garde ringmaster Pierre Restany put it this way: 'viewed again from a distance of another forty years by the new … generation, Duchamp's readymades have killed the fascination with Picasso that was rooted in brute pleasure in painting …'.[55]

Picasso took these criticisms very badly, and responded with bitter private condemnation.[56] In the years after his death the crude opposition between his late paintings and neo-avant-garde art inspired by Duchamp became crucial in arguments over the 'Late Picasso', and scholars and critics who had lauded the late work from the start strove to convince the wider art public of its complexity and importance. The motives for the gradual resurgence of interest were inevitably not purely aesthetic, however. Some dealers understood early on that this stockpile of paintings could be

84
*Reclining Nude Woman
and Head I* 1973
Oil on canvas
130 x 195
Private Collection

promoted advantageously. The settlement of Picasso's estate left members of his family with large numbers of late works that they could now lend. The Galerie Louise Leiris in Paris also held large quantities of such works. In the touring exhibitions of the artist's donation to the French State, and in the Museum of Modern Art's major retrospective of 1980, late paintings were not celebrated (the latter featured only four examples). In 1981 things changed: there were shows in Basle and New York; however, most significantly in terms of the reinvention of Picasso's late paintings as a 'contemporary' phenomenon, they featured in the exhibition *The New Spirit in Painting* at the Royal Academy of Arts alongside works by 'new' painters such as Georg Baselitz, Frank Auerbach, Anselm Kiefer and Julian Schnabel.[57]

By 1988, with the jointly organised major exhibition at the Centre Pompidou, Paris, and Tate, London, *Reclining Nude Woman and*

Head had already been branded as 'Late Picasso'. 'Lateness' is of course a temporal concept that, as well as being a stylistic category built on the notion of narrated life, can also be thought of in relation to cultural and historical meanings and understandings.[58] Perhaps the questions posed by the second exhibition in Avignon found no answer in 1973, so the work was ignored. Whether or not the institutionalisation of 'Late Picasso' in the 1980s was an answer, or whether we still have not understood Picasso's interrupted acts of painting, remains an open question.

Picasso's Techniques

Picasso's varied approaches to the many media in which he worked demonstrate both a willingness to improvise and an interest in technical skill.[1] In a conversation recorded in 1932 he gave a good indication of his general attitude:

> Technique? I don't have any, or rather, I have one but it wanders a great deal, according to the mood I'm in when I begin working. I apply it at will to express my idea. I think I have discovered many methods of expression, and still I believe there are a great many more to discover.[2]

At a time when he was becoming interested in notions of the seismic recording of his mental life, Picasso here acknowledges the importance of being at ease with the technical demands of any medium as a prerequisite for expressive effect.

Painting and drawing

Picasso's first and most valued media, on which his education at art school were based, were drawing and oil painting. His early paintings were made traditionally, with paint blended on a palette before being applied to the canvas and controlled surfaces with little impasto (thick, raised areas of paint). The young Picasso used perspective construction to model the space in his pictures and he gave volume and mass to his figures based on the principles of drawing learnt from studying plaster casts and life models, requiring particular attention to the use of directional light and its logic of light and shade in the depiction of bodies and faces.

He was swift to abandon the rules of academic painting and drawing, rejecting in particular notions of 'finish' and favouring instead roughly painted surfaces that retained the drips, changes of mind and scrapings that suggested improvisation and spontaneity. By the time he painted *Les Demoiselles d'Avignon* (fig.28) in 1907 he often diluted oil paint to the point where it became a matt wash with the appearance of gouache. By now he had also stopped using a palette (he sometimes used a newspaper instead), and in any case often did not bother to mix paints before applying them to the canvas. At some point Picasso abandoned the academic practice of varnishing his paintings, though it is hard to tell when, since his paintings continued to be varnished by others in order to make them conform to expectations of brightness and colour. As his Cubism developed, Picasso's approach to painting became more and more inventive and even wilfully anarchic. Alongside the introduction of elements of collage discussed below, among his interventions in what had been a stable medium for hundreds of years was the introduction of industrial house paints into his oil paintings, particularly a brand of enamel paint called Ripolin; he continued to use both gloss and matt house

paints throughout his career. Picasso used contrasting types of paint to enhance spatial effects or to create textural juxtapositions that made objects appear more palpable. He increasingly deployed a negative drawing principle by overpainting, sometimes sharpening outlines or 'cutting out' new forms from existing layers of paint.

From Braque Picasso learnt the technique of combing paint using specialist metal decorators' combs to produce the effect of wood-grain. Characteristically, from the summer of 1912 he used the combs to produce the effect of neatly combed hair or moustaches, in paintings, such as *The Poet* (Kunstmuseum, Basle).[3] That same summer saw both artists adding heterogeneous materials, sawdust and sand, to their oil paint in order to enhance texture and impasto.

In the immediate post-war period Picasso experimented with hardboard and with the new material fibro-cement as painting surfaces, while the work of his last decade developed with audacity the idea of non-finish and of the free-flow of liquid paint, a cavalier approach perhaps suited to his musketeer and juicily erotic subjects.

He made drawings most days for most of his adult life, many of them preparatory to paintings, some of them reflections on works already completed, and others amusing gestures or caricatural exercises in self-mockery. Picasso used most kinds of drawing implement, including pencil, charcoal and crayon, but also ballpoint and felt-tip pen.[4]

Collage and *papiers collés*

One broad definition of collage might be as the incorporation of foreign elements into painting in a spirit of extreme juxtaposition, a definition well supported by Picasso's first collage, *Still Life with Chair Caning* (fig.12). *Papiers collés* might then be defined as collage within the medium of work on paper.[5] The technical variety of collage, and the subtle plays with the idea of *papiers collés*, are the product of Picasso's confidence in improvisation and his dialogue with Braque, another supreme technician and an artist less inclined to celebrate contradictoriness. If Picasso's first *papiers collés* followed the principle of Braque's invention closely, using newspaper fragments juxtaposed with charcoal or pencil drawing on a white paper ground, Picasso rapidly moved in the direction of adding coloured paper, wallpaper, and dressmakers' pins into the equation.[6] He also used gouache and gesso (chalk mixed with rabbit-skin glue, normally a primer for paintings on wood) as a means of creating solid blocks of colour different in effect from coloured paper; in at least one instance he used gouache to create a mute texture on coloured paper.[7] But as discussed in Chapter 2, his key technical feat with these new media was the transformation of pictorial space, so that the depth of perspective constructions all but disappears and the material character of representation leaps to our attention.

Sculpture

Picasso's sculptural work is extremely diverse in its technique. Although his first sculptures were made in the conventional materials of carved wood, plaster and clay, by 1912 he was making sculptural objects out of all manner of found materials, often combined through improvised constructive techniques. The elements of his *Still Life* of 1914 (Tate), a construction in painted wood, include roughly sawed pine (probably from a wine crate); an upholstery fringe glued and nailed to another, thicker piece of pine; diagonally sawn dowel painted to look like salami; and salvaged wooden moulding. The work also shows traces of the form of a Cubist glass over which Picasso changed his mind.[8] Such changes of heart reflect his working process: objects were half made or finished, then recycled in other objects. Photographs of his Cubist constructions published by Apollinaire in November 1913 show works in states that differ from their present form, the artist having apparently taking his tools to them afresh later on.[9]

The idea of working with found objects was exploited with brilliance during the late 1940s and early 1950s in the animal and figure sculptures discussed in Chapter 5. But Picasso sometimes, perhaps surprisingly, returned to the more conventional material of plaster as a medium for figure sculpture, most tellingly during his burst of activity in Boisgeloup in the early 1930s, where he made both emphatically three-dimensional works and relief carvings. (Some of these reliefs may not have been carved, however: he told Kahnweiler that he had made them by hollowing out forms in sand and then pouring in wet plaster.[10]) Meanwhile, for his monumental and emotionally charged *Man with a Sheep* (fig.51) of 1943 he returned briefly to modelling in clay.

Picasso made sculptures with the most fragile of materials – paper and card – and, often with the help of collaborators, with the most resilient, including metal and concrete. During the war he made tiny paper sculptures of animals or skulls by tearing paper and burning it with his cigarette. By contrast, he made highly resilient welded metal pieces with Gonzaléz in the late 1920s and early 1930s, and sheet metal objects with Joseph-Marius Tiola, a technician at a scrap metal business, in the early 1960s.[11] In 1957 Picasso began collaborating with Norwegian sculptor Carl Nesjar to reproduce some of his sculptures on a monumental scale, using sandblasted concrete. The climax of this collaboration was the figure group based on Manet's 1862 painting *Déjeuner sur l'herbe* (Musée d'Orsay, Paris) now in the gardens of the Moderna Museet, Stockholm (installed 1965). Picasso made eighteen small cardboard maquettes (or models), four of which Nesjar transformed into concrete sculptures some 3–4 metres high.[12]

Ceramics and precious metals

Picasso delighted in practising a wide variety of decorative arts regarded as minor both in the academy and in contemporary writing on modern art, such as ceramics and gold and silverwork. In ceramics he was a determined innovator, attending assiduously to the information he gleaned from technician Jules Agard at the Madoura Pottery, Vallauris, from 1946, and supplementing his knowledge by visiting a local chemical works.[13] The early structural pots he made from forms thrown by Agard were sometimes over-ambitious, collapsing or fragmenting in the kiln. As a painter Picasso was particularly interested in the permanence of colour, though in all cases there was a fundamental challenge: the colours did not show until after firing, so he was, like all ceramic decorators, working blind. He engraved patterns or pictures into the clay by scratching them into the surface (a technique called *sgraffito*) and also atempted to draw on the clay with paraffin wax, creating a wax-resistant effect when painted over with a glaze. He also applied hand-moulded or cut-out shapes to plates and painted them in *trompe-l'œil* fashion; in other works he made painted sculptural objects from kiln furniture (the clay forms used to support the shelves on which objects were placed for firing); and in others he used corrugated cardboard as a mould for texture. In an unusual gesture Picasso licensed the Madoura pottery to produce editions of some of his plates from moulds, though some of these lack the spontaneity of the artist's own painted glazing.

His forays into manufacturing jewellery and salvers in gold and silver have only recently been the subject of study.[14] Picasso had made jewellery for Dora Maar by adapting existing brooches or rings through engraving or drawing, and he made gold brooches for Gilot by engraving them with pictures of his children. The idea of working in gold was developed with the aid of his dentist, who helped him make a necklace for a friend. Jacqueline Roque seems to have commissioned gold jewellery from the smith François Hugo, but Picasso was not directly involved with most of these pieces (although he did make ceramic necklaces for Jacqueline). He was much more enthusiastic in his collaboration with Hugo over silver plates, dishes, vases and plaques, which lasted from 1956 until 1961. The forms and designs of these pieces were made on the same principle as the editioned ceramics, based on Picasso's interventions in plaster moulds normally used for making plates at Madoura. He drew in the plaster with a tool or pressed objects into it while it was still damp; when clay was pressed into the dried-out mould, the result was a plate with a raised design in Picasso's hand. As the partnership developed, Picasso and Hugo made platters or dishes on stands, the pieces showing a developing interest in contrasting finishes in silver, using polishing and burnishing against less finished surfaces.

Printmaking

Picasso made enthusiastic use of intaglio printing techniques (such as drypoint, where lines are incised in a metal plate, or etching, where the lines are drawn in varnish and then burned into the plate with acid), planography (especially lithography, where the image is drawn on stone using a special crayon to which the ink sticks), and after the Second World War he also embraced relief-printing methods (involving cutting away the negative elements to leave the positive, raised image for printing), particularly linocut, with which he had only toyed before.[15] One of the most important printmakers of the twentieth century, he excelled in his technical command of intaglio techniques, taught by highly skilled technicians such as Roger Lacourière and Aldo Crommelycnk. From Lacourière he learnt techniques that could add tone or shading to prints, such as sugarlift aquatint, which involved painting a sugar solution on to the plate so that when it was dipped in acid the sugar dissolved and the acid bit tiny grainy dots. By the time Picasso made his late series of etchings with Crommelynck, the *Suites 347* and *156*, he reportedly had such an excellent command of the tools and processes involved that he could achieve new effects in the medium.

Although he had experimented with lithography in the 1930s, it was not until he worked with Ferdinand Mourlot that Picasso became more adept at the process, producing some 400 prints. He used not only crayons but also a lithographic paintbrush, and he also used a transfer process to draw on a sheet of paper and then transfer the image to the stone, producing in the end a positive rather than a negative image.

Picasso also made linocuts from 1951, when he met Hidalgo Arnera in Vallauris. Tiring of the laborious process of making a linocut for each different colour to be printed in the same image, he came up with his own bravado solution, cutting for one colour and then returning to the same sheet of lino cut the next colour. Such a trick depended of course on the ability to improvise an image, and to foresee how it might develop in coloured stages. Picasso also invented a technique of washing linocut prints in the shower, printing in cream lithographic ink on white paper, painting over the paper with black ink and then rinsing in the shower, producing a pale grey and textured ground with a strong line drawing.

Photography and film

Recent publications and exhibitions have revealed the degree to which Picasso engaged with photography and, to a much lesser degree, film, throughout his life.[16] He seems to have acquired his first camera around 1908, though he had previously taken photographs using a friend's camera. He started using a camera very early in his career to record works in his studio, sometimes as backgrounds to portraits but often just as studio views;

other photographs relate to motifs that appear in his Cubist paintings, as in his photographs of Horta from 1909. By 1913 he had started drawing on photographs, translating views of Cubist works and assemblages back into two-dimensional geometries. He also used masking-off during the printing process to fragment his photographic images. From the Cubist period onwards he sometimes engraved photographic plates or negatives, and during the 1930s he made portraits of Dora Maar by painting directly onto glass plates that were then printed as photographs. Collaborating with André Villers in the late 1950s, Picasso made photographic cut-outs in a process involving cut paper, photographic paper and objects.

Genres

In the academic tradition in which Picasso trained there was a clear hierarchy of subject matter for paintings. Depictions of history, mythology and religious themes were considered the most noble and lofty subjects, demanding the most complex skills for their representation. Next in rank were scenes of village or town life, then landscape, and last of all, still life. This hierarchy mattered for artists who sought success on the terms of the academy. For those, like Picasso, whose artistic careers were in a sense based on defying the principles cherished by his educators, the hierarchy was there to be ignored. Thus still-life painting played a central role in Picasso's art, and he furthered its cause in a radical fashion by making numerous still-life sculptures.[17]

Nevertheless, Picasso's still-life paintings rehearse many of the standard forms of the genre: there are *vanitas* depictions (reminders of mortality) complete with skulls, sheeps' heads or candles; there are the food-laden tabletops with bowls of fruit, wine bottles or plates of fish garnished with lemon; and there are the tobacco still lifes, showing pipe, newspapers and wine glasses. He also rehearses some of the game or kitchen still-life compositions of Chardin, the leading eighteenth-century exponent of the genre: Picasso's *Dog and Cock* 1921 (Yale University Art Gallery) is a clear homage to Chardin's *Le Buffet* 1728 (Louvre).

Picasso made some remarkable still-life paintings in tribute to lost friends, some of the best featuring the head or skull of a bull, such as the two pictures made after the death of Julio Gonzaléz on 27 March 1942 (Kunstsammlung Nordrhein Westfalen and Pinacoteca di Brera, Milan). He also, under the impetus of Surrealism, made still life into an art of burgeoning eroticism, as in the large musical still lifes of 1924 (Solomon R. Guggenheim Museum, New York; National Gallery of Ireland, Dublin).[18]

Like many other artists of his generation, Picasso did of course invent his own subjects and forms of art, such as his series of minotaurs, which are to some extent sub-genres. Yet at the same time the nature of the modern exhibition, together with the modern artist's career, markets, and audiences, make the old genre classifications redundant.

Picasso's Writings

. . . you can write a picture in words,
just as you can paint sensations in
a poem.[1]

Picasso's views on his own art and that of others, and his attitudes to politics and to life, are well known in English thanks mainly to the wonderful anthology *Picasso on Art* edited by Dore Ashton in 1973, which supplements many memoirs or records of conversations published by friends and ex-lovers.[2] In 1998 an excellent new anthology appeared in French.[3] Nearly all the material included is based on interviews or reported speech. Less well known are Picasso's literary activities. Aside from letters to his friends or business correspondence, most of what he actually wrote is in the form of prose-poetry.[4] Some 280 of these poems appeared in a flurry from 18 April 1935 to late 1940, and he produced a further 80 sporadically up to August 1959.[5]

The majority of Picasso's poems (around 200) are written in French (some oscillate between French and Spanish), with the remainder composed entirely in his native Spanish tongue. Some of the manuscripts are accompanied by drawings, or show an interest in calligraphic effects, while others are roughly and furiously scribbled. He also wrote two plays, *Desire Caught by the Tail* (1941) and *The Four Little Girls* (1947–8), and *The Burial of Count Orgaz* (1959), a hybrid poem-play that was also his last important text.

Although his great supporter Gertrude Stein found Picasso's poetry weak, Michel Leiris compared it to the stream of consciousness writing of James Joyce, particularly his last major work, *Finnegan's Wake*, with its neologisms and freedom with punctuation, and its earthy humour.[6] Picasso's poems were published almost as soon as he had begun writing, thanks to the Surrealist poet André Breton, who prefaced them with his own essay, 'Picasso Poet', in the magazine *Cahiers d'Art*.[7] This intervention has meant that Picasso's poetry has been seen as fundamentally Surrealist. Certainly it is indebted to aspects of Surrealist poetic technique, including apparently random metaphors, vulgar or intense eroticism, and a sense of imagery being distilled to the point of obscurity, where it resembles the 'pure psychic automatism', unconsciously precipitated, described in Breton's 1924 'Manifesto of Surrealism'. Typically, in later life Picasso distanced himself from this association: 'Critics have said that I was affected by Surrealist poetry as well as by family problems. Absolute nonsense! Basically I've always written the same way . . . Poems about the postman or the priest.'[8] His poems are nevertheless driven by an irrational and endless flood of images, unconnected words and numbers, where each fragment is precisely dated, suggesting the recording of thought.

Reflecting on the artist's relationship to Surrealism in the early 1960s, Breton described Picasso's poetry as 'semi-automatic'; the double meaning functions well enough to capture the scattergun craziness of many texts.[9] Some poems appear in verse form, though these are mostly scabrous with only occasional

examples of lyric tenderness. In their very precise dating they often beg the questions of autobiography, biography and identity discussed in Chapter 1 above. Some poems refer directly to Picasso's work, or to great works of the past, but more often they reflect a kind of collage of everyday events, thoughts or things.

Note: *The excerpts below are drawn from an important recent anthology of translations. It uses the American English idiom to capture Picasso's occasionally slangy or vulgar turns of phrase. The date headings are Picasso's own.*

Boisgeloup – 18 April x x x v

if I should go outside the wolves would come to eat out of my hand just as my room would seem to be outside of me my other earnings would go off around the world smashed into smithereens but what is there to do today it's thursday everything is closed it's cold the sun is whipping anybody I could be and there's no helping it so many things come up so that they throw the roots down by their hairs out in the bull ring stencilled into portraits not to make a big deal of the day's allotments but today has been a winner and the hunter back with his accounts askew how great this year has been for putting in preserves like these and thus and so and always things are being left behind some tears are laughing without telling tales again except around the picture frame the news arrived that this time we would only see

the spring at night and that a spider crawls across the paper where I'm writing that the gift is here the others putting ties on for the holidays . . .[10]

nothing more than that my little darling

so unknot your veil and tell your teacher that you're jealous that it's all the same to me and if we trace a line from A to C and K to T bypassing X and Y and subdividing D x H it's just the same as what a parrot has so let them give it all to me I've seen it all a thousand times and more I've got it clinched because it's necessary to believe in mathematics and art is really something else

with the *curas* and their *culos* it's olé no way josé and the chick I want to lay with a porkchop in her porgy and the swallows with a switchblade clean and mean a little sky . . .[11]

Paris Sunday 7 August x x x v

(1) swooping up the handout in his golden plate – in garden garb – here comes the bullfighter – his joys are bleeding through his pleated cape – and with his pinking shears he cuts out stars – his body shaking out the sand from clocks – inside a square that dumps a rainbow on the bull ring – that fans an afternoon of painless birth – a bull ring is being born – a pin cushion that cries out loud – that whistles as the race track whizzes by – a round of handclaps ink aflame in cazuela – his hands that draw the air out of the melted glass – the crown of

mouths – and eyes like 'birds of paradise'
– the flags in hand go sailing off –at roof's
edge – he climbs down a ladder hanging
from the sky – cloaked in desire – love –
behind the fence he soaks his feet – he swims
around the bleachers like a champ

(II) this venus pricked by pin point
disappears – and leaves her lover staring
after her only the imprint of her body no
the sand – and that the wave erases it in its
haste[12]

28 October xxxv

if I think in a language and write 'the dog
chases the hare through the woods' and want
to translate this into another language I
have to say 'the table of white wood sinks its
paws into the sand and nearly dies of fright
knowing itself to be so silly'[13]

8 December xxxv

if the drum boomboom consumes itself in
flames free willing in the sky and spikes it
with a thousand thousand banderillas – if
the ink be hidden so it scrapes its scabies at
its pleasure showing naught of nose betwixt
the flanges of the scissor in quick motion – it
is not that he is scared to climb the ladder
to the paper light athwart the little palm
tree – nor the reflection so distorted that it
causes grief and that the hand does falsely
show him underneath the table thus to fool
him when the clock is struck on seven of

this evening that may never end – if not
the wish to complicate the business of the
painting – and to have no peace and quiet
for even a moment – nor to deck himself
out from a wish for silence – but the naked
cup afloat atop the reddish slabber on the
tablecloth – an icy venus in his mouth – so
like an open knife – nor does he yet cry
out – only the seesaw at the deep end of the
garden keeps up with the measure of his
grief

at twenty before one at night my
grandmother's big balls are like potatoes
with tomatoes whistle jerk off up your ass
today december 9th of this year which is
1.935[14]

4 January xxxvi

the paintings are madwomen
struck to the heart
radiant bubbles
by the eyes taken by the throat
of the cannoning whip lash
beating its wings
around the square of his desire[15]

6 January xxxvi 3 am

she and I
from our heart
the finesse of its hearing is such
that at the eye which opens his wings
 fearful
the pigeon in the cage

fans the feather horse stretched out on its hazel-tree
rummages among the vermin
the ends of threads[16]

February 29 XXXVI

the raft of the medusa unties itself from the sea to take the wash of the bird's pocket mirror in its arms

if the raft of the medusa finally unties its chains flies through the dark its forehead hooks into the pocket mirror's wash

if the raft of the medusa divests its body of its chains and lets the rags of waves float hanging on by the fingertips its forehead grinds its caress on the stone of the wash cut by the detached wing of pocket mirror

if my raft of the medusa divests its body of its chains and only lets the rags of waves float hanging on by the fingertips its forehead grinds its caress on the stone of the wash cut by the detached wing of the tender wounded bird singing sitting on the tip of the great amorous buffalo's horn[17]

9 March XXXVI

Sabartés you who count the hours off one at a time tell them at half past 8 to jump into my bed until I wake from sleep
(now that it's just turned two a.m. the 9th of march the year MCMXXXVI)[18]

24 March XXXVI

pot
 saw
my lady
 gay
laugh sand[19]

6 October XXXVI

in the painting of 30 april canvas # 15 F.
woman seeing herself in a mirror puts down a comb with some hairs in its teeth and some lice in her hair and if possible some crabs in her pubic hair

(charming idea to add to the package)[20]

4 November XXXVI

mathematically pure illusory image of the terrifying throb of the piece of lace detached from sight of the vaginal burp farting at top speed the drawing reborn in the folds of the powder compact hidden under a layer of the gateau of lies glued to a tear-skittle reason that burns in the middle of the foot of the nose of the painting immersed in the silver soup plate
presents its back to the desperate blows of love removing its blindfold 3 4 5 10 29 0 10 224 3 3 0 10 11 23 32 34 35 38 22 tell me colours proofs presented against[21]

Dream and Lie of Franco
15–18 June 1937

owl fandango escabeche swords of octopus of evil omen furry dishrag scalps afoot in middle of the skillet bare balls popped into a cone of codfish sherbert fried in scabies of his oxen heart – mouth full of marmalade of bedbugs of his words – silver bells and cockle shells and guts braided in a row – a pinky in erection not a grape and not a fig – commedia dell'arte of bad weaving and smudged clouds – cosmetics of a garbage truck – the rape of las meninas cries and outcries – casket on shoulders crammed with sausages and mouths – rage that contorts the drawing of a shadow that lashes teeth nailed into sand the horse ripped open top to bottom in the sun which reads it for the flies who tack a rocket of white lilies to the knots spliced in the sardine heavy nets – lamp of lice where dog is and a knot of rats and hide outs in a palace of old rags – the banners frying in the skillet twist in black of ink sauce spilled in drops of blood that gun him down – the street soars to the clouds its feet bound to a sea of wax that makes its guts rot and the veil that covers it is singing dancing mad with sorrow – a flight of fishing poles alhigui and alhigui of the moving van first class interment – broken wings spinning in the spider web of dry bread and clear water a paella made of sugar and of velvet that paints a whiplash on its cheeks – the light blocked out the eyes before the mirror that make monkeyshines the chunk of nougat in the flames that gnaws itself the lips around the wound – cries of children cries of women cries of birds cries of flowers cries of wood and stone cries of bricks cries of furniture of beds of chairs of curtains of casseroles of cats and papers cries of smells that claw themselves of smoke that gnaws the neck of cries that boil in cauldron & the rain of birds that floods the sea that eats into the bone and breaks the teeth biting the cotton that the sun wipes on its plate that bourse and bank hide in the footprint left imbedded in the rock.[22]

Today 9 June of the Year 1939

dollop of syrup
frizzing her hair
like feathers
in the middle of the fried egg
smelling of her song
of lilies[23]

9.8.40

falls from the sky high blast furnaces wrapped in blood veils of his wings tree that flings itself out from the window head first to that sea with candles aflame and unfurled yellow green of an apple that scratches the cotton its gold coming loose from the wall daubed with jet blackened aloe with flames of the flange of the salt blazing up on the blind burro's belly and making the water wheel turn with his sword he has cut through the mirror . . .[24]

18 September 40
Seen in the Morning

I

petrified flames of angora clouds oozing
drool on the sky's liquid bricks stinking up
the sheets on the vines * the feet of the table
biting the breast of the sun that wallows at
its feet covered in chains * the canary of the
blue's harp sprinkled over the batter chimes
the hour with its little bells

II

cheese crusts tangled hair trees that
evaporate on the sky's flag stone laid on the
river's beams the wool oiled by the lamp
of his nostrils butter grass caress of fingers
swaddled breath a-tremble

III

the windows four corners shred the day
that dawns and wham a rain of dead birds
hits the wall and bloodies the room with its
laughter[25]

30 May 1943

intervention at each blood drop spattered
in iridescent sheaves and in silent mirrors
on fire and festivities put off developed
in music and songs rolled up as fields and
silks parsimoniously distilled detailed
descriptions on each page on each line on
each crushed sun . . .[26]

8–9 November 1944
. . .

the miraculous rainbow festoons of the jars
full of milk drinking with loud yells the
azureal blue jumping with both feet on the
tropics of the mirror hanging with all hands
at the window[27]

27 July 47. Antibes

the boreal dawn of the closed fan of her mane
of hair the nails jammed into the curtains of
sweat of the clenched screams at the spear-
head of the scared flocks of bronze moons
beating their wings kneeling around giant
amphorae dragged by the white lemon of the
sheets dirtied by the couple's horizontal blue
orange of the oxen . . .[28]

Vallauris Thursday 7 June 1951

we're in the sun

I hear Paloma crying in the garden

I see the tip of my foot stretched out on the
bed and the fireplace and the little radio the
books the newspapers the letters Rousseau's
portraits of his wife and himself this
afternoon at twenty past 4

and I see the armchair and the white jersey
that I wear at night and the blue jersey
bought in Paris at Old England and on the
wall Goya's engraving *lluvia de toros* (a rain of
bulls)

and in the mirror the upside down world of
the landscape and the room . . .[29]

**Paris 31 March 1952
(for Beloyannis)**

the glimmer of the lanterns' oil lighting
up the night of a Madrid may evening the
noble faces of the people shot down by the
rapacious stranger in Goya's painting is the
same seed of horror sewn by the fistful of
projectors on the open chest of Greece by
governments sweating with fear and hate.
A huge white dove dusts the anger of its
mourning over the earth.[30]

**Today the 23rd February 1955
. . .
for Don Jaime Sabartés on his Saint's Day**

I
my grandmother's big balls
are shining midst the thistles
and where the young girls roam
the grindstones whet their whistles

II
the sausage that you shove
up the ass of your señora
feels like a passion fruit
and the chokes of estramadura

III
the cardinal of cock
and the archbishop of gash
are a couple of well hung boys
with an eye for garlic and cash

IV
from the chairs on which the nuns
and the sacristan dropped their pants
hot honey sizzles their buns
till they cross themselves and dance[31]

**The Burial of the Count of Orgaz
. . .
14.8.57**

the burial of the Count of Orgaz continues

Don Diego Firm and Steady Don Ramon
Don Pedro Don Gonzalo Don the Judge
and Don the Pilgirim Don the Flavio and
Don Gustavo Don the Rich and Don the
Flower Don the Sausage Don the Instant
Don Ricardo Don the Rumble Don the
Joyboy Don the Blond and Don the Brunet
Don the Greybeard at the open circle's
edge they eat the silk the water pipe rains
down the golden wires of a party of small
owls crying sucking needed fringes . . . And
here the story and the celebration end.
And whatever has already happened even a
madman wouldn't know . . .[32]

Chronology

This timeline is based on those published by the Musée Picasso, Paris, the Museu Picasso, Barcelona, the Official Website of the Picasso Administration (http://www.picasso.fr) and the On-Line Picasso Project (http://picasso.shsu.edu/).

DATE	PICASSO'S LIFE
1881	25 October, Pablo Picasso born, eldest son of José Ruiz Blasco and María Picasso Lopez. Picasso's father is a painter and teaches art at the San Telmo School of Fine Arts. He is also curator of the Municipal Museum.
1884	Picasso's sister Lola is born.
1887	Picasso's sister Conchita is born.
1891	The family moves to La Corunna, following the appointment of Picasso's father as a teacher in the Guarda School of Fine Arts.
1892	Picasso enrols as a student at the Guarda.
1895	Death of Conchita from diptheria. Picasso's first visit to the Prado. After summer in Malaga, the family move to Barcelona. Picasso enters the Llotja School of Fine Arts.
1896	Picasso paints bullfighting scenes, sets up first studio with friend, Manuel Pallares, and completes large painting, *First Communion*.
1897	Studies at San Fernando Academy of Fine Arts in Madrid.
1898	Contracts scarlet fever. Stays with Pallares in Horta de San Juan.
1899	Returns to Barcelona, meets Jaime Sabartés and other poets and writers at Els Quatre Gats café.
1900	First solo exhibition (at Els Quatre Gats). With Carles Casagemas, in September makes first trip to Paris and meets Pedro Manach, his first dealer. Returns to Barcelona end December and is in Malaga with Casagemas for New Year.
1901	Suicide of Casagemas in Paris. Begins to sign his work 'Picasso'. Picasso works with Francesc d'Assis Soler on an art magazine (*Arte Joven*). Returns to Barcelona and then makes second trip to Paris. 25 June to 14 July, joint exhibition with Francisco Itturino at Ambroise Vollard Gallery. Meets Max Jacob.

1902	Returns to Barcelona, then third trip to Paris. Shares room with Max Jacob.
1903	Returns to Barcelona.
1904	Makes fourth trip to Paris, and stays. Takes studio in buildings in Montmartre known as Le Bateau-Lavoir. Meets Fernande Olivier, a model with whom he has a relationship lasting until 1912. Meets poets André Salmon and Guillaume Apollinaire and dealer Wilhelm Uhde.
1905	Spends three weeks of summer in Schoorl, Holland. Back in Paris, Meets Gertrude and Leo Stein, introduced to them by dealer Clovis Sagot.
1906	The Steins introduce Picasso to Henri Matisse. Goes to Barcelona with Fernande, then summer in Gósol, Northern Spain. Returns to Paris.
1907	Meets German art dealer and publisher Daniel-Henry Kahnweiler and artist Georges Braque. Visits Trocadéro Museum; sees and is impressed by African and Oceanic artefacts.
1908	Summer at La Rue-des-Bois, north of Paris.
1909	To Barcelona with Fernande; they then spend summer at Horta. Returns to Paris and moves studios to 11 boulevard de Clichy.
1910	Picasso and Fernande spend a few days of summer in Barcelona, then continue on to Cadaqués, where he paints alongside André Derain.
1911	July, leaves for Céret. Joined by Fernande and Braque in August. Returns to Paris in September. Begins relationship with Eva Gouel.
1912	Leaves for Céret, then Avignon. June, working in Sorgues, where he is joined by Braque. Breaks with Fernande. In Paris, September, moves to 242 boulevard Raspail. December, signs contract with Kahnweiler.

1913	March, leaves with Eva for Céret, where they are joined by Jacob. Brief trip to Barcelona after death of Picasso's father. Back in Paris in September, moves again to rue Schoelcher, Montparnasse.
1914	June, leaves for summer in Avignon, where he sees Braque and Derain onto a train to join the French Army. Returns to Paris in October.
1915	14 December, death of Eva in Paris. Picasso meets Jean Cocteau.
1916	Cocteau introduces him to Sergei Diaghilev. Picasso moves to southern Parisian suburb, Montrouge.
1917	February, leaves for Rome with Cocteau. Meets Stravinsky and Olga Khokhlova. End of March, visits Naples and Pompeii, returning to Paris end of April. Beginning of June, leaves for Madrid and Barcelona. End of November, Olga moves in with Picasso in Montrouge.
1918	Lives with Olga in the fashionable Hotel Lutetia. 12 July, marries Olga at Russian church in Paris, with Apollinaire and Jacob as witnesses. Honeymoon in Biarritz. Since Kahnweiler's business closed down by the war, enters relationship with dealers Paul Rosenberg and Georges Wildenstein. 9 November, death of Apollinaire. End of November, Picasso moves to 23 rue de la Boétie.
1919	Travels to London for premier of ballet *Le Tricorne*. Stays in Biarritz, then holidays with Olga at Saint-Raphaël on the Côte d'Azur.
1920	Meets young painter Joan Miró and they become friends. June, leaves Paris with Olga for Saint-Raphaël, then Juan-les-Pins, Côte d'Azur.
1921	4 February, birth of son Paulo. Moves to Fontainebleau with Olga.
1922	June, summer at Dinard, Brittany.
1923	Meets poet and critic André Breton. Summer at Cap d'Antibes.

1924	Summer at Juan-les-Pins.
1925	March and April spent in Monte-Carlo. To Juan-les-Pins in July. November, takes part in first exhibition of Surrealist art in Paris.
1926	Summer at Juan-les-Pins. October, visits Barcelona.
1927	Meets Marie-Thérèse Walter in Paris and begins relationship with her. May, death of Cubist painter Juan Gris. Summer holiday in Cannes with Olga and Paulo.
1928	Collaboration with sculptor Julio Gonzaléz. Salvador Dalí visits Picasso on first trip to Paris. Summer in Dinard.
1929	Summer in Dinard.
1930	Buys country house in Boisgeloup, north of Paris. Summer at Juan-les-Pins. During the autumn, Marie-Thérèse moves into flat at 44 rue de la Boétie, just down the road from the Picasso household.
1931	Creates sculpture studio at Boisgeloup. Summer at Juan-les-Pins. Printmaking activity increases.
1932	Christian Zervos begins to publish his catalogue raisonné of Picasso's work, a project that would comprise thirty-two volumes and last until 1978, remaining nevertheless incomplete. Zervos publishes special issue of his magazine *Cahiers d'art* on Picasso. Major retrospectives in Paris and Zurich.
1933	Holidays in Cannes with Olga and Paulo, leaving for Barcelona in August, returning to Paris in September. Participates in Surrealist periodical *Minotaure*. Fernande Olivier's memoir, *Picasso and his Friends*, is published against Picasso's wishes. First volume of Bernhard Geiser's catalogue of Picasso's graphic work appears.
1934	Trip to Spain with Olga and Paolo, where sees bullfights and visits museum of Catalan art in Barcelona, returning to Paris in September.

1935	In May, begins writing Surrealist poems. Separates from Olga in June. Sabartés becomes personal secretary and Picasso remains in Boisgeloup for the summer. 5 October, birth of daughter, Maya, to Marie-Thérèse. Friendship with poet Paul Eluard.
1936	25 March, leaves in secret with Marie-Thérèse and Maya for Juan-les-Pins. August, leaves for Mougins, where photographer Dora Maar, with whom he has embarked on a relationship, joins him. They are visited there by Roland Penrose and his wife Lee Miller, and by Man Ray. Is named Honorary Director of the Prado. Uses studio in Le Tremblay-sur-Mauldre belonging to Vollard as home for himself, Marie-Thérèse and Maya during separation from Olga.
1937	Takes studio at 7 rue des Grands-Augustins. February in Le Tremblay-sur-Mauldre. Visits Paul Klee in Switzerland.
1938	July, in Mougins with Dora Maar.
1939	His mother dies, but Picasso vows not to return to Spain until after death of General Franco. Leaves for Antibes with Dora Maar, both lodge with Man Ray. Publication of *Vollard Suite*, but Ambroise Vollard killed in car crash. September, leaves for Royan.
1940	In Paris frequently; May to August in Royan, then back to Paris to move possessions from rue de la Boétie to rue des Grands-Augustins before returning to Royan.
1941	Marie-Thérèse and Maya move into a new apartment on boulevard Henri IV. August, moves into rue des Grands-Augustins for duration of war.
1942	27 March, death of Julio Gonzaléz.
1943	May, meets and begins relationship with young painter, Françoise Gilot.
1944	5 March, death of Max Jacob. Mid-August, stays with Marie-Thérèse during battles to liberate Paris. Joins French Communist Party.

1945	Leaves for Cap d'Antibes with Dora Maar. Travels to Ménerbes, buying a house for her there. Begins making lithographs in the studio of Fernand Mourlot. Françoise Gilot moves in with Picasso in the autumn.
1946	Meets with Françoise at Golfe-Juan. Visits Matisse in Nice. 27 July, death of Gertrude Stein. Visits Madoura Pottery, Vallauris. August, stays temporarily with printer Louis Fort at Golfe-Juan, then in October begins working and living at the Château Grimaldi in Antibes.
1947	Gives ten major paintings to the Musée National d'Art Moderne, Paris. 15 May, birth of son, Claude, to Françoise. June, leaves for Golfe-Juan. Lives and works in Vallauris.
1948	Summer, moves into villa La Gauloise, Vallauris. August, attends Peace Congress in Wrocław, Poland. Returns in September to Vallauris.
1949	19 April, birth of daughter, Paloma, to Françoise. Attends Peace Congress in Paris in April. Acquires large studios, route du Fournas, Vallauris. Birth of Pablito, Picasso's first grandson, to Paulo.
1950	Awarded Lenin Peace Prize. Birth of Marina, Picasso's first granddaughter, to Paolo.
1951	Summer in St Tropez with young writer Geneviève Laporte. Is evicted from rue de la Boétie, but purchases two apartments on the rue Gay-Lussac.
1952	Death of poet and close friend Paul Eluard.
1953	Discussions between Picasso and officials from Malaga about establishing a Picasso museum there. September, Françoise Gilot leaves, taking Claude and Paloma with her to one of the rue Gay-Lussac apartments in Paris. Meets Jacqueline Roque.
1954	Relationship with Jacqueline develops. Deaths of André Derain (8 September) and Henri Matisse (3 November).

1955	11 February, death of Olga. Picasso leaves Paris with Jacqueline for the south, buys the villa La Californie at Cannes.
1956	Cannes Film Festival première of Henri-Georges Clouzot's film *Le Mystère Picasso*.
1957	Begins collaboration with Norwegian sculptor Carl Nesjar.
1958	Death of Picasso's sister Lola. September, buys Château de Vauvenargues near Aix-en-Provence.
1959	Birth of Paolo's son Bernard, Picasso's second grandson.
1960	Sabartés is instrumental in the agreement to establish a Museu Picasso in Barcelona, to which Sabartés donates his personal collection.
1961	2 March, marries Jacqueline Roque in Vallauris. June, moves into farmhouse Notre-Dame-de-Vie, Mougins.
1962	Second award of Lenin Peace Prize.
1963	Deaths of Georges Braque (31 August) and Jean Cocteau (11 October). Opening of Museu Picasso in Barcelona.
1964	Publication in English of Françoise Gilot's *Life with Picasso*, and, in French, of Brassaï's more favourable *Conversations avec Picasso*.
1965	Tries to prevent publication of French translation of Gilot's book. November, stomach operation at the American Hospital in Neuilly, outside Paris.
1966	Deaths of Fernande Olivier (20 January) and André Breton (28 September).
1967	Refuses the Legion d'Honneur. Loses his studio on rue des Grands-Augustins, Paris.

1968	13 February, death of Sabartés; in his honour, Picasso donates his 1957 *Las Meninas* variations to the Museu Picasso. Publication of first volume of catalogue by Georges Bloch of Picasso's printed works and ceramics, and of second volume of Bernhard Geiser's catalogue of prints.
1969	Yvonne and Christian Zervos plan exhibition of Picasso's latest works, to be staged at the Palais des Papes, Avignon, the following year.
1970	Early works previously retained by Picasso's family in Spain donated by the artist to the Museu Picasso. Deaths of Christian Zervos and his wife Yvonne. The Bateau-Lavoir is destroyed by fire.
1971	Made honorary citizen of Paris. Exhibition of his work in the Grand Galerie of the Louvre.
1972	25 November, Picasso awarded an honorary degree by the Faculty of Fine Arts of the Université de Paris I, Sorbonne.
1973	8 April, dies at Notre-Dame-de-Vie. Picasso is buried at Château de Vauvenargues on 10 April, where stepdaughter Catherine Hutin still lives. A few months later, grandson Pablito dies after drinking bleach, having been refused entry (along with Marina, Claude and Paloma) to the funeral by Jacqueline.
1974	Agreement to establish a Picasso museum in Paris.
1975	5 June, death of Paolo.
1977	20 October, suicide of Marie-Thérèse Walter.
1978	Settlement of estate and agreement to donate works in lieu of inheritance tax.
1979	11 January, death of Kahnweiler.
1980	Major retrospective exhibition at the Museum of Modern Art, New York.

1981	Touring exhibition of works donated to the French State.
1985	Musée Picasso opens its doors in seventeenth-century mansion the Hôtel Salé, Paris.
1986	15 October, suicide of Jacqueline Roque.
1990	Further donation of works to Musée Picasso, Paris, in lieu of inheritance tax on the estate of Jacqueline Roque.
1992	Personal archives of Picasso donated to the Musée Picasso, Paris. Exhibition of Picasso's classicism in Malaga revives project for a permanent museum collection there.
1997	16 July, death of Dora Maar.
2003	Opening of the Museo Picasso, Malaga, based on donations of works from the collection of Christine Ruiz-Picasso, Paolo's widow, and her son Bernard.

Where to See Picassos

Picasso's work is distributed across a great many separate institutions in different countries, the majority in Western Europe and North America. This brief guide mentions some but not all of the institutions with holdings in each country, but only major works are included in the detailed lists. It does not include works held in the major Picasso museums, or Picasso's graphic work.

United Kingdom
London
NATIONAL GALLERY
Child with Dove 1901; *Fruit Dish, Bottle and Violin* 1914

TATE
Girl in a Chemise 1905; *Head of a Woman* 1909; *Seated Nude* 1910; *Still Life* 1914; *Seated Woman in a Chemise* 1923; *The Three Dancers* 1925; *Nude Woman in a Red Armchair* 1932; *Weeping Woman* 1937; *Reclining Nude with Necklace* 1968

Cambridge
FITZWILLIAM MUSEUM
Head of Fernande 1910; *Minotauromachia* 1935

Edinburgh
SCOTTISH NATIONAL GALLERY OF MODERN ART
Mother and Child 1902; *Head* 1913; *Nude Woman Lying in the Sun on the Beach* 1932; *End of a Monster* 1937; *Lee Miller* 1937; *Les Soles* 1940

Australia
Brisbane
QUEENSLAND ART GALLERY
La Belle Hollandaise 1905

Melbourne
NATIONAL GALLERY
Weeping Woman 1937

Austria
Vienna
ALBERTINA
Woman in a Green Hat 1947; *Naked Woman with Bird and Flute Player* 1967

Canada
Montreal
MUSEUM OF FINE ARTS
Embrace 1971

Ottawa
NATIONAL GALLERY OF CANADA
The Small Table 1919; *Woman in a Hat with Flowers* 1944

Toronto
ART GALLERY OF TORONTO
La Soupe 1902; *Nude with Clasped Hands* 1906

Czech Republic
Prague
NATIONAL GALLERY
Self Portrait 1907; *Landscape with Bridge* 1909; *Violin, Glass, Pipe and Inkwell* 1912

France
Paris
MUSÉE NATIONAL PICASSO
The most important and extensive collection in the world of Picasso's work in all media, comprised of the works he retained during his lifetime.

L'ORANGERIE
The Embrace 1903; *Nude on a Red Ground* 1906; *Large Nude with Drapery* 1920–1; *Large Bather* 1921

CENTRE GEORGES POMPIDOU, MUSÉE
NATIONAL D'ART MODERNE
Very significant collection, including
Bust of a Woman 1907; *Seated Woman in an
Armchair* 1910; *The Guitarist* 1910; *Glass of
Absinthe* 1914; *Curtain for the Ballet 'Parade'*
1917; *Girl with a Hoop* 1919; *Milliner's
Workshop* 1926; *Figure* 1928; *Minotaur* 1928;
Dawn Serenade 1942; *Woman Pissing* 1965

Antibes
MUSÉE PICASSO
Large collection of work made on site in
1946, including *La Joie de Vivre*.

Vallauris
MUSÉE NATIONAL PICASSO LA
GUERRE ET LA PAIX
War and Peace 1952; *Man with a Lamb* 1943

Germany
Berlin
MUSEUM BERGGRUEN
Harlquin 1905; *Head of a Woman with a
Colourful Hat* 1939

Cologne
LUDWIG MUSEUM
Very large collection, including *Woman
with a Mandolin* 1910; *Woman with an
Artichoke* 1941; *Head of a Woman* 1941
(original plaster); *Woman with a Pram* 1950
(original assemblage); *Reclining Woman with
Bird* 1968

Düsseldorf
KUNSTSAMMLUNG NORDRHEIN-
WESTFALEN
Bust of a Woman with a Vase of Flowers 1909;
Seated Woman 1933; *Still Life with Bull's Skull*
1942; *Large Profile* 1963

Münster
GRAPHIKMUSEUM PABLO PICASSO
MÜNSTER
Important collection of prints and
drawings.

Stuttgart
STAATSGALERIE STUTTGART
Head, Study for Les Demoiselles d'Avignon 1907;
Violin 'Jolie Eva' 1912; *The Open Window* 1929;
Bathers 1956 (wood); *Le Déjeuner sur l'herbe*
1962

Hungary
Budapest
LUDWIG MUSEUM OF
CONTEMPORARY ART
Matador and Nude Woman 1970; *Musketeer
with Sword* 1972

Iran
Tehran
MUSEUM OF CONTEMPORARY ART
Painter and Model 1927

Ireland
Dublin
NATIONAL GALLERY OF IRELAND
Still Life with Mandolin 1924

Italy

Venice

PEGGY GUGGENHEIM MUSEUM

The Poet 1911; *Pipe, Glass, Bottle of Vieux Marc* 1914; *The Studio* 1928; *On the Beach* 1937

Japan

Hakone

OPEN AIR MUSEUM

Still Life with Cat and Lobster 1965

Sakura City

KAWAMURA MUSEUM

Woman in an Armchair 1927

The Netherlands

Amsterdam

STEDELIJK MUSEUM

Guitar and Fruit Dish on a Table 1924; *Seated Woman with a Fish Hat* 1942

Russia

Moscow

PUSHKIN MUSEUM OF FINE ARTS

Girl on a Ball 1905

St Petersburg

STATE HERMITAGE MUSEUM

Thirty-eight works including *Absinthe Drinker* 1901; *Two Sisters (The Meeting)* 1902; *Three Women* 1908; *Friendship* 1908; *The Dryad* 1908; *Brick Factory at Horta* 1909

Spain

Barcelona

MUSEU PICASSO

A major collection of Picasso's earliest works and the complete suite of *Las Meninas Variations* of 1957.

Madrid

MUSEO NACIONAL CENTRO DE ARTE REINA SOFIA

Major collection, principally known for *Guernica*, including *Woman in Blue* 1901; *Still Life (the Dead Pigeons)* 1912; *Seated Woman in a Grey Armchair* 1939; *Guernica* and related studies 1937; *Man with a Lamb* 1943 (unique plaster cast of clay original).

THYSSEN-BORNEMISZA MUSEUM

Head of a Man 1913–14; *Man with a Clarinet* 1911–12; *Bullfight* 1934

Malaga

MUSEO PICASSO

A very significant collection supplemented by long-term loans, strong on works from Picasso's middle and later life and with original ceramics and drawings.

Sweden

Stockholm

MODERNA MUSEET

Bottle, Glass and Violin 1912–13; *The Spring* 1921; *Woman with Dark Eyes* 1941–3; *Woman with a Blue Collar* 1941; *Déjeuner sur l'herbe* 1962 (monumental sculptures)

Switzerland

Basle

KUNSTMUSEUM

The Two Brothers 1906; *Bread and Fruit Dish on a Table* 1908; *The Afficionado* 1912; *The Poet* 1912; *Sleeping Nude* 1934; *Woman in a Hat seated in an Armchair* 1941–2; *Women on the Banks of the Seine* 1950

United States

Boston

MUSEUM OF FINE ARTS

Rape of the Sabines 1963

Chicago

ART INSTITUTE

Over three hundred works, including *The Old Guitarist* 1903–4; *Nude with a Pitcher* 1906; *Head of a Woman* 1909; *Portrait of Kahnweiler* 1910; *Man with a Pipe* 1915; *Head* 1927

RICHARD J. DALEY CENTER

Head of a Woman 1965 (monumental public sculpture)

Cleveland

MUSEUM OF ART

Woman with a Cape 1901; *La Vie* 1903; *The Harem* 1906; *Harlequin with Violin* 1918; *Bull's Skull, Fruit and Pitcher* 1939

Detroit

INSTITUTE OF ARTS

Six works, including *Bottle of Anis del Mono* 1915

Los Angeles

LOS ANGELES COUNTY MUSEUM OF ART

Head of a Woman 1906; *Still Life* 1927; *Weeping Woman with a Handkerchief* 1937; *Women of Algiers* 1955

Merion

BARNES FOUNDATION

Harlequins 1905

New Haven

YALE UNIVERSITY ART GALLERY

Shells on a Piano 1912; *Dog and Cock* 1921; *First Steps* 1943

New York

METROPOLITAN MUSEUM OF ART

Seated Harlequin 1901; *Portrait of Gertrude Stein* 1906; *The Scream* 1927; *Reading at a Table* 1934

MUSEUM OF MODERN ART

Boy Leading a Horse 1905–6; *Two Nudes* 1906; *Les Demoiselles d'Avignon* 1907; *Bather* 1909; *Girl with a Mandolin* 1910; *Ma Jolie* 1911–12; *Guitar* 1912; *Green Still Life* 1914; *Glass of Absinthe* 1914; *Harlequin* 1915; *Three Women at a Spring* 1921; *Three Musicians* 1921; *Studio with Plaster Head* 1925; *The Studio* 1927–8; *The Studio* 1928; *Seated Bather* 1930; *Girl before a Mirror* 1932; *Night Fishing in Antibes* 1939; *Woman Dressing her Hair* 1940; *The Charnel House* 1944–5

SOLOMON R. GUGGENHEIM MUSEUM

Le Moulin de la Galette 1900; *Woman Ironing* 1904; *Accordionist* 1911; *The Poet* 1911; *Mandolin and Guitar* 1924

Pasadena

NORTON SIMON MUSEUM

Woman with a Guitar 1913; *The Ram's Head* 1925; *Head of a Woman* 1927; *Woman with a Book* 1932

Philadelphia

MUSEUM OF ART

Self Portrait with Palette 1906; *Female Nude* 1910; *Man with a Guitar* 1912; *Glass of Absinthe* 1914; *Three Musicians* 1921

Washington, DC

NATIONAL GALLERY OF ART

Tragedy 1903; *Woman with a Fan* 1905; *Family of Saltimbanques* 1905; *Nude Woman* 1910

Notes

Preface: Origins?

1 Cooper 1973; Lord 1993. For the extraordinary life of Douglas Cooper, see Richardson 1999.

2 Caillois 1975.

3 For Duchamp's impact on art since the 1960s, see Hopkins 2000 and Buskirk and Nixon 1996. Parkinson 2008, p.165, includes comments by contemporary artists underlining Duchamp's importance for them.

4 Estimates of the size of Picasso's output vary. This is partly based on the figures given by Pierre Daix to John Richardson, and cited in his 'L'Epoque Jacqueline', in Bernadac et al. 1988, p.48, n.21.

1. Picasso's 'Picasso'

1 Kant 1987 edn, esp. pp.174–89.

2 See Cranston 1994 for an excellent introduction to Romanticism.

3 Marcel Duchamp quoted in Parkinson 2008, p.153.

4 *Self-Portrait with Wig*, Barcelona, c.1897; Museu Picasso, Barcelona (oil on canvas, 55.8 x 46cm).

5 Richardson, 1991, pp.29, 45.

6 The most important of these religious/allegorical works are *First Communion*, 1896; Museu Picasso, Barcelona (oil on canvas, 116 x 118cm) and *Science and Charity*, 1897; Museu Picasso, Barcelona (oil on canvas, 197 x 249.5cm).

7 See Ocaña 1995 for more on the milieu of Els Quatre Gats.

8 For more background on Symbolism see 'Symbolism and the Dialectics of Retreat', in Eisenman 1994; for Art Nouveau see Greenhalgh 2000.

9 Daix and Boudaille 1960, p.60. For more on Picasso's interest in Gauguin, see Richardson 1991, pp.455–61, and Cox 2007.

10 Interpretations offered by Blunt and Pool 1962, p.21 and caption to ill. 46.

11 Reff 1980, p.28.

12 Picasso in Antonina Vallentin, *Picasso*, Paris 1957, p.46, quoted in Richardson 1991, p.275. Picasso's suggestion that *La Vie* was not his title is contradicted by the fact that it was used in print within a week or so of the work's completion.

13 Richardson 1991, pp.270–5.

14 Gilot and Lake 1965, p.42. According to Bolliger's 1956 classification of the *Vollard Suite* prints, there are eleven on the theme of the minotaur, and four on the 'blind minotaur'. It seems that the minotaur subjects in the *Vollard Suite* were given added impetus after April 1933, when Picasso was invited to make the first cover of the Surrealist journal *Minotaure*. The *Vollard Suite* minotaur prints were mostly made in 1933, but reworked in 1934 while Picasso was learning more about printmaking with the master printer Roger Lacourière. The *Minotaure* cover, *Minotaure assis avec un poignard*, was executed on 25 May 1933; the original is now in the Museum of Modern Art, New York.

15 Bernadac et al. 1994, p.152, argues that the minotaur was for Picasso all too human, whereas for Surrealists it represented all that is beyond the human.

16 Elliott 2007, p.61.

17 For a second-century CE telling of the myth see Pseudo-Apollodorus 1921 edn, Book 3, 1.3–1.4, and Epitome 1.7–1.9.

18 Ovid, *Metamorphoses*, Book VIII, 152–82.

19 Reported by Dor de la Souchère, in Ashton 1973, p.159.

20 She is, for example, thought by Daix to 'be' the female matador lying across the wounded horse in *Minotauromachia*. Daix 1993, p.231.

21 *Composition, Dora et le Minotaure* (china ink, coloured pencil and scraper on paper, 40.5 x 72cm, inv. 1998-308), reproduced in Baldassari 2006, p.87.

22 See, for example, Florman 2000, p.239, n.85.

23 *Large Corrida, with female bullfighter*, 8 September 1934.

24 Picasso's former dealer Daniel-Henry Kahnweiler to Bernhard Geiser, the compiler of the first catalogue of Picasso's prints, on 19 March 1936, quoted in Geiser and Baer (vol. 3) 1986, p.27. For an extended discussion of Picasso's print, see Goeppert and Goeppert-Frank 1987.

25 Cowling 2006, p.350, n.31.

26 See Florman 2000, p.239, n.82.

27 Daix 1993, p.231.

28 Barr [1946] 1966, p.193.

29 Daix 1993, p.231. Brigitte Baer has suggested that the little girl holding the lamp is another incarnation of Marie-Thérèse, arguing that the hat she wears recalls that in a photograph of 20 October 1922, which she gave to Picasso.

30 Notably Read 1960, esp. pp.66–7.

31 Florman constructs a complex reading of this kind, culminating in the claim that *Minotauromachia* 'attests above all to a profound loss of self . . . and . . . threatens the absolute loss of meaning' (Florman 2000, p.195).

2. Picasso Poetic

1 Lake 1957.

2 Richardson, 1991, p.204.

3 Ibid., p.319.

4 Ibid., p.327 and Read 2008, p.9.

5 According to André Salmon. See Hélène Seckel, 'Three Portrait-Manifestoes of Poets: André Salmon, Guillaume Apollinaire, and Max Jacob', in Rubin 1996, pp.181–201.

6 On Picasso and the cinemato-graph, see Staller 2001, pp.137–60.

7 Picasso's painting is visible, together with these objects, in a photograph from around 1905, reproduced in Richardson 1991, p.373.

8 For a discussion of the figure of Harlequin in Picasso's later career, see Bois 2009.

9 Ironically, the painting is among the most expensive ever sold at auction in recent years, bought for $40.7 million in 1989 by Walter H. Annenberg, who bequeathed it in 1992 to the Metropolitan Museum of Art, New York.

10 See Robert J. Boardingham, 'Gustave Coquiot and the Critical Origins of Picasso's "Blue" and "Rose" Periods', in McCully 1997, pp.143–7.

11 Read 2008, p.22.

12 Tim Hilton argues for the importance of Puvis in terms of the pastoral genre and the formal problems of modern painting (Hilton 1975, pp.55–9). For a recent study of Puvis de Chavannes, see Shaw 2002.

13 Reff 1971. Reff's interpretation is extended in Carmean 1980. Both erroneously identify the little girl as Raymonde, briefly adopted by Picasso and Fernande (but not in fact until two years later, according to Richardson, 1991, p.385).

14 For more on Picasso and caricature, see Gopnik 1983, Staller 2001, Ocaña et al. 2003 and Michael Raeburn, 'Umoristi e Cubisti', in McCully 2004, pp.65–77. For the caricature of Apollinaire, see Rubin 1996, p.191.

15 Read 2008, p.18. The link between these poems and the painting was first analysed in McCully 1980.

16 English translation by Read 2008, p.19.

17 Richardson, 1991, p.337.

18 Rilke 1998, p.45.

19 For the text of the Serrurier review, see McCully 1981, pp.52–3.

20 Jacob 1936, pp.49–50.

21 Ibid., pp.20–4.

22 Goeppert, Goeppert-Frank and Cramer 1983, p.16.

23 For a detailed catalogue of these prints and those not published, see Geiser and Baer (vol.1) 1990, pp.57–64. There is also a painting of Mlle Léonie – see Richardson 1996, p.146.

24 See chaps. 3 and 5. For a contemporary example of the linking of the two elements see the text by American journalist Gelett Burgess, published in 1910, in Antliff and Leighten 2008, pp.26–40.

25 Ibid., p.362.

26 For the composite idea see Baldassari 1997, p.87. John Richardson suggests that the painting may depict Louis Codet, a local of Céret, where Picasso stayed in 1911 (Richardson 1996, p.189).

27 Quoted in Karmel 2003, p.1.

28 See Baldassari 2007, p.40.

29 Dora Vallier, 'Braque, la peinture et nous', p.16, quoted in Richardson 1996, p.190.

30 Karmel goes so far as to call Cubism 'a happy accident' consisting of 'brilliant extrapolations and naïve misreadings, wrong turns and lucky breaks' (Karmel 2003, p.viii).

31 Such metamorphoses, or their burgeoning, were the subject of a recent exhibition at the Museu Picasso, Barcelona, *Living Things: Picasso Figure/Still Life*, selected by Christopher Green (November 2008 to March 2009; see Green 2009). A classic essay pointing out a particularly striking example of the process in an early Cubist work is Rubin 1983.

32 See Poggi 1993, chap.3, pp.59–89.

33 Letter of 17 June 1912, Baldassari 2007, p.346.

34 Fry 1966, p.60.

35 The two key writers who approach Picasso's work in this way are Rosalind Krauss and Yve-Alain Bois: Bois 1992; Bois, 'The Semiology of Cubism', in Zelevansky 1992, pp.169–208; Krauss 1980; Krauss 1981; Krauss, 'The Motivation of the Sign', in Zelevansky 1992, pp.261–86; Krauss 1998.

36 Bois in 'The Semiology of Cubism', in Zelevansky 1992, pp.169–208.

37 Apollinaire 2002 edn, p.260.

38 Pierre Daix reports this in Zelevansky 1992, p.213.

39 Apollinaire 2002, p.41.

40 For the idea of pure painting, see Apollinaire 2002 edn, pp.262–5; for Apollinaire's invention of Surrealism, see Read 2000.

41 The drawing was made before 7 January 1915 (Jacob wrote to Apollinaire about the portrait on this date, Baldassari 2007, p.351). During 1915 Picasso made similar drawings of Apollinaire, Léonce Rosenberg (the dealer pursuing him at the time) and Vollard.

42 See Cowling 2002, pp.274–6 for more on the reception of the drawing and for the Max Goth 'portrait'.

43 For the wider context see Silver 1989, giving a detailed account of the cultural politics in question; for a discussion of Picasso in comparison with other Neo-Classical artists, see Cowling and Mundy 1990.

44 See Richardson 1996, pp.277, 354 for incidents of Eva's illness from 1913–14.

45 For Lagut, see Richardson 1996, chap.25.

46 Cowling 2002, p.283. Krauss argues that the turn to a pastiche Classical language was in fact a reaction to the way photography had supplanted the artistic form of portraiture (Krauss 1998, pp.89–212).

47 See, for example, Green 2000, p.216.

48 Reff 1980.

49 Richardson 2007, p.198.

50 Cowling 2002, p. 367.

51 For Apollinaire's statement see Read 2008, p.132. For the comparison with Greek relief sculpture, see Cowling 2002, p.427.

52 Cowling 2002, p.429.

53 See Richardson's excellent discussion (Richardson 2007, pp.192–5).

54 Richardson 2007, p.182. For the idea of Picasso's Neo-Classicism as disconcerting, an observation of Roger Fry's, see Cowling 2002, p.430.

55 Breton 1972, p.26.

56 For more on Breton's reinvention of Cubism, see Cox 2009b.

57 Barr 1939, p.125. In his expanded 1946 version, Barr suggests that *The Three Dancers* is a 'turning point in Picasso's art almost as radical as was the proto-Cubist *Les Demoiselles d' Avignon*' (Barr [1946] 1966, p.143).

58 In using the word 'convulsive' Barr was self-consciously evoking Surrealist notions; Breton famously stated in the last words of his novella *Nadja* of 1928 that 'Beauty will be convulsive or will not be at all' (Breton 1960, p.160). See Alley 1981 for an extensive discussion of the painting in these terms.

59 See Cowling 2002, pp.463–9, for a reading strongly linked to the Surrealist context. Richardson argues instead that this painting is actually a kind of crazed or demonic jazz-age Charleston, believing this to be typical of Picasso, who often 'plugged modernity into the savagery of antiquity' (Richardson 2007, p.282).

60 For more discussion see John Golding, 'Picasso and Surrealism', in Golding and Penrose 1988; Cowling 1985; Baldassari 2005.

61 Eluard published a series of brilliant critical texts on Picasso throughout the late 1930s, and these, together with poems such

as this one, were collected in a book of 1944 (see Eluard 1944; Gateau 1983).

62 Stevens 1937.

63 The first to date the newspaper were Daix and Rosselet (1979, p.290).

64 First noted by Robert Rosenblum in his essay 'Picasso and the Typography of Cubism', in Golding and Penrose 1988, p.60.

65 Greenberg, 'Modernist Painting', in Greenberg 1993, pp.85–93, and 'The Pasted-Paper Revolution', in Greenberg 1993, pp.61–6; see also Florman 2002.

66 See Krauss in Zelevansky 1992, p.263.

67 Quoted in Baldassari 2005, p.32.

68 Leo Steinberg, 'Un tour dans le collage de Stockholm', Baldassari 2007, pp.165–73 (this reference p.166).

3. Disfigurations

1 The exhibition, *Art in our Time*, ran from 10 May to 30 September 1939.

2 Baldassari 2005, pp.232–3.

3 The dealer was Jacques Seligmann. Picasso did not give Doucet *The Three Dancers* but kept it himself until 1965. It was then that Picasso agreed to sell the painting to Tate for £80,000 (see Cowling 2006, pp.271–81).

4 Kahnweiler 1949a.

5 Gelett Burgess, 'The Wild Men of Paris', Antliff and Leighten 2008, p.34.

6 See in particular the exhibition catalogue, *Les Demoiselles d' Avignon*, 2 vols., Musée Picasso, Paris 1988, trans. as Rubin 1994.

See Steinberg 1988 for an updated version of Leo Steinberg's groundbreaking essay. For other recent critical discussions of the work, see Green 2001.

7 On the notion of 'deformation' see Benjamin 1997. On Matisse's subject matter at this time, see Werth 2002.

8 As argued in Richardson 1996, chap.1.

9 On the story of the Iberian sculptures, see Read 2008, chap.8.

10 See Leo Steinberg, 'The Algerian Women or Picasso at Large', in Steinberg 1972, p.174.

11 Antliff and Leighten 2008, p.34.

12 See Rubin 1994 for the infra-reds, one of which is also reproduced at http://www.moma.org/explore/conservation/demoiselles/index.html.

13 All Salmon quotations from Fry 1966, pp.82–4. Among others who were deplored or baffled were André Derain, Félix Fénéon and Leo Stein. See Cowling 2002, p.162.

14 See Freud 2003 and Bois, 'Painting as Trauma', in Green 2001, pp.31–54.

15 Freud 1955.

16 The first to grasp the importance of the Medusa myth to Picasso's painting was John Nash in an essay first drafted in 1970; see Nash 2004.

17 Cowling 2002, p.175. On the beginnings of the collecting of tribal objects by modern artists see Rubin 1984.

18 This tendency to trace particular sources probably began with Robert Goldwater's remarkable book, *Primitivism in Modern Painting* (New York 1938), and Barr's comparison of the upper right-hand figure to an Etoumbe

mask then in the collection of the Museum of Modern Art in his Picasso exhibition catalogue of 1939. The most comprehensive attempts to track down the objects are in Rubin 1984 and 1994.

19 For critical discussion of the issues raised here, see Green 2006, chap.3. See also the essays by Christopher Green, Patricia Leighten and David Lomas in Green 2001. For the wider context see Rhodes 1997.

20 Cowling 2002, p.162.

21 J. Golding, 'Picasso and Surrealism' in Golding and Penrose 1988, p.133, where a Papua New Guinean mask (now collection of Claude Picasso) is wrongly described as African (corrected in Golding 1994, p.216). The mask is well illustrated in Rubin 1984, p.315.

22 Picasso to Malraux, quoted by Hélène Seckel in Rubin 1994, p.219.

23 In *Journal Littéraire*, 5 July 1922. Translated in Baldassari 2005, p.235

24 Cowling 1985.

25 Breton [1965] 2002.

26 Quoted in Golding 1994, p.210. For more on Picasso's preference for Apollinaire's definition, see Read 2000 and Richardson 2007, pp.348–50.

27 Golding 1994, p.211.

28 See Green 2009.

29 It seems likely that Bellmer was greatly impressed by Picasso's drawings when he came to know them; perhaps this informed the title of his essay, 'The Anatomy of the Image', first published in 1957, from which this sentence comes. Semmf and Spira 2006, p.43.

30 Cowling 2002, p.509.

31 A theme first properly isolated for discussion by Leo Steinberg, 'Picasso's Sleepwatchers', in Steinberg 1972. Dora Maar reversed the equation when she photographed Picasso sleeping in Mougins around 1936–7 (see Baldassari 2006, p.258).

32 Richardson 2007, p.371.

33 Cowling 2002, pp.453, 492.

34 Richardson 2007, p.470.

35 Bois 1998, pp.17–21.

36 Aragon and Breton 1928.

37 Cowling 2002, p.489.

38 Statement in Jardot 1955, note following catalogue entry no.40.

39 Richardson 2007, pp.369–71.

40 Cowling 2002, p.487.

41 Kaufmann 1969, p.557.

42 Kaufmann 1969, p.557. C.F.B. Miller (2007, p.13) rejects the identification.

43 Bataille 1930, author's translation. See also Bataille 1985, pp.57–8.

44 Miller 2007, p.2.

45 Bataille 1929, p.369, trans. from Bataille 1985, p.24.

46 Miller 2007, p.18.

47 Ibid., pp.15–16.

48 See Hopkins 2004 and Gale 1997 for introductory accounts on the feud. For *Documents* see Ades and Baker 2006 (and for the treatment of Picasso in the journal, pp.214–21).

49 See Breton, 'Second Manifesto of Surrealism', in Breton 1972, pp.180–6.

50 Bataille 1985 edn, p.57.

51 For more on the painting's context, see Cox 1994. For an

analysis of David's painting, see Clark 1999.

52 Bataille 1985 edn, p.55.

53 Brotchie 1995, pp.99–106.

54 Zervos 1970.

55 Picasso to Tériade, 1932, in Richardson 2007, p.478.

56 Translated in Green 2006, p.5.

57 Richardson 2007, p.466.

58 Brassaï 1999, p.133.

59 Green 2006, pp.12–13.

60 For further and intelligent reflections on these issues, see Lomas 2000, chap.3.

61 Baldassari 2006, pp.202–3, for an excellent discussion and reproductions.

62 Freeman 1994, p.195, emphasis added.

63 For a detailed discussion of *Weeping Woman* in relation to *Guernica*, and for the history of the painting in Britain, see Tate 1996.

64 For a discussion of Salmon's possible confusion, see Green's own essay in Green 2001, pp.128–49. The Salmon quotation is from Antliff and Leighten 2008, p.362.

65 Steinberg 1978.

66 For the exchanges in the debate see Rubin 1977, Steinberg 1979 and Rubin 1979.

4. Histories of Bombing

1 See Caizergues and Seckel 1992, pp.126–7, 134–5 for reproductions of examples.

2 See Leighten 1989 and, for a critique, Lubar 1990.

3 For a series of useful essays on the material addressed in this chapter, see Nash 1998.

4 For Maar and Picasso see Baldassari 2006 and Combalía 2002, esp. pp.205–30.

5 Chipp 1988, p.11.

6 Ashton 1973, p.3.

7 The 'sketches' (this term includes here painted studies for individual elements) were numbered by Rudolf Arnheim (Arnheim 1962).

8 See Bernadac 1994 for examples.

9 The drop curtains for *Parade* and other theatre sets were bigger, but produced with a team of assistants.

10 Published by Zervos in *Cahiers d' Art*, vol.12, nos.4–5 (1937).

11 Chipp 1988, p.135.

12 Ibid., p.126.

13 Blunt, cited in Calvo Seraller et al. 2006.

14 In the play the people of Spanish city Numancia die rather than fall victims to their Roman besiegers, an image of collective self-sacrifice that caught Bataille's attention. See Brunner 2001; Brunner 2004, pp.68–77.

15 Cowling 2002, p.589.

16 Chipp 1988, p.159.

17 Ibid.

18 Barr [1946] 1966, p.202. The rest of the statement is on p.264.

19 On 27 January 2003 a full-size tapestry version of *Guernica* (a gift to UN from Nelson Rockefeller) that hangs outside the entrance to the United Nations Security Council was covered for six hours with a large blue curtain while weapons inspectors Hans Blix and Mohammed el Baradei reported on their work in Iraq, and US Secretary of State Colin Powell responded. Although UN officials later protested that this was merely to manage the background for TV cameras, *The New York Times* pointed out that 'Mr Powell can't very well seduce the world into bombing Iraq surrounded on camera by shrieking and mutilated women, men, children, bulls and horses' (Dowd 2003). Some 125,000 Anti-War protesters took their revenge a few months later, parading cut-out characters from the painting held high on cardboard tubes through the streets of New York. *Guernica* comes back into focus in such moments.

20 Retort 2005, p.191. For another episode in the story of *Guernica*'s afterlife as a political weapon, see Frascina 1995; for an overview see Hensbergen 2004.

21 Hilton (1975, pp.233–46) offers a powerful critique of the painting in terms of the Classical modes of pastoral and epic.

22 Bernadac and Piot 1989, pp.166–8.

23 Translated in Brunner 2004, p.64. For another translation, see p.173 above.

24 Daix 1993, p.236, suggests that the issue did not appear until early 1936.

25 See Burgard 1986 and Rosenthal 1983.

26 Baldassari 2006, p.235.

27 Powell 1996.

28 See the excellent discussion of the issues in Utley 2000, pp.26–31.

29 Reported by Peter D. Whitney, *San Francisco Chronicle*, 3 September 1944, cited in Utley 2000, p.31.

30 Vlaminck in the newspaper *Comoedia*, 6 June 1942, cited in Daix 1993, p.266. Vlaminck's invective had its model in the tirades of earlier right-wing critics, particularly Camille Mauclair.

31 See Cox and Povey 1995; Calvo Seraller et al. 2006, pp.264–9.

32 Cowling and Golding 1994, p.275.

33 Picasso interviewed in 1944, cited in Beck Newman 1999, pp.106–22.

34 For a detailed discussion see Utley 2000, chap.4, pp.53–83.

35 Quoted ibid., p.76.

36 Quoted ibid., p.43.

37 Quoted Baldassari et al. 2002, p.386.

38 Utley 2000, pp.143–5.

39 In 1965 the British Marxist art critic John Berger puts it this way: '. . . either we lose the sense that this is a modern massacre or else we consider the soldiers as symbols of an eternal, unchanging force of cruelty and evil. Either way our indignation, which the painting was meant to provoke, is blunted' (Berger 1980 edn, p.114).

40 Utley 2000, p.152.

41 Ibid., p.187.

42 Ibid., p.191.

43 Utley (ibid., p.47) suggests that they may have had a role as eavesdroppers for the PCF on Picasso.

44 For a discussion of one sketchbook see Gert Schiff, 'The *Sabines*, Sketchbook No.163, 1962', in Glimcher and Glimcher 1986, pp.179–89.

45 Daix 1993, p.339.

46 Utley 2000, pp.203, 245 n.94.

47 An excellent catalogue, Lacambre and Forest 1999, discusses all aspects of the paintings.

48 See Bois 1998, pp.212–15.

49 Bernadac and Breteau-Skira 1992.

5. Gifts of Metamorphosis: Sculpture in Play

1 Hughes 1997, p.3.

2 Apollinaire/Read 2003, p.28. 'Orphism' was made an art historical designation in Spate 1977.

3 Hughes 1997, p.xi.

4 Spies and Piot 2000, nos.67, 67a.

5 J. Golding, 'Introduction', in Cowling and Golding 1994, p.26.

6 *Head* is Spies and Piot 2000, nos.66, 66a, 66b.

7 Read 2008, p.173.

8 Kahnweiler 1949b.

9 For more on the impact of the iron sculpture of Picasso, and that of González, on other later artists including David Smith, see Giménez 1993.

10 A second bronze replica of *Woman in the Garden*, made by González, is in the Museo Nacional Centro de Arte Reina Sofía, Madrid.

11 On the sculptures featured in 1932, see Spies and Piot 2000, p.14.

12 The original plaster of the *Head of Dora Maar*, made in the bathroom of rue des Grands Augustins, is in the Ludwig Museum, Cologne. The most detailed and riveting account of the monument story is in Read 2008.

13 Kahnweiler 1949b.

14 Bois, 'The Semiology of Cubism', in Zelevansky 1992, p.173. Bois gives three further semiological lessons that follow from the mask: 'that signs are constituted by differences or oppositions, not by their substance'; 'that signs are eminently contextual'; and 'that signs are arbitrary and oppositional, yet not everything is possible within a given sign system' (pp.173–4). For a different interpretation of Picasso's interest in signs, based on Kahnweiler's little-known sources in linguistic theory rather than on the thinking of Saussure favoured by Bois, see Green 1992, pp.83–7.

15 Salmon's text on Cubism implies that Picasso thought of the approach to representation in some non-Western objects as being what he termed 'intellectual' or 'rational', while the idea of 'conception' predominating over 'vision' was promulgated in the same year by critic Maurice Raynal in 'Conception et vision', trans. Antliff and Leighten 2008, pp.318–20.

16 Ashton 1973, pp.18–19. Cf. Apollinaire in 1913: 'the social role of great poets and artists is constantly to renew the way nature appears in the eyes of man . . . Without poets and artists . . . There would be no more seasons, no more civilisation, no more thought, no more humanity, no more life even, and impotent obscurity would reign for evermore' (Apollinaire/Read 2002, p.21). The notion that poetry is necessary for the renewal of our sense of reality, and therefore for the vitality of humanity, is also to be found in the work of Russian Formalist theoretician Roman Jakobson. See Bois in Zelevansky 1992, p.178, where it is clear that the reason why Jakobson believed this is that poetic thinking disturbs habitual belief in the sign as referring to real objects, an automatic relation to language that, paradoxically, vitiates the relationship to reality by preventing mobility of concepts.

17 For a reading of the sheet-metal *Guitar* as tied to the 'spectacle of modernity' rather than to semiotics, see Green 2006, pp.153–63.

18 See Karmel 2003, pp.99–194.

19 Ibid., p.169; for the transformation of a painting (fig.23) into a construction see ibid., pp.178–9.

20 Read 2008, p.108.

21 Ashton 1973, p.18.

22 Picasso to Spies, cited in Spies and Piot 2000, p.88.

23 Cowling and Golding 1994, p.274.

24 Ashton 1973, pp.156–7.

25 J. Golding, 'Introduction', in Cowling and Golding 1994, p.15.

26 Brassaï 1999, p.286.

27 Spies and Piot 2000, p.232.

28 See Andral 2006.

29 McCully 1998, p.35.

30 Penrose 1958, p.325.

31 Gilot quoted in Spies and Piot 2000, p.270.

32 Cowling and Golding 1994, p.281.

33 Spies and Piot 2000, p.270.

34 For example, Gilot and Lake 1965, p.173.

35 Jardot 1955. The catalogue was the first comprehensive overview of Picasso's work to date in French, and the exhibition was the first major retrospective since 1932.

36 Michel Ragon, catalogue preface to *Les Mains éblouies*, Galerie Maeght, 1950, cited in Lacambre and Forest 1999, p.63.

37 See the comment by Bois in Zelevansky 1992, pp.197–8.

38 As pointed out by Elizabeth Cowling in Cowling and Golding 1994, p.262.

39 Brassaï 1999, p.100.

40 See Cowling and Golding 1994, p.262; Utley 2000, pp.55–7.

41 Utley 2000, p.63.

42 Morris 1993, p.37.

43 Ibid., p.79.

44 Gilot and Lake 1965, p.298.

6. Dream and Lie of Picasso

1 Elizabeth Cowling in conversation with the author.

2 Some of course outlived him, including Aragon, Leiris, Miró and Dalí, all much younger.

3 Glimcher and Glimcher 1986, no.40, p.313.

4 According to Leiris in Golding and Penrose 1988, p.256.

5 Brassaï 1999, p.168, dated 27 April 1944.

6 Richardson 1996, pp.338–9. On the basis of his idea of the figures as clashing paradigms, Richardson argues, unconvincingly in my view, that the man is not an artist at all.

7 The Cézanne relationship was the subject of a major exhibition in Aix-en-Provence in 2009, and that with Ingres was explored at the Musée Picasso in 2004.

8 The origins of the project are obscure – it is possible that a poet (Pierre Reverdy or Blaise Cendrars) proposed it to his old dealer Ambroise Vollard, but it seems in any case that Vollard asked Picasso to undertake the illustrations as early as 1926. Vollard bought etchings from Picasso in 1927, but he also selected dot and line drawings of guitars.

9 Radio interview 1961 in Chabanne 1985, p.117.

10 This idea may well have inspired an important early painting on the theme of *Artist and Model* in 1926 now in the Musée Picasso, Paris, the representational idiom of which is a web of lines. See Richardson 2007, p.305.

11 Gilot and Lake 1965, p.18.

12 Balzac 2001 edn, pp.40–1.

13 Ibid., p.43.

14 Ashton 1980.

15 Ashton 1973, p.11.

16 See Green 2006; Green and Morris 2005.

17 Green (2006) sees Mondrian as the reference point, while Cowling cites a contemporary review that connects the work to Léger. See Cowling 2002, p.499.

18 Lydia Gasman reads it as a mirror and as a magical object, according to Green 2006.

19 Hilton (1975, p.170) makes much of the Mondrian connection. See Cowling 2002, p.497, for a convincing Gris comparison.

20 Green 2006, p.211.

21 Einstein 1929, pp.35–47. For more on Einstein's approach to these works see Green 2006, pp.28–9; Haxthausen and Zeidler 2004; Florman 2007; and Zeidler 2007.

22 See FitzGerald 2001, p.123.

23 See Dore Ashton, 'Picasso in his Studio', in Rylands 1996, p.133. Painter Robert Motherwell was moved by another painting then in the collection of Solomon R. Guggenheim, now in Venice, *The Studio* (1928), but the strong black elements of *Painter and Model* also seem to resonate

with Motherwell's *Elegies to the Spanish Republic*.

24 As Michael FitzGerald has suggested (2001, p.124), this profile looming against a manifestation of hideousness is to be found in another painting (*Figure and Profile*, 1927–8, private collection, illustrated in Rubin 1996, p.328). It seems to derive from a photograph that Picasso took of his own shadow profile, seen against a framed drawing on the wall, at around this time. The shadow could be the trace of the realist idiom of art before Cubism, the realism of the *artiste-peintre* before Frenhofer. It is also, perhaps, a trace of the camera, the ultimate realist machine. Finally, a sign for some of the presence of 'Picasso' in the studio, the shadow might seem to lead us back from the brink. (The photograph is illustrated in Baldassari 2005, p.173.)

25 The critic was Charles Roger Marx, cited in Cowling 2002, p.18.

26 Picasso's comment was to Kahnweiler, Ashton 1973, p.82.

27 Pacheco and Palomino 2007 edn.

28 See Susan Grace Galassi, 'Picasso in the Studio of Velázquez', in Brown 1986, p.126.

29 Parmelin 1963, p.232.

30 See Brown 1978. For an artistic response to this temporality, see the high-definition video work by Eve Sussman, *89 seconds in Alcazar* (2004).

31 Picasso to Kahnweiler in 1912, cited in Zelevansky 1992, p.169.

32 Parmelin 1963, p.230. The equation of art and bullfighting goes back to Leiris's important preface to his 1939 autobiography, *L' Age d' homme*, 'Literature considered as a Bullfight' (trans. as 'The Autobiographer as Torero' in Leiris 1984).

33 Parmelin 1963, p.233.

34 Calvo Serraller 2006, p.376, undated.

35 See Kleinfelder 1993, pp.29–30.

36 Bernadac et al. 1988, p.120.

37 Hollier 1989.

38 Cf. Schiff 1976 and Wollheim 1987.

39 The idea of equation is borrowed from Steinberg 1973.

40 The term is from David Sylvester's essay, 'Endgame', Bernadac et al. 1988, pp.136–47.

41 Spies 2007, p.14.

42 See Kirk Varnedoe, 'Picasso's Self-Portraits', in Rubin 1996, pp.111–79.

43 Richardson 1991, pp.49–50.

44 Quoted in Spies 2007, pp.36–7.

45 Daix 1993, p.369.

46 To Penrose in the 1940s, quoted in Ashton 1973, p.43.

47 De Man 1984, p.69.

48 Cf. Spies 2007, p.30.

49 Picasso to Angela and Siegfried Rosengart, quoted in Spies 2007, p.30.

50 Picasso to Parmelin in Ashton 1973, p.101.

51 Cited by Gallwitz in 1971, quoted in Bernadac et al. 1988, p.85.

52 Spies 2007, esp. p.38.

53 This point is made by John Richardson, 'L'Epoque Jacqueline', in Bernadac et al. 1988, p.42.

54 An important contrast noted by Spies 2007, p.23.

55 Restany, quoted in Spies 2007, p.281.

56 Bernadac et al. 1988, p.25.

57 The other two exhibitions were: *Pablo Picasso: Das Spätwerk. Themen 1964–1972*, Kunstmuseum, Basle 1981, and *Picasso: The Avignon Paintings*, Pace Gallery, New York 1981.

58 This is superficially evident in the different dates that have been proposed in exhibitions for the beginning of Picasso's 'late period'.

Picasso's Techniques

1 The most important general discussion of Picasso's technique is Finn 2007. I draw upon this text here.

2 Picasso to Felipe Del Pomar, translated in Ashton 1973, p.99.

3 For a discussion that contrasts the attitudes of Braque and Picasso, see Christine Poggi, 'Braque's Early *Papiers Collés* and the Certainties of *Faux-Bois*', in Zelevansky 1992, pp.129–49.

4 For a range of essays on the topic, see Dupuis-Labbé et al 2005.

5 See the discussion in Zelevansky 1992, pp.150–1.

6 See Cowling 1995.

7 See Cox 2009b.

8 For a detailed discussion see Heumann 2009.

9 See, for example, the two different states of Picasso's *Violin*, 1912–13 (the surviving state is in the Musée Picasso, Paris), shown in Karmel 2003, p.174.

10 According to Kahnweiler, in Ashton 1973, p.115.

11 See Prejger 2009, pp.23–7; and 'Picasso's Sheet Metal Sculptures:

The Story of a Collaboration, Lionel Prejger interviewed by Elizabeth Cowling and Christine Piot', in Cowling and Golding 1994, pp.241–53.

12 See Fairweather 1982.

13 On the ceramics see Bloch 1972; Finn 2007; McCully 1998; McCully 1999.

14 Finn 2004. Some of Finn's research has been published in 'Picasso et les bijoux' and 'L'argenterie dans la vie et dans l'oeuvre de Picasso', both in Finn et al. 2004, pp.79–123.

15 See Elliott 2007 for a helpful discussion of Picasso's printmaking techniques and collaborations and, for complete catalogues, Geiser and Baer 1986–92; Baer 1992–6; Mourlot 1970.

16 See e.g. Baldassari 1997 for photography, and, for film, Bernadac and Breteau-Skira 1992.

17 For an overview, see Boggs 1992.

18 These and other related works are discussed in Green 2009, chap.7.

Picasso's Writings

1 Penrose 1958, p.366.

2 Ashton 1973, and e.g. Brassaï 1999; Gilot and Lake 1965; Olivier 1965.

3 Bernadac and Michael 1998.

4 For published correspondence, see, for example, Caizergues and Seckel 1992; Rubin 1989; Stein and Picasso 2005.

5 The main source for Picasso's writings and for the cataloguing of them is Bernadac and Piot 1989, which also contains a useful 'dictionary' of recurrent words in Picasso's texts. For more interpretative approaches, see Brunner 2004; and Lydia Csatò Gasman, 'Death Falling from the Sky: Picasso's Wartime Texts', in Nash 1998, pp.55–67.

6 See Stein 1937; Michel Leiris, 'Picasso the Writer, or Poetry Unhinged', in Picasso 2004 edn, pp.311–16.

7 An excerpt of this February 1936 publication is translated in McCully 1981, pp.197–9.

8 Picasso to Roberto Otero, quoted in Richardson 1991, p.107

9 '80 Carats . . . and a single flaw' (1961), in McCully 1981, p.244.

10 Picasso 2004 edn, p.1 (trans. Jerome Rothenberg). This first text by Picasso is written entirely in Spanish. All subsequent texts are in French in the original, unless otherwise noted.

11 Ibid., pp.4–5 (trans. Jerome Rothenberg).

12 Ibid., pp.24–5 (trans. Jerome Rothenberg). Section I of this poem is in Spanish.

13 Ibid., p.36 (trans. Pierre Joris).

14 Ibid., p.57 (trans. Jerome Rothenberg). Written in Spanish.

15 Ibid., p.74 (trans. Pierre Joris).

16 Ibid., p.75 (trans. Pierre Joris).

17 Ibid., p.95 (trans. Pierre Joris).

18 Ibid., p.97 (trans. Jerome Rothenberg). Written in Spanish.

19 Ibid., p.98 (trans. Pierre Joris). In the original French this text puns on the phrase 'poetry, curable illness'.

20 Ibid., p.121 (trans. Anselm Hollo). This text refers to a painting now in the Musée Picasso, Paris (inv. 153), and which therefore Picasso kept.

21 Ibid., p.125 (trans. Anselm Hollo).

22 Ibid., pp.142–3 (trans. Jerome Rothenberg). A colour lithograph of Picasso's autograph original of this poem (written in Indian ink with a coloured crayon drawing of a weeping woman at the bottom of the page, now in a private collection) accompanied the prints *Dream and Lie of Franco* I and II (figs.44, 45).

23 Ibid., p.181 (trans. Mark Weiss).

24 Ibid., p.215 (trans. Jerome Rothenberg).

25 Ibid., pp.223–4 (trans. Pierre Joris).

26 Ibid., p.260 (trans. Pierre Joris).

27 Ibid., p.261 (trans. Pierre Joris).

28 Ibid. (trans. Pierre Joris).

29 Ibid., p.263 (trans. Pierre Joris).

30 Ibid., p.270 (trans. Pierre Joris). Nikos Beloyannis was a Greek Communist leader executed on 30 March 1952 for his political affiliation. The next day Picasso made a portrait drawing (Private Collection) of Beloyannis based on a photograph of him holding a carnation, and wrote this text.

31 Ibid., pp.274–5 (trans. Jerome Rothenberg).

32 Ibid., pp.290–91 (trans. Jerome Rothenberg). The text relates to a famous painting by El Greco of the same title (1586–8), now in the Church of Santo Tomé, Toledo.

Select
Bibliography

Dawn Ades and Simon Baker (eds.), *Undercover Surrealism: Georges Bataille and Documents*, exh. cat., Hayward Gallery, London 2006

Ronald Alley, *Catalogue of the Tate Gallery's Collection of Modern Art, Other than Works by British Artists*, London 1981

Jean-Louis Andral (ed.), *Picasso: La Joie de vivre, 1945–1948*, exh. cat., Palazzo Grassi, Venice 2006

Mark Antliff and Patricia Leighten (eds.), *A Cubism Reader: Documents and Critcism 1906–1914*, Chicago 2008

Apollinaire on Art: Essays and Reviews 1902–1918, ed. L.C. Breunig, New York 1972

Guillaume Apollinaire, *The Cubist Painters* with Peter Read, *Apollinaire and Cubism*, East Sussex 2002

Louis Aragon and André Breton, 'Le Cinquantenaire de l'hysterie (1878–1928)', *La Révolution surréaliste*, no.11 (15 March 1928), pp.20–2

Rudolf Arnheim, *The Genesis of a Painting: Picasso's Guernica*, Berkeley, CA, 1962

Rudolf Arnheim, 'On the late style', *New Essays on the Psychology of Art*, Berkeley, CA, 1986, pp.285–93

Dore Ashton (ed.), *Picasso on Art: A selection of views,* London 1973

Dore Ashton, *A Fable of Modern Art*, London 1980

Brigitte Baer, *Picasso: Peintre-graveur, catalogue raisonné de l'oeuvre gravé*, vols. 4–7, Bern 1992–6

Anne Baldassari, *Picasso and Photography: The dark mirror*, exh. cat., Museum of Fine Arts, Houston 1997

Anne Baldassari (ed.), *The Surrealist Picasso*, exh. cat., Musée Picasso, Paris 2005

Anne Baldassari (ed.), *Picasso/Dora Maar: Il faisit tellement noir*, exh. cat., Musée Picasso, Paris 2006

Anne Baldassari (ed.), *Picasso Cubiste*, exh. cat., Musée Picasso, Paris 2007

Anne Baldassari et al., *Matisse Picasso*, exh. cat., Museum of Modern Art, New York, Tate, London, Musée Picasso, Paris, and Centre Georges Pompidou, Paris 2002

Honoré de Balzac, *The Unknown Masterpiece*, trans. Richard Howard, New York 2001

Alfred H. Barr, *Picasso: Forty Years of his Art*, exh. cat., Museum of Modern Art, New York 1939

Alfred H. Barr, *Picasso: Fifty Years of his Art*, New York 1946, repr. 1966

Georges Bataille, 'Le "Jeu lugubre"', *Documents*, no.7 (1929), pp.369–72

Georges Bataille, 'Soleil Pourri', *Documents*, no.3, second year (1930), *Hommage à Picasso*, pp.173–4

Georges Bataille, *Visions of Excess: Selected Writings, 1927–1939*, trans. Allan Stoekl, Minneapolis 1985

Roger Benjamin, 'Matisse, the female nude and the academic eye', in Terry Smith (ed.), *In Visible Touch: Modernism and masculinity*, Chicago 1997, pp.75–106

John Berger, *The Success and Failure of Picasso*, London 1980

Marie-Laure Bernadac and Androula Michael (eds.) *Picasso, Propos sur l'art*, Paris 1998

Marie-Laure Bernadac and Christine Piot (eds.), *Picasso: Collected writings*, New York 1989

Marie-Laure Bernadac and Gisèle Breteau-Skira, *Picasso à l'écran*, exh. cat., Centre Georges Pompidou, Paris 1992

Marie-Laure Bernadac et al., *Late Picasso*, exh. cat., Tate, London 1988

Marie-Laure Bernadac et al. (eds.), *Picasso: Toros y Toreros*, exh. cat., Musée Picasso, Paris, Musée Bonnat, Bayonne, and Museu Picasso, Barcelona 1993–4

Georges Bloch, *Catalogue of the Printed Ceramic Works, 1949–1971*, vol.3, Bern 1972

Anthony Blunt and Phoebe Pool, *Picasso: The Formative Years*, London 1962

Jean Sutherland Boggs, *Picasso and Things*, exh. cat., Cleveland Museum of Art 1992

Yve-Alain Bois, 'Kahnweiler's Lesson', *Painting as Model*, London 1992, pp.65–97

Yve-Alain Bois, *Matisse and Picasso*, Paris 1998

Yve-Alain Bois (ed.), *Picasso Harlequin 1917–1937*, exh. cat., Complesso del Vittoriano, Rome 2009

Hans Bolliger, *Picasso's Vollard Suite*, London 1956

Brassaï, *Conversations with Picasso*, trans. Jane Marie Todd, Chicago 1999

André Breton, *Nadja* [1928], trans. Richard Howard, New York 1960

André Breton, *Manifestoes of Surrealism*, trans. Richard Seaver and Helen R. Lane, Ann Arbor, MI, 1972

André Breton, *Surrealism and Painting*, trans. Simon Watson Taylor, Boston [1972] 2002

Alastair Brotchie (ed.), *Encyclopedia Acephalica*, London 1995

Jonathan Brown, 'The Meaning of Las Meninas', *Images and Ideas in Seventeenth-Century Spanish Painting*, Princeton, NJ, 1978, pp.87–110

Jonathan Brown (ed.), *Picasso and the Spanish Tradition*, London 1996

Kathleen Brunner, '*Guernica*: the Apocalypse of Representation', *Burlington Magazine*, vol.143, no.1175 (February 2001), pp.80–5

Kathleen Brunner, *Picasso Re-Writing Picasso*, London 2004

T.A. Burgard, 'Picasso's *Night Fishing in Antibes*: Autobiography, apocalypse and the Spanish Civil War', *Art Bulletin*, vol.68, no.4 (1986), pp.637–72

Martha Buskirk and Mignon Nixon (eds.), *The Duchamp Effect*, Cambridge, MA, 1996

Roger Caillois, 'Picasso le liquidateur', *Le Monde*, no.28 (November 1975)

Pierre Caizergues and Hélène Seckel (eds.), *Picasso/Apollinaire, Correspondance*, Paris 1992

E.A. Carmean Jnr, *Picasso: The Saltimbanques*, exh. cat., National Gallery of Art, Washington, DC, 1980

Thierry Chabanne 'Picasso illustré . . . le *Chef-d'oeuvre inconnu* de Balzac', in *Autour du Chef d'oeuvre inconnu de Balzac*, ed. T. Chabanne, Paris 1985, pp.99–117

Herschel B. Chipp, *Picasso's Guernica: History, transformations, meanings*, Berkeley, CA, 1988

Herschel B. Chipp and Alan Wofsy (eds.), *The Picasso Project*, 13 vols., San Francisco 1995–2004

T.J. Clark, 'Painting in the Year 2', *Farewell to an Idea: Episodes from a History of Modernism*, London 1999, pp.15–53

Victoria Combalía, *Dora Maar*, exh. cat., Haus der Kunst, Munich, and Centre de la Vieille Charité, Marseille 2002

Douglas Cooper, letter, *Connaissance des Arts*, no.257 (July 1973), p.23

David Cottington, *Cubism in the Shadow of War: The Avant-Garde and Politics in Paris, 1905–1914*, London 1998

Elizabeth Cowling, '"Proudly we claim him as one of us": Breton, Picasso and the Surrealist Movement', *Art History*, vol.8, no.1 (March 1985), pp.82–104

Elizabeth Cowling, 'The Fine Art of Cutting: Picasso's *Papiers Collés* and Constructions in 1912–1914', *Apollo*, vol.142, no.405 (November 1995), pp.10–18

Elizabeth Cowling, *Picasso: Style and Meaning*, London 2002

Elizabeth Cowling, *Visiting Picasso: The Notebooks and Letters of Roland Penrose*, London 2006

Elizabeth Cowling and John Golding (eds.), *Picasso: Sculptor/Painter*, exh. cat., Tate, London 1994

Elizabeth Cowling and Jennifer Mundy (eds.), *On Classic Ground: Picasso, Léger, De Chirico and the New Classicism, 1910–1930*, exh. cat., Tate, London 1990

Neil Cox, 'Marat/Sade/Picasso', *Art History*, vol.17, no.3 (September 1994), pp.383–417

Neil Cox, 'Ultra-barbaric: Gauguin, Picasso and Modernist Primitivism', *Picasso: Small Figure*, Museo Picasso, Malaga, 2007, pp.3–63

Neil Cox, 'The Sur-reality Effect in the 1930s', in *Picasso: Challenging the Past*, exh. cat., National Gallery, London 2009a, pp.87–93

Neil Cox, *Picasso's 'Toys for Adults': Cubism as Surrealism*, Edinburgh 2009b

Neil Cox and Deborah Povey, *A Picasso Bestiary*, London 1995

Pierre Daix, *Picasso: Life and Art*, trans. Olivia Emmett, London 1993

Pierre Daix and Georges Boudaille, *Picasso: The Blue and Rose Periods. A Catalogue of the Paintings 1900–1906*, Neuchâtel 1966

Pierre Daix and Joan Rosselet, *Picasso: The Cubist Years. A Catalogue Raisonné of the Paintings and Related Works*, Boston 1979

Maureen Dowd, 'Powell Without Picasso', *The New York Times* (5 February 2003), available at http://www.nytimes.com/2003/02/05/opinion/05DOWD.html

Dominique Dupuis-Labbé et al., *Picasso: La Passion du dessin*, exh. cat., Musée Picasso, Paris 2005

Carl Einstein, 'Pablo Picasso: quelques tableaux de 1928', *Documents*, no.1 (1929), pp.35–47

Stephen F. Eisenman (ed.), *Nineteenth-Century Art: A Critical History*, London 1994

Patrick Elliott, *Picasso on Paper*, exh. cat., National Galleries of Scotland, Edinburgh 2007

Paul Eluard, *A Pablo Picasso*, Geneva 1944

Sally Fairweather, *Picasso's Concrete Sculptures*, New York 1982

Clare Finn, 'The Decorative Metalwork of Pablo Picasso: His

Collaboration with François Hugo', unpublished Ph.D. thesis, 2004, Royal College of Art, University of London

Clare Finn, 'The Making of Picasso's Art: "Not . . . by thought but with your hands"', in *Picasso: Fired with Passion*, Edinburgh 2007, pp.3–35

Clare Finn et al. *Picasso Peintre d' objets, Objets de peintre*, exh. cat., Musée d'Art Moderne, Céret 2004

Michael Fitzgerald, *Making Modernism: Picasso and the Creation of a Market for Twentieth-Century Art*, Berkeley, CA, 1995

Michael FitzGerald, *Picasso: The Artist's Studio*, exh. cat., Wadsworth Atheneum Museum of Art, Hartford, CT, 2001

Lisa Florman, *Myth and Metamorphosis: Picasso's Classical Prints of the 1930s*, London 2000

Lisa Florman, 'The Flattening of "Collage"', *October*, no.102 (autumn 2002), pp.59–86

Lisa Florman, '*L' Art mantique* of Picasso, and *Documents*', *Papers of Surrealism*, no.7 (2007) http://www.surrealismcentre.ac.uk/papers of surrealism/journal7/

Francis Frascina, 'Meyer Schapiro's Choice: My Lai, *Guernica*, MoMA and the Art Left, 1969–70', *Journal of Contemporary History*, vol.30, no.3 (July 1995), pp.481–511 and no.4 (October 1995) pp.705–28

Judi Freeman, *Picasso and the Weeping Women: The Years of Marie-Thérèse and Dora Maar*, exh. cat., Los Angeles County Museum of Art 1994

Sigmund Freud, 'Medusa's Head', *The Standard Edition of the Complete Psychological Works of Sigmund Freud*, vol.18, ed. and trans. James Strachey and Anna

Freud, London 1955, pp.273–4

Sigmund Freud, 'The Case of the Wolf-Man: From the History of an Infantile Neurosis', in *The Wolfman and Other Cases*, London 2003, pp.203–319

Edward Fry, *Cubism*, London 1966

Susan Grace Galassi, *Picasso's Variations on the Old Masters: Confrontations with the Past*, New York 1996

Matthew Gale, *Dada and Surrealism*, London 1997

Jean-Charles Gateau, *Eluard, Picasso et la peinture, 1936–1952*, Geneva 1983

Bernhard Geiser and Brigitte Baer, *Picasso: Peintre Graveur, Catalogue Raisonné de l' oeuvre gravé et lithographié et des monotypes*, vols.1–3, Bern 1990, 1992, 1986

Françoise Gilot and Carlton Lake, *Life with Picasso*, London 1965

Carmen Giménez, *Picasso and the Age of Iron*, exh. cat., Solomon R. Guggenheim Museum, New York 1993

Carmen Giménez (ed.), *Colección Museo Picasso Málaga*, Malaga 2003

Arnold Glimcher and Marc Glimcher (eds.), *Je Suis le Cahier: The Sketch books of Picasso*, exh. cat., Royal Academy of Arts, London 1986

Sebastian Goeppert, Herma C. Goeppert-Frank and Patrick Cramer, *Pablo Picasso, The Illustrated Books: Catalogue Raisonné*, Geneva 1983

Sebastian Goeppert and Herma C. Goeppert-Frank *Minotauromachy by Pablo Picasso*, Geneva 1987

John Golding, *Visions of the Modern*, Berkeley, CA, 1994

John Golding and Roland Penrose

(eds.), *Picasso in Retrospect*, Ware 1988

Adam Gopnik, 'High and Low: caricature primitivism and the cubist portrait', *Art Journal*, vol. 43, no.4 (winter 1983), pp.371–6

Christopher Green, *Cubism and its Enemies*, London 1987

Christopher Green, *Juan Gris*, exh. cat., Whitechapel Art Gallery, London 1992

Christopher Green, *Art in France 1900–1940*, London 2000

Christopher Green (ed.), *Picasso's ' Les Demoiselles d' Avignon'*, Cambridge 2001

Christopher Green, *Picasso: Architecture and Vertigo*, London 2006

Christopher Green, *Life and Death in Picasso, Still Life/Figure c.1907–1933,* exh. cat., Museu Picasso, Barcelona 2009

Christopher Green and Frances Morris (eds.), *Henri Rousseau: Jungles in Paris*, exh. cat., Tate, London 2005

Clement Greenberg, *The Collected Essays and Criticism*, vol.4: *Modernism with a Vengeance, 1957–69,* ed. John O'Brian, London 1993

Paul Greenhalgh, *Art Nouveau 1890–1914*, exh. cat., Victoria and Albert Museum, London 2000

Charles Haxthausen and Sebastian Zeidler (eds.), *October* (special issue on Carl Einstein), no.107 (winter 2004)

Gijs van Hensbergen, *Guernica: The biography of a twentieth-century icon*, London 2004

Jackie Heuman, *Tate Papers*, issue 11 (spring 2009), http://www.tate.org.uk/research/tateresearch/tatepapers/09spring/jackie-heuman.shtm

Tim Hilton, *Picasso*, London 1975

Denis Hollier, 'Pablo Picasso: The Painter without his Model', *Raritan* vol.10, no.1 (summer 1989), pp.1–26

David Hopkins, *After Modern Art 1945–2000*, Oxford 2000

David Hopkins, *Dada and Surrealism: A Very Short Introduction*, Oxford 2004

Ted Hughes, *Tales from Ovid*, London 1997

Max Jacob, *Saint Matorel*, Paris 1936

Maurice Jardot, *Picasso: Peintures 1900–1955*, exh. cat., Musée des Arts Décoratifs, Paris 1955

Daniel-Henry Kahnweiler, *The Rise of Cubism*, trans. Henry Aronson, New York 1949a

Daniel-Henry Kahnweiler, *The Sculptures of Picasso*, London 1949b

Pepe Karmel, *Picasso and the Invention of Cubism*, London 2003

Ruth Kaufmann, 'Picasso's Crucifixion of 1930', *The Burlington Magazine*, vol.111, no.798 (September 1969), pp.553–61

Ray Anne Kibbey, *Picasso: A Comprehensive Bibliography*, New York 1977

Karen L. Kleinfelder, *The Artist, His Model, Her Image, His Gaze: Picasso's Pursuit of the Model*, London 1993

Rosalind Krauss, 'Re-presenting Picasso', *Art in America*, vol.68, no.10 (December 1980), pp.90–6

Rosalind Krauss, 'In the Name of Picasso', *October*, no.16 (spring 1981), pp.5–22

Rosalind Krauss, *The Picasso Papers*, London 1998

Jean Lacambre and Dominique Forest (eds.), *Vallauris, Picasso, La Guerre et la Paix*, exh. cat., Musée National Picasso la Guerre et la Paix, Vallauris 1999

Carlton Lake, 'Picasso Speaking', *The Atlantic*, vol.200, no.1 (July 1957), pp.35–41

Brigitte Léal et al., *The Ultimate Picasso*, New York 2000

Patricia Leighten, *Re-Ordering the Universe: Picasso and Anarchism, 1897–1914*, Princeton 1989

Michel Leiris, *Manhood: A Journey from childhood into the fierce order of virility* (trans. Richard Howard), London 1984

David Lomas, *The Haunted Self: Surrealism, Psychoanalysis, Subjectivity*, London 2000

James Lord, *Picasso and Dora: A Personal Memoir*, New York 1993

Robert Lubar, 'Patricia Leighten's *Re-Ordering the Universe: Picasso and Anarchism, 1897–1914*', *Art Bulletin*, vol.72, no.3 (September 1990), pp.505–10

Paul de Man, *The Rhetoric of Romanticism*, New York 1984

Marilyn McCully, 'Magic and Illusion in the *Saltimbanques* of Picasso and Apollinaire', *Art History*, vol.3, no.4 (December 1980), pp. 425–34

Marilyn McCully (ed.), *A Picasso Anthology: Documents, Criticism, Reminiscences*, London 1981

Marilyn McCully (ed.), *Picasso: The Early Years 1892–1906*, exh. cat., National Gallery of Art, Washington, DC, 1997

Marilyn McCully (ed.), *Picasso Painter and Sculptor in Clay*, exh. cat., Royal Academy of Arts, London 1998

Marilyn McCully, *Ceramics by Picasso*, Paris 1999

Marilyn McCully (ed.), *Il Cubismo, Rivoluzione e tradizione*, exh. cat., Palazzo dei Diamanti, Ferrara 2004

C.F.B. Miller, 'Bataille with Picasso: Crucifixion and Apocalypse', *Papers of Surrealism*, no.7 [2007] (http://www.surrealismcentre. ac.uk/papers of surrealism/ journal7/)

Frances Morris (ed.), *Paris Post-War: Art and Existentialism 1945–1955*, exh. cat., Tate, London 1993

Ferdinand Mourlot, *Picasso Lithographs*, 4 vols, Boston 1970

Musée Picasso: Catalogue sommaire des collections, vol.1, Paris 1985,

Musée Picasso: Catalogue sommaire des collections, vol.2, Paris 1987

Musée Picasso: Les Demoiselles d' Avignon, 2 vols., Paris 1988

Musée Picasso: Carnets: Catalogue des dessins, 2 vols., Paris 1996

John Nash, 'Pygmalion and Medusa: an Essay on Picasso's *Les Demoiselles d' Avignon*', *Umení* no.52, no.1 (2004), pp.61–7

Steven Nash (ed.), *Picasso and the War Years 1937–1945*, exh. cat., Fine Arts Museums, San Francisco 1998

Victoria Beck Newman, '"The Triumph of Pan": Picasso and the liberation', *Zeitschrift für Kunstgeschichte*, no.62 (1999), pp.106–22

Patrick O'Brian, *Picasso*, London 1976

Maria Teresa Ocaña (ed.), *Picasso and Els 4 Gats: The Key to Modernity*, exh. cat., Museu Picasso, Barcelona 1995

Maria Teresa Ocaña et al., *Picasso from Caricature to Metamorphosis of Style*, exh. cat., Museu Picasso, Barcelona 2003

Fernand Olivier, *Picasso and his Friends*, London [1933] 1965

On-line Picasso Project [OPP], http://picasso.tamu.edu/picasso/

Ovid, *Metamorphoses*, trans. Mary M. Innes, London 1955

Francisco Pacheco and Antonio Palomino, *Lives of Velázquez*, London 2007

Gavin Parkinson, *The Duchamp Book*, London 2008.

Hélène Parmelin, *Picasso Plain: An Intimate Portrait*, London 1963

Roland Penrose *Picasso: His Life and Work*, London 1958

Pablo Picasso, *The Burial of Count Orgaz and Other Poems*, eds. Jerome Rothenberg and Pierre Joris, Cambridge, MA, 2004

Oliver Widmaier Picasso, *Picasso: The Real Family Story*, Munich 2004

Christine Poggi, *In Defiance of Painting: Cubism, Futurism, and the Invention of Collage*, London 1993

Kirsten H. Powell, '"La Drôle de guerre": Picasso's "Femme nue se coiffant" and the "Phony War" in France', *Burlington Magazine*, vol.138, no.1117 (April 1996), pp.235–45

Lionel Prejger, 'Picasso Cuts out Iron', in Elizabeth Cowling, *Picasso's Late Sculpture Woman: The Collection in Context*, Malaga 2009, pp.23–7

Pseudo-Apollodorus, *The Library*, trans. J.G. Frazer, London 1921

Herbert Read, *The Forms of Things Unknown*, London 1960

Peter Read, *Apollinaire et les Mamelles de Tiresias, la revanche d'Éros*, Rennes 2000

Peter Read, *Picasso and Apollinaire: The Persistence of Memory*, Berkeley, CA, 2008

Theodore Reff, 'Harlequins, Saltimbanques, Clowns and Fools', *Artforum*, October 1971, pp.30–43

Theodore Reff, 'Picasso's "Three Musicians": Maskers, Artists and Friends', *Art in America*, December 1980, pp.124–42

Retort, *Afflicted Powers: Capital and Spectacle in a New Age of War*, London 2005

Colin Rhodes, *Primitivism and Modern Art*, London 1997

John Richardson (with M. McCully), *A Life of Picasso*, vol.1: *1881–1906*, London 1991

John Richardson (with M. McCully), *A Life of Picasso*, vol.2: *1907–1917: The Painter of Modern Life*, London 1996

John Richardson, *The Sorcerer's Apprentice: Picasso, Provence and Douglas Cooper*, New York 1999

John Richardson (with M. McCully), *A Life of Picasso*, vol.3: *1917–1932, The Triumphant Years*, London 2007

Rainer Maria Rilke, *Duino Elegies, a Bilingual Edition*, trans. S. Cohn, Chicago 1998

Mark Rosenthal, 'Night Fishing in Antibes: A Meditation on Death', *Art Bulletin*, vol.65, no.4 (December 1983), pp.649–58

Deborah Menaker Rothschild, *Picasso's 'Parade' from Street to Stage*, London 1991

William Rubin (ed), *Cézanne: The Late Work*, exh. cat., Museum of Modern Art, New York 1977

William Rubin, 'Picasso and Georges and Leo and Bill', *Art in America*, vol.67, no.2 (March–April 1979), pp.128–47

William Rubin (ed.), *Pablo Picasso: A Retrospective*, exh. cat., Museum of Modern Art, New York 1980

William Rubin, 'From Narrative to "Iconic" in Picasso: The Buried Allegory in *Bread and Fruitdish on a Table* and the Role of *Les Demoiselles d'Avignon*', *Art Bulletin*, vol.65, no.4 (December 1983), pp.615–49

William Rubin (ed.), *"Primitivism" in 20th Century Art: Affinity of the Tribal and the Modern*, 2 vols., exh. cat., Museum of Modern Art, New York 1984

William Rubin (ed.), *Picasso and Braque: Pioneering Cubism*, exh. cat., Museum of Modern Art, New York 1989

William Rubin (ed.) *Picasso and Portraiture*, exh. cat., Museum of Modern Art, New York, and Grand Palais, Paris 1996

William Rubin et al., *Picasso: Les Demoiselles d'Avignon*, New York 1994

Philip Rylands (ed.), *Pablo Picasso L'Atelier*, exh. cat., Peggy Guggenheim Collection, Venice 1996

Jaime Sabartés, *Picasso: An Intimate Portrait*, London 1946

Gert Schiff, '"Suite 347", or Painting as an Act of Love', in *Picasso in Perspective*, Englewood Cliffs, NJ, 1976

Gert Schiff, *Picasso: The Last Years, 1963–1973*, exh. cat., Grey Art Gallery, New York 1983

Gert Schiff, 'Picasso's Old Age 1963–1973', *Art Journal*, vol.46, no.2 (summer 1987), pp.122–6

Michael Semff and Anthony Spira (eds.), *Hans Bellmer*, Ostfildern 2006

Francisco Calvo Serraller et al., *Picasso: Tradition and Avant-Garde*, exh. cat., Museo Nacional del Prado, Madrid 2006

Jennifer L. Shaw, *Puvis de Chavannes: Modernism, and the Fantasy of France*, London 2002

Kenneth Silver, *Esprit de Corps: The Art of the Parisian Avant-Garde and the First World War 1914–1925*, Princeton 1989

Virginia Spate, *Orphism*, Oxford 1977

Werner Spies (ed.), *Picasso: Painting Against Time*, exh. cat., Albertina Museum, Vienna 2007

Werner Spies and Christine Piot, *Picasso Sculpteur: Catalogue raisonné*, Paris 2000

Natasha Staller, *A Sum of Destructions: Picasso's Cultures and the Creation of Cubism*, London 2001

Gertrude Stein, *Everybody's Autobiography*, New York 1937

Gertrude Stein and Pablo Picasso, *Correspondance*, ed. Laurence Madeleine, Paris 2005

Leo Steinberg, *Other Criteria: Confrontations with Twentieth-Century Art*, New York 1972

Leo Steinberg, 'A Working Equation or Picasso in the Homestretch', *Print Collector's Newsletter*, vol.3 (February–March 1973), pp.102–5

Leo Steinberg, 'Resisting Cézanne: Picasso's *Three Women*', *Art in America*, vol.66, no.6 (November–December 1978), pp.114–33

Leo Steinberg, 'The Polemical Part', *Art in America*, vol.67, no.2 (March–April 1979), pp.114–27

Leo Steinberg, 'The Philosophical Brothel', *October*, no.44 (spring 1988), pp.7–44

Wallace Stevens, 'The Man with the Blue Guitar', *The Collected Poems of Wallace Stevens*, London 1955, pp.165–84

Tate Gallery: Illustrated Catalogue of Acquisitions 1986–88, London 1996, available online at http://www.tate.org.uk/

Gertje Utley, *Picasso: The Communist Years*, London 2000

Margaret Werth, *The Idyllic in French Art, circa 1900*, Berkeley, CA, 2002

Richard Wollheim, 'Painting, omnipotence and the gaze: Ingres, The Wolfman, Picasso', in *Painting as an Art*, London 1987, pp.249–304

Sebastian Zeidler, 'Life and Death from Babylon to Picasso: Carl Einstein's Ontology of Art at the Time of *Documents*', *Papers of Surrealism*, issue 7 (2007) http://www.surrealismcentre.ac.uk/papers of surrealism/journal7/

Lynn Zelevansky (ed.), *Picasso and Braque: A Symposium*, New York 1992

Christian Zervos, *Pablo Picasso*, 33 vols, Paris 1932–78

Christian Zervos, catalogue essay in *Pablo Picasso 1969–70*, exh. cat., Palais des Papes, Avignon 1970

Credits

Index